# Drawing Blood

# Drawing Blood

## Molly Crabapple

### A Memoir

HARPER
18 17

An Imprint of HarperCollinsPublishers

This is a work of nonfiction. The events and experiences detailed herein are all true and have been faithfully rendered as remembered by the author, to the best of her ability, or as told to the author by people who were present. Some names, identifying characteristics, and circumstances have been changed to protect the privacy and anonymity of the individuals involved.

HarperCollins books may be purchased for educational, business, or sales promotional use. For information, please e-mail the Special Markets Department at SPsales@harpercollins.com.

FIRST EDITION

*Designed by Leah Carlson-Stanisic*

Images on the following pages have previously appeared in the following places: pp. 2, 130, 322, 325, 327 and 330 at *Vice* (vice.com); p. 3 at *Medium* (medium.com); p. 41 at *Talking Points Memo* (talkingpointsmemo.com); p. 226 in the *Paris Review* (theparisreview.org); p. 305 at the *New Inquiry* (thenewinquiry.com); pp. 307, 308, 309 in *Discordia: Six Nights in Crisis Athens* by Laurie Penny and Molly Crabapple (Vintage Digital, 2012); p. 335 in *Vanity Fair* (vanityfair.com).

Library of Congress Cataloging-in-Publication Data has been applied for.

ISBN 978-0-06-232364-4

15 16 17 18 19 ov/rrd 10 9 8 7 6 5 4 3 2 1

*To Fred*

June 2013, Guantánamo Bay Naval Base.

*i* was drawing Khalid Sheikh Mohammed.

I sat in the courtroom at Guantánamo Bay Naval Base, watching a pretrial hearing for the 9/11 military commission in a room bisected by three layers of soundproof glass. On one side sat a few dozen legal observers and journalists, minded by soldiers. On the other, the tribunal hashed out a new, Orwellian form of law. We listened to the proceedings as we watched them through the glass—the audio delivered on a thirty-second delay, through CIA-controlled video monitors. One woman, whose husband had been burned alive in the towers, sat in the front row. Holding her husband's photo, she tried unsuccessfully to meet Khalid Sheikh Mohammed's eyes.

The court took a break. Through the glass, I stared at the alleged mastermind of 9/11 as he chatted with his codefendants. With fruit juice, he'd dyed his beard an implausible orange. He wore a camouflage hunting vest that accentuated his paunch.

I sketched frantically, pens held between my teeth. *You're the man who blew up my city*, I thought. *You beheaded Daniel Pearl. The American government kidnapped you, tortured you, drowned you till near death. Now you're in this prison, filled with innocent men, being used as its excuse.*

I was in Guantánamo Bay researching the story of one such wrongly imprisoned man. It was easiest to visit the base during a military commission, so Khalid Sheikh Mohammed's hearings gave me a reason for being

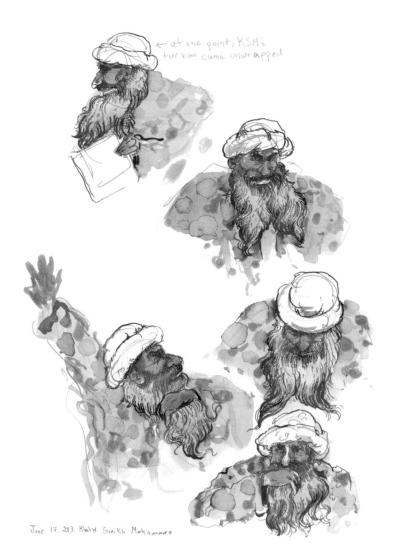

← at one point, KSM's turban came unwrapped

June 17, 2013. Khalid Sheikh Mohammed

there. But, during the commissions, Guantánamo forbade members of the press to see the prisons themselves. So instead I sat in the courtroom, drawing KSM because he was there.

It's a strange kind of disassociation, to stare into another's eyes only to make those eyes into shapes on paper. To draw is to objectify, to go momentarily to a place where aesthetics mean more than morality. I shaded the alleged murderer's brow bone. I rendered the curls of his beard so they would fall across the page in an interesting sweep.

Khalid Sheikh Mohammed smirked at me through the glass. *I'm watching you like a zoo animal*, I thought. *You want to watch me back? Fair enough.*

I turned the page, switched my markers, and started another sketch.

During my seven days at Guantánamo, the prison kept us from seeing any detainees besides the 9/11 codefendants. The other men, 152 in all, remained entombed in Camps Five and Six. The military press officers were forbidden even to speak their names. These prisoners' absence hung heavier than any presence could. I drew compulsively, hoping that sketches of Gitmo's facilities could serve a purpose something like the chalk outlines of bodies at a crime scene, delineating space around the lost. I drew signs flaunting the base's motto: "Honor-Bound to Defend Freedom."

Guantánamo is built on erasure. But art is a slippery thing. The prison may have had guns, razor wire, and oceans of redactor's ink, but I had pictures. By the end of the week, I'd filled two sketchbooks. With each brushstroke, I thought about drawing the men back into existence.

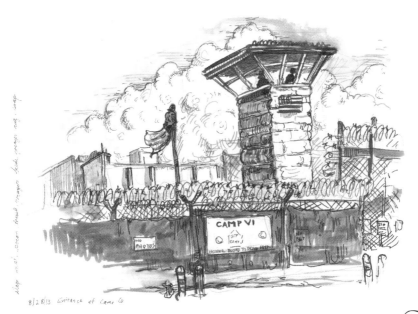

8/28/13 Entrance of Camp 6

I was twenty-nine when I stood on the Guantánamo ferry. By that time, I had been drawing for twenty-five years. For me, art was obsession at first sketch. Each new drawing was at once an escape and a homecoming. The pen was a lockpick, the paper a castle I could hide within. To draw was trouble and safety, adventure and freedom. Art was a stranger making eyes through the smoke of a foreign dive bar. Art was my dearest friend.

But before I could try to draw anyone else out of trouble, I had to save myself. I grew up angry, kicking against the boundaries of childhood. Unable to pay attention in school, I turned my worksheets into illuminated manuscripts. Demons frolicked around my biology handouts, and mermaids sprawled across my unfinished algebra tests. These early works earned me a punishment called "in-school suspension," which involved sitting in a windowless room for eight hours, staring at a wall. Deprived of my sketchpad, I scratched drawings into the desk with my nails.

Authority may have controlled the rest of my life, but in that four-cornered kingdom of paper, I lived as I pleased. There I was the actor, not the acted upon. When my mind turned in on itself, I drew anyway, learning that art can't save you from pain, but the discipline of hard work can drag you through it. My pen became my life preserver.

Once I was out in the world, the art that so horrified my teachers would become my way of gaining the attention of politicians, criminals, nightclub barons, and porn stars. It slipped me past doors marked "No Admittance," past velvet ropes to rooms where dancers glittered, their lips the purest red.

As the world changed, my art changed with it. The sketchbook I held on that Guantánamo ferry took me to protests, refugee camps, and war zones. Drawings became means of exposure, confrontation, or reckoning. Every line a weapon.

Each time, my hand raced to finish before the kids scattered, the fighters noticed, the curtain rose, or the cops showed up.

Drawing reduced me to essentials. Hand. Eyeball. Pencil.

Fused with my subject, I was alone in the clean work of creation.

This is the story of a girl and her sketchbook.

# 1

ithout art, you're dead!" my great-grandfather Sam used to say.

I never knew Sam Rothbort. He died before I was born. Photos show him as a shrunken old man, spry and lined, who liked to eat fire, stick pins through his cheeks, and hang from his feet on a chin-up bar at the door of his basement studio. Sam was born in a Belarusian shtetl in 1882. By 1905, he may have been involved with the Bund, an underground political party of Jewish communists. To avoid the draft, he fled to New York. When he got there, he painted—compulsively, promiscuously, selfishly. He turned out hundreds of canvases: Memories of his shtetl childhood. Tableux of Moses and the

prophets. Self-portraits in drag. The dreamscape of Coney Island. The communist fist. When, during the Depression, he grew too poor to paint, he sculpted driftwood.

Sam did not believe in formal education, war, eating meat, or respecting authority. Every morning he hauled dozens of paintings out onto the lawn of his tiny house in Brooklyn. He called this house the Rothbort Home Museum of Direct Art, and he was convinced it would threaten MoMA.

"Make art every day," Sam used to say.

My mother is Sam's granddaughter, and she followed in his footsteps. I grew up drawing by her side. My mother drew with looping, fluid lines. From her pen came a universe of Greek gods, princesses, maidens transforming into snails. She worked as an illustrator for toy companies and children's books, drawing the Cabbage Patch Kids and Holly Hobbie from nine to five, then taking freelance jobs at night.

In our family's world, art was neither exotic nor unattainable, but instead both a family tradition and an adult way to earn a paycheck—as prosaic in its way as fixing cars.

My mother's studio was a wonder, filled with things children weren't supposed to touch: rubber cement that stank of poison; X-acto blades that left me with stitches in my hands; rows of foul-smelling markers and T squares lined up neatly; an airbrush she wore a ventilator to use. I knew about Pantone swatches before I knew there was a movie called *Star Wars*. At night, when my mom did freelance work, I banged on her studio door, begging her to let me in. She sat inside, working, sick with guilt. She worked all day and all night too, and had done so since she was twenty. During her pregnancy, when doctors consigned her to strict bed rest, she propped a board up next to her night table so she could keep turning out art jobs until she was scheduled to deliver.

I knew I'd be an artist from the time my four-year-old hands first defaced a page. It wasn't a matter of inborn talent, or of any love of the results. I hated everything I drew. But I had a child's monomania, and for artists, that's the most important thing. My mother encouraged me. She bought me paper dolls of Ziegfeld Follies dancers to mutilate, and showed me her own fat volumes of works by decadent English illustrator Aubrey Beardsley, and French poster artist Henri de Toulouse-Lautrec. I watched in awe as she assembled a dollhouse from cut paper. She helped me with my first attempts at art, squeezing paint into a neatly arrayed color wheel for me. I mixed the colors together until I ruined the palette. When my Aladdin looked nothing like the one in the books, I howled till my eyes were raw.

"He doesn't look right because you're drawing his nose like an upside-down seven," my mother told me, and held my hand, guiding me through tear ducts and nostrils.

When I was young, my parents lived in a house in Far Rockaway, Queens. The city had neglected the neighborhood so thoroughly that packs of wild dogs stalked through the streets. The neighbors ran a chop shop in our shared backyard, concealing the cars beneath overgrown ivy. Their two daughters played with me in the cars until the day we found a dead cat, rotting on the front seat of a gutted Chevy. After that, we hid in their basement, leafing through their father's porn.

When I was seven, my parents divorced. The year 1991 was a bad one for my mom: her mother died of cancer, and computers hit the toy industry, making her hand-done illustrations obsolete. She had been a successful commercial artist for more than twenty years, but a field can change fast. Suddenly, she and her colleagues were no longer needed. My mother and I moved to a small apartment on Long Island, and she started dating a big Irish guy who spent the weekends getting smashed and singing "Danny Boy" at local bars. Money was tight. She worked a series of gigs—substitute teacher, receptionist—before finally landing a job as the art director at a vending machine company. At least it paid for her health insurance.

Every other weekend, *mi padre* made the three-hour drive to pick me up from my mother's apartment. As our car crossed the Verrazano Bridge, he had me recite the names of New York's boroughs—Brooklyn. Manhattan. Staten Island. Bronx. Queens.—repeated like a catechism. The green cables holding up the bridge flew past, the water swirled beneath us, and the skyscrapers pulled into the distance. It was an impossible city, a silver Babylon.

Mi padre came to New York as a child. His own father, *mi abuelito*, had escaped the sugarcane fields of Puerto Rico by joining the US Army. After World War II, abuelito married a seamstress, moved to Brooklyn, and had four kids. They lived in one room. He got a job in a factory, which gave him the cancer that eventually killed him, and augmented his wages by making loans and buying property that he rented out to other Latino immigrants. Because he was brown, the factory he worked at refused to promote him. Every Saturday, he drank till he passed out, sometimes in tears, because he had to train the white men who would become his supervisors.

Growing up, mi padre worked the midnight shift loading trucks with copies of the New York *Daily News*. He rode shotgun, throwing bundles of papers out at the stops, though the driver refused to deliver to black or Puerto Rican neighborhoods. My father's intellect crackled around him in sly, sarcastic sparks, and eventually he won a place at Brooklyn Tech,

one of the city's elite public high schools. From there he went to the City University of New York and finally to Columbia University.

When mi padre was in his early twenties, he got into a motorcycle crash. My mother was riding on the back. His shoulder was dislocated, which saved him from Vietnam. Her leg was shattered. She spent nearly a year in a cast up to her hip.

Mi padre became a professor of political science. He was also a Marxist, and he was eager to introduce me to Puerto Rico's history of resistance. On our car rides, he entertained me with stories of Jean Lafitte, reimagining him as a communist pirate who liberated plantations across the Caribbean—a spiritual precursor to the *independentistas*, the anti-imperialist Puerto Rican political party that was persecuted by the FBI.

Mi padre raised labor issues with similar bravura. One day, he made up a story about a factory worker whose boss would not give him time off to sleep. When fatigue finally overcame the man, his hand was ripped off by machines, and he bled to death on the shop floor. Later, the story went, the man's hand came back to strangle the boss.

Mi padre grabbed me by the back of the neck.

"*The hand!*" he screamed.

I screamed right back, fear mixed with delight.

He'd sit with me in his woodshop, holding a hammer, and tell me how the worker added value with his labor, and the capitalist made money only by paying the worker less than the value he added. He taught me to see each object as the culmination of a whole chain of such anonymous, exploited efforts.

Mi padre had a chip on his shoulder, as I do now. Not many people wanted either of us to win. He'd been kicked around by life, and he taught me to kick back. But our edginess left scars—on others and on ourselves. Like me, he keeps grudges for decades. We are both small, dark, bug-eyed. We look like angry owls. I see flashes of him in my own face when I am too determined. It's not a feminine look. I try to hide it. It comes out anyway.

Mi padre gave me New York as my birthright. He taught me every inch of the city. The brownstones of Fort Greene, Brooklyn, where his

parents lived. In immigrant fashion abuelito had ripped out the ironwork and marble of his home and replaced it with the plastic schlock he considered modern.

Fort Greene then was still the barrio; New York's gentrification lay far in the future. In summer, kids pried open the fire hydrants to dance in the jets of water. When he was young, mi padre built boats to race in the rivers the open fire hydrants made.

Mi padre argued politics with me beginning when I was eight, making me cry until I learned my way around an argument. From that point forward, no one ever made me cry again, except the men I loved. He'd tape-record his fights with university adversaries, then play them back for me. "Listen," he'd say. "Who thinks they have the power here? Who *really* has the power?"

Despite my loving parents and comfortable upbringing, I hated being a child.

I would happily have doused my childhood in gasoline and lit a match. I would have dropped it in battery acid, then stood nearby and cackled. I would have fed my childhood a poisoned apple, locked it in a glass coffin, and forbidden all princes from the land. I loathed it to my tiny core.

It wasn't just *my* childhood I hated. It was the concept of childhood itself. Being a child meant having no control over my life. I bristled every time I had to ask permission to go to the bathroom during class—or to take an aspirin during school when I had cramps. I recoiled when a lady stopped me as I walked to the library, demanding to know where my parents were. The ride to school filled me with such foreboding that I faked a twisted ankle in order to be allowed to stay home. That worked until my mom caught me walking without a limp.

Hating childhood meant I didn't like other children much either. I drew portraits of the popular kids as gifts so they wouldn't hit me, but I kept a secret notebook where I caricatured them cruelly. I gravitated toward anyone who seemed as bratty or bookish as I was, trying to enlist them

to help me create an alternate world of art and adventure. Mostly they ran away.

Reading obsessed me. I crossed the street with my head buried in books—a biography of Cleopatra, or an issue of Neil Gaiman's Sandman series. Books showed me a future. When I was eighteen, I vowed I'd turn myself into a chimera of my favorite characters: an artist/Folies Bergères dancer/spy. I hid books in my lap during classes. After school, I climbed the tree that grew in a park near our apartment. Shielded by the leaves, I sank into reading. The world faded. The sky grew dark. I pretended I was grown.

When I was twelve, I found my consolation in punk rock.

Nineties alt was a kingdom whose flags were the smeared pages of *Maximum Rocknroll*, the stripes of faded Kool-Aid pastel in a sad boy's hair. It was a place where my loneliness and bizarre interests could be validated—if I could just mimic the right cultural markers. I stalked through school's hallways, a brat in shredded black, wearing my superiority complex like a shield. I pierced my ears with safety pins. I scribbled cheerleaders tearing their own heads off. I worshipped Kurt Cobain as a martyr.

In art class, we were assigned to create dioramas of our favorite artist. I chose Toulouse-Lautrec. An alcoholic little person with syphilis, he was the poster artist for the Moulin Rouge. While other posters attempted to portray wholesome fun, Lautrec's art captured all the ambition and darkness behind a cancan girl's ruffles. I sculpted him in papier-mâché seated at a

KURT COBAIN

café table with an absinthe bottle and a sketchbook. A dancing girl stood frozen behind him, her gartered leg kicking high. I wanted to be Toulouse-Lautrec—to draw beautiful women and sell my art to obscure magazines.

My first attempt didn't go well. In ballpoint, I drew a nude anorexic in front of a spiderweb. *Requiem*, I wrote at the top. I didn't know what it meant, but it sounded deep. With great hope, I sent the original art to a Xeroxed goth zine whose address I found in the zine directory *Factsheet Five*. They sent the drawing back. "We don't accept art that isn't spelled correctly," read the publisher's note.

I was furious. Spelling shouldn't matter! Didn't they understand my genius?

Baggy band T-shirts couldn't hide my tits, which started to come in when I was nine. Grown men began harassing me on the street. My family isn't the kind that sees no intermediate steps between early puberty and teen motherhood, but the Hasidic men who offered me fifty bucks for a handjob didn't much care. When I was fourteen and wandering through Brooklyn, a sixty-year-old Rodney Dangerfield look-alike asked me on a date. I declined. "No, a sex-type date," he said. When I declined again, he told me I was ugly anyway.

A girl doesn't so much realize she can attract men as notice she's being watched. Her body, formerly her instrument, is now the reason she must be fetishized and confined.

I was less popular with my schoolmates than I was with the old men on the street. I was one of the only punk girls in my middle school. As I stomped into homeroom in my illicit anarchy T-shirts, classmates sniped, "Where's the funeral?" Books kept me company. I made my own

antiauthoritarian canon: Marquis de Sade, *Lolita*, Huey Newton's *Revolutionary Suicide*. I shoplifted these books using pockets I'd sewn into my coat for the purpose. The teachers didn't like it when I read during lectures. They stuck me in in-school suspension: a day staring at the walls of a windowless room, no books allowed. With my brain unoccupied, minutes became their own sort of torture.

When I got home, I blared Trent Reznor till the bass drowned out my thoughts, and doubted I'd ever be done with childhood. My loyalties will always lie with the angry girl I was.

The guidance counselor emoted at me during meetings, her eyes moist with false concern. She asked me why I was so angry.

I was angry because I was twelve.

The right way for a white girl to be angry is to turn her anger inward. She should be a victim, like a patient in *Reviving Ophelia*, the late-nineties ode to broken girlhood. She should starve or cut or blow boys who treat her badly. A crusading shrink should scoop her up and return her to good grades, tasteful clothes, and happiness—heart and hymen intact.

Like many smart kids, I had age dysmorphia. In my head, I was ready for adventures. In the world, I couldn't hang out alone at Starbucks. What the guidance counselor didn't want to remember is that childhood is helplessness. Schools have a kind of power over their students that most American adults will never experience until they enter a hospital, an old age home, an institution, or a prison.

At the end of seventh grade, the school had slapped me with a diagnosis of oppositional defiant disorder, and my mom sent me to live with mi padre. After a year of being forced to leave work in the middle of the day to take me home because of my art, or my clothes, or my lippy disposition, she'd understandably had enough.

Mi padre had moved to rural New Jersey. I did not adapt well. My stepmother saw me get off the school bus one day and described me as a little black smudge against the bucolic forest leaves.

I moved into a basement room lined with black vinyl, where I could hide out with the Emma Goldman biographies mi padre had bought me and have long phone calls with boys who sold weed. I enrolled in the local school, but I fit in there even worse than I had in Long Island. I was the only Jew—a fact that became clear when, in English class, the teacher dissected *Fiddler on the Roof* with the condescension of a Victorian anthropologist.

That year, I dispensed with my virginity, with the help of a high school senior. He was pale and scrawny, and he wore his curly black hair jaw-length, like Brandon Lee. He emphasized the resemblance by hanging the movie poster for *The Crow* over his bed. He and Brandon made eye contact as he came. Afterward, I walked alone around his suburban cul-de-sac. I felt sick to my stomach, but I couldn't tell if it was from fear or excitement. I was rid of what the world said was most precious about me. I didn't miss it.

I didn't see that senior again, or any other boys either. Instead, I lost myself in the town library, devouring biographies: Oscar Wilde. Josephine Baker. Lola Montez. I sat reading on a bridge over the train tracks. The trees were frail as bones. There was no graffiti, no empty liquor bottles, no signs of life. As the sun set, I walked home past brown fields and I thought about dying. Life was just a few seconds in the sunlight. We should consume it voraciously, and give back everything in us.

The year passed. My mother, in her kindness, took me back.

It was the first week of high school. I sat in the overlit cafeteria reading Nietzsche. I understood every tenth word, but just reading it made me feel superior.

A small girl sat down next to me. She wore a knit cloche, like those I'd seen in books about the 1920s. She had a plain pale face, bobbed hair, and mocking olive eyes nearly as large as her mouth.

"That book is bullshit," she said, reaching for it. Her frail fingers made mine look ogreish in comparison.

"It is not! It's about how the most intelligent people will triumph!"

"It's the first thing an adolescent reads when they haven't read any other philosophy but want to feel special."

I started to object, but I actually hadn't read much else.

The girl introduced herself as Nadya, with a blurred Russian accent. I repeated her name back.

"You're mispronouncing," she told me. I never would get it right.

The next day, Nadya sat at my table again. The day after, we walked home together. She was seventeen, but she looked far younger, and she stood only four foot ten. As we left the school, some Italian girls jeered that we were lesbians.

We didn't listen. We had a whole world to build together.

A recent immigrant from Moscow, Nadya became my best friend. Alone in the hostile school, we clung to each other, imagining other identities, different worlds where we would win. We wanted to be writers and artists. We wanted to live in Europe, drinking wine all night and arguing ideas with cynicism and passion.

One lunch hour, she shoved an envelope into my hands. It was a manuscript for the novel she'd written: a love story between a mobster and a flapper that took them from Paris to Corsica to Stalin's gulags.

I read it fast, while sitting next to her.

"Come with me to this blue city, where the smoke will swallow up the stones," one line read.

I recited her words aloud, ravished. I imagined Moscow, snow frosting Saint Basel's domes. I'd have done anything to go there with Nadya.

We snuck into Manhattan to eat a single expensive blini at Anyway Café. We argued philosophy. We ate pomegranates and read poems. We clung to each other, as bookish young people often do, while waiting out the years until our real lives could begin.

At the end of the year, Nadya graduated and moved back to Moscow.

No new friends came along to replace her. Every weekend, I snuck into the city. After getting off the train, I always paused at the bottom of Penn Station's escalators and looked up at the crush of New York, the hustlers and newspaper vendors and taxis, the crowds shoving for space. I said a silent prayer. One day I'd live here on my own. I'd belong to this city. This city would belong to me.

When I passed the crustpunks panhandling on Saint Mark's Place, I went sick with envy. Why couldn't I be as brave as them? They had no adults watching over their lives. They were free.

Come Monday morning, I was back in high school. I couldn't even stand to be in the cafeteria. Most days, I feigned illness during lunch hour, so I could lie in the nurse's office, reading or writing in the sweet white quiet. It shattered only once, when a boy flopped on the cot next to me and whispered that he'd rape me.

I ignored him. Instead, I scribbled a novel, in imitation of Nadya. To block out the pain of missing her, I built myself into the girl I imagined her to be.

With Nadya gone, I went looking for my community online. I found it on Usenet, a series of text-based special-interest message groups that focused on everything from art to obscure video games to Anne Rice. On one favorite haunt, alt.gothic.fashion, weird kids taught each other to make coffin purses—and supported each other while they came out as gay.

It was the 1990s, and our apartment had a dial-up modem that knocked me offline when my mom picked up the phone. Bandwidth was expensive,

so pictures were a rarity. But Usenet's community was real, and it saved kids like me.

This early Internet was simpler than today's. Because only nerds and freaks really knew about it, online was safe. The mass media were already starting to sensationalize its dangers, but it was my hideout from a world that saw little use for anything I had to give. Online, I was praised for my precocity. Offline, I was mocked as a pretentious little bitch. Online I could pretend to be what I wished I were: a few years older, a lot more confident.

Girls like me used the Web in all the ways our parents feared. We read anarchist manifestos and exchanged lurid porn with grown men. We ruined perfectly good bottles of vodka trying to make absinthe with recipes we learned on Gothic Martha Stewart. We learned about trolls—a phrase that then referred to charismatic assholes who brilliantly derailed message board conversations. We learned to troll ourselves.

On the old Internet, even the flame wars were word wars—fought with written insults, not with hacked photos of the target having sex, as they are now. Behind our chosen handles, we had neither age nor gender nor body. We could win on brains alone.

When I was fifteen, I met a girl named Lilith on an occult Usenet group. I charmed her there, as I charmed everyone online, but when we arranged to meet at the hot dog stand near Penn Station, I could see the disappointment in the downward arc of her lips. The words that flowed so easily from my fingers choked somewhere around my throat. I hated myself for being so young and so eager for her to like me. Why was I so damn uncool?

Lilith told me she was meeting friends, probably to get out of our awkward tête-à-tête. Not getting the hint, I tagged along.

We went to a goth bar. Dust sparkled in the sunlight, above velvet couches patched with tape. In a corner sat three older guys in black trench coats. One of them, named Anthony, drank a sticky herbal concoction he told me was chartreuse. He was twenty-two, an Italian guy from Queens with black hair, absinthe eyes, and a boyish, smirking mouth.

Anthony offered me a cigarette. I didn't smoke, but I wanted him to like me, so I sucked on it, letting the smoke leak out of my mouth like I'd seen my heroines do in movies. Looking at him, I thought he knew everything, and I knew almost everything, and he might help me make up the difference.

They decided to go to Washington Square Park to buy weed. No one told me to leave, so I tagged along silently. Finding no dealers, we sat by the park's empty fountain. It was spring, and a contortionist hustled money from the crowd of NYU students. Around him, pigeons puffed and fucked and vomited food into each other's mouths. Anthony offered me another cigarette.

"Do you know a pigeon is really just a dove with a bad rap?" he said, then exhaled theatrically.

A few days later, Anthony picked me up in a flashy muscle car, with pin-striping down the side. It *vroomed* menacingly, the result of a dubiously legal cooling system he'd had installed to make it go faster. We drove circles around Long Island, making out at the stoplights.

"I hate your sunglasses," I announced, then plucked them off his face and threw them into traffic. The next day, he wrote me an email saying I was insane. I was incredulous. Didn't guys like carefully scripted crazy?

We drove out to Jones Beach. It was closed. We snuck in anyway. I shucked off my dress. We fumbled with his pants. The air was ice, and the wet sand stuck, and we froze till we couldn't feel our lips kissing, but didn't people always have sex on the beach in books?

That night, on miserable Long Island, I told him I loved him. He told me he loved me too.

Being in love suddenly gave me purpose. When I started seeing Anthony, the teachers who ratted me out to my mom no longer mattered. The Fs on

my biology tests didn't matter. All that mattered was Anthony. He saw me as a woman rather than a child. He gave me a new self to try.

In return, I adored him, in a way that had little to do with who he was.

Anthony was a depressive smart-ass. He'd graduated high school early with a chemistry scholarship, but he'd been thrown out of college for allegedly planning to blow up the campus church. "It was a rip-off of the Pantheon," he told me. "But it didn't have any hole at the top. Someone needed to add a skylight."

After getting arrested, getting expelled twice, and running up thousands of dollars in credit card debt from going to raves and souping up his car, Anthony slunk back home and moved into his childhood bedroom. He worked nights at a tech job and slept most of the day. On Saturdays we drove all night, smoking weed and blaring the Cure, speeding from one end of Long Island to the other. I shimmied out of my dress and sat naked next to him. The white of the road dashed on the black. To us, those mall-clogged arteries felt like freedom.

After the first year, Anthony began to pick me up later and later, sometimes not bothering to show up at all. He never told me why.

On Saturdays, I leaned out the window, watching for his car.

Waiting for him to come, I started bargaining with myself. If three cars pass before he gets here, I promised, I'll punch my arms raw. If five cars pass . . . Finally I gave up. I walked away from the window. To distract myself, I sat down and decided to draw a century-old fern my mom had taken from Sam Rothbort's house. It was a complicated subject, the leaves curving trickily, ducking under each other. I obsessed over the edges, shading them, getting them wrong. I tore out the paper angrily. I tried again.

Turned outward, anger is restorative. If you can hang on to a pen, you can hang on to living, if just for that day.

Hours passed. I felt the edge smoothing, millimeter by millimeter. I stopped caring about Anthony, or about anything outside my sketchpad.

All that mattered was how closely I could observe those leaves. I held my pencil up like a ruler. My angles were off. I redrew.

Then, finally, the buzzer rang. I threw down the sketchpad and smoothed my hair. I was back, a girl again, not an artist. My man was here. Everything would be fine.

I opened the door. He stood there in the hallway, with his smirk and his old trench coat, not even embarrassed to be four hours late. I stared at the curve of his lips and hated myself. If I were any good, he'd have shown up on time.

I kissed him like nothing had happened, then led him to my bedroom. My mom was out with friends, and the apartment was empty. After sex, we smoked, leaning out the window. The night air was cold on our faces. One of these days, he told me, he'd pay off his credit cards, finish college, and drive cross-country. He'd be like a chemist Hunter S. Thompson. I could be like Hunter S. Thompson's girl. That was supposed to be good enough for me.

By senior year, paying attention in class was an impossibility. I aced my AP history exams without trying. But in subjects like math for which I had less aptitude, I handed in assignments filled with nothing but sketches of cats.

I applied to two New York City art schools and got into both. One of them was known for producing famous illustrators, but it was elite and pricey. The other, the Fashion Institute of Technology (FIT), was blue-collar, and with no famous art graduates at all. My mother refused to let me take on any debt, knowing it would constrain my future. Resentfully, I signed up for FIT.

Despite my poor grades, I was able to double up on classes my senior year, skipping lunch to walk in lonely circles around the track to make up for a year's worth of gym, thus earning enough credits to graduate six months early. I was seventeen, and ready to be someone— somewhere—else.

I decided I'd go to Paris. Every artist I loved had been educated there, and I hoped to win my place in their ranks. I knew, vaguely, that young women were not supposed to travel alone. But in the books I read, they did. And what did the rules of suburban Long Island matter next to the books I worshipped? I'd inherited a thousand bucks from mi abuelito that was meant to pay for college, and mi padre was willing to pay his child support directly to me. I had just enough money for a student-rate plane ticket and the most pinched of accommodations. I bought my ticket from a student travel agency in Manhattan, then using the horrific French I'd learned from kids' books, I called up a twenty-dollar-a-night hotel in Paris and booked a room.

Then I told my mother. Afraid I'd get killed in some strange city, she tried desperately to talk me out of it. I didn't listen; I never did.

Instead of a yearbook, I had my classmates sign a thrift-store copy of *Death in Venice*. I'd always felt excluded during high school. But high on their own nostalgia, my classmates left such kind notes that when I showed the book to a friend years later, he told me I'd probably been excluding them.

Before I left, I gathered every childhood photo of myself I could find. Without looking, I burned them all. They were baggage I didn't need. I was going far, and I wanted to travel light.

Anthony drove me to the airport. We sat next to each other, mostly in silence, passing the malls and mosques that lined the roads to JFK. Long Island fell away behind me, and with it Anthony too. When we got to the departure gate, I was too scared to leave. He shoved me toward the gate. "I love you, and there's a piece of me that's always there with you," he said with a pained half smile.

I buried my head on his shoulder, then turned and walked away, toward security.

*t*he streets of Paris were as familiar as a dream. The city smelled of dog shit and cherry blossoms. Its baroque buildings shimmered the same color as the Seine.

The room I booked was at the Hôtel Saint-Jacques, up eight twisting flights of stairs. The shower was down the hall. On weekends I wandered through the bird market on the Île de la Cité, scribbling the squawking canaries, then walked for hours through Les Halles and Pigalle, past sex stores and three-card monte games and bakeries luscious with pastries I couldn't afford. I read books at the Institut du Monde Arabe. Paris was not the postcard cliché I'd read about. It was something better: a raw metropolis, both New York's opposite and its equal.

I was happy, with a quiet joy that I'd never felt before, a slow and ferocious freedom. Solitude and newness were the twin gifts travel gave me, at the same time it took my context away. When I traveled I became nothing but an eye, soaking up the world. I lost all the dullness of home. I could draw with compulsion and rigor.

After a week in the city, I went looking for Shakespeare and Company.

Named for Sylvia Beach's lost generation hangout, the bookstore on 37 Rue de la Bûcherie had opened its doors in 1951. Since then, it had become legend, not just for its selection of English-language books but also for its hospitality. Over the second-floor archway, the shop's founder, George Whitman, had painted the words "Be kind to strangers, for they may

be angels in disguise." The store lived by that motto. Shakespeare and Company claimed to have hosted thirty thousand travelers on the narrow beds tucked between its bookshelves in the years since it opened. These guests—including writers like Lawrence Ferlinghetti and Anaïs Nin—were known as "Tumbleweeds."

I wanted more than anything to stay in Paris. The store was a center of the city's Anglophone community, and I hoped that if I hung out there, I could find some work. Doing what, I didn't know.

When I got there, at eleven A.M., the store was closed, its green doors pulled firmly shut. I sat in the courtyard, beneath the cherry trees that were just starting to cry their first blossoms. There was a fountain in front of me, three art nouveau nymphs entwined. I took out my sketchbook and started to draw them. Drawing is always a disruptive act. You produce when you're expected to consume. When you draw, you are performing quietly, inviting strangers to engage you. I often used my sketchbook as a talisman.

The side door opened. An old man hobbled out. He was thin and stooped, wearing a stained velveteen smoking jacket and pajama pants.

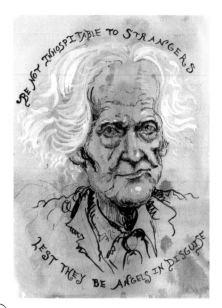

Beneath a torrent of white hair, his face was as lined as a piece of paper that had been crumpled and flattened and crumpled again. Painfully, he picked his way over to me.

I knew it was the owner, George Whitman, though he did not introduce himself. Instead, he peered into my sketchbook. He said nothing for a moment, just stood judging. Then he nodded approvingly.

"You're in Paris, eh?" he asked.

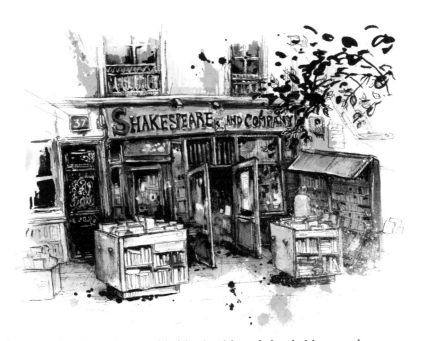

I stared at him, then nodded back. I'd read that he'd spent the year 1935 hopping boxcars from Washington D.C. to Central America, learning hospitality from a tribe in the Yucatan that once nursed him back to health. In the white sunlight, he looked every moment of his eighty-six years.

"There is no miracle greater than to be a young girl in Paris in the spring," George told me. He gestured to the bookstore, which was coming awake. A young man in a corduroy jacket unlocked the front doors, then started laying out rows of cheap paperbacks on the sidewalk. George told me that the man was one of the Tumbleweeds. In exchange for their beds, they had only to read a book a day and work an hour a day at the store. George invited me to join them.

"Be my little daughter. I have many little daughters," he said.

To my astonishment, his intentions were genuinely paternal. Letting myself trust him, I left my squalid hotel room and moved into the shop.

Shakespeare and Company hid thirteen sleeping spaces between its overflowing bookshelves. Some of the beds were boards with thin mattresses

on top, propped up by manuscripts. Others were bunks, hidden behind the hundreds of letters George dangled from the walls. An obese cat prowled through the shop, scratching who it pleased.

We woke up each day from the sunlight that spilled through Shakespeare's bare windows, then waited our turn at the single shower, which hadn't been washed for many years. Then we headed off to the Café Panis to jostle around the green zinc bar for our coffees. The manager always snuck me cookies, and I smiled at him mutely, too shy to flirt.

The bookstore opened at noon. I worked the cash register, which was not a cash register at all, but rather a ledger and a money box. Like many Tumbleweeds, I made up prices on the spot. Sometimes George staggered downstairs in his stained dressing gown and demanded that we not sell a book after all. There was a small wishing well in the back room, and the Tumbleweeds told tourists fantastical lies about the luck it would bring them if they threw in their francs. When no one was looking, we scooped out the coins and spent them on cheap wine, which we drank by the river.

Dirt coated every surface at Shakespeare and Company. It was brown, fragrant, a mixture of mold, cooking oil, and the dust of decaying books. Sometimes if I slept on a top bunk, cockroaches fell on my face. In the upstairs kitchen, the mold-furred refrigerator was stuffed with rotten soup. For Sunday tea parties, George baked pancakes with rancid flour. Ants drowned in the tea. Yet all that decay only made the store more lovely; the place had all the dark romance of Miss Havisham's wedding dress.

Tumbleweeds came and went. I shared the upper rooms with a Uighur dissident, a Dutch ballerina, and a slumming British violinist. I made friends with an aristocratic Sri Lankan girl studying math at Oxford. After work, we sat around gossiping next to a first edition of *Ulysses*. She had a delicate little fairy face and had chopped her thick hair into a 1930s bob. I remember her smirk fading only once, when a recurring vein disease caused her hands to swell to twice their size. She hid in the back room, crying, then wrapped them in mittens and strutted back out to the front.

Sometimes, George's daughter, Sylvia Beach Whitman, came over from England. She was twenty, a little gold Clara Bow, as shy as I was, and once she did a watercolor of a Ballets Russe dancer in my sketchbook. She was George's heir apparent, but that spring it seemed like the old man would live forever.

I was too intimidated to talk to George at length, then or during my other trips to Paris. But Shakespeare and Company showed me another way to live. The bookstore was a fortress, built from a past at once faded and imagined, when will and eccentricity were all one needed. George liked to call it "a little socialist utopia disguised as a bookshop." Yet, unlike most utopian experiments, it has survived.

I never wondered what deals George made to keep the store afloat. He was a businessman in a dying field, negotiating complicated French bureaucracies, while we kids wandered through his world. We drank and postured and disappeared without notice, thinking our incompetent efforts at the cashbox were enough to pay back George's gift.

Only later would I realize what a rare thing he had built, and how difficult it must have been to sustain.

I had little but time in that lazy Paris April, so I filled the hours drawing. I bought myself a leather-bound sketchbook, heavy, marble-edged and so expensive that each time I touched a pen to page, I dreaded fucking it up. In it, I developed a drawing style as finicky as that employed by Victorian travel writers, but instead of a crow quill, I used a cheap, ubiquitous Pilot pen. Every day, I chronicled the store. I drew the award-bedecked poets who seemed too glamorous to speak to after they gave readings. I drew the slumming Oxford girl and the Dutch ballerina so they'd think I was worth their time. My ink grew spiraling, compulsive.

One night, we sat around drinking in the upstairs office. The Uighur dissident had made us a vat of ratatouille, and we ate it out of unwashed cups. An American boy recited a poem about Notre Dame. How it must hate all those tourists, the poem read. One day, the cathedral would rise,

its flying buttresses stretching out like the limbs of a daddy longlegs. It would stand for a moment, regarding its tormentors. Then it would jump into the Seine.

As he read, I stared out the window. The Seine was black, and the streetlights shone gold where the wind rippled the water. In my sketchbook, I drew every single wave.

One of the characters staying at Shakespeare and Company was a perpetually grubby British academic named Edward. Twenty years older than any other Tumbleweed, Edward had just been thrown out by his wife, yet I immediately liked his posh voice, cynical posture, and, most of all, the attention he gave me.

Precocious girls often hope that older men will shape us. Older men often oblige in the hope that we'll sleep with them. The trade is slanted in favor of the girl, since behind the Bambi eyes, we're selfish little vampires. Edward bought me a blue shawl from one of the Vietnamese stores near Shakespeare and Company, and he sat with me at Panis, talking about a play he planned to write but never did. Inspired by my sour disposition, he based a character on me, naming her Molly Crabapple.

Spring turned into summer. I moved on to Venice, where Anthony and I met again. We wandered around the beauty-drunk, tourist-flooded, false, dying city; then we visited Rome, sleeping on a single bed, wrapped around each other so hard we were ground into each other's skin. I bought

flowers in the plaza where the Roman Catholic church had burned the dissident astronomer Giordano Bruno, then laid them at the foot of his statue.

Anthony went home. I went to Spain.

On La Rambla in Barcelona, I met a girl named Alex with tangled red hair and a handsome boy's face, pink from the wind. We were both hustling tourists: I drew portraits, she read palms. All around us were buskers and fire spinners, men painted silver, frozen, their ties wired stiff and suspended in midair. We spent our earnings at an absinthe bar in the crumbling Barrio Gotico. It was then a squatters' neighborhood, beloved by the circus punks who performed beside us on La Rambla. They formed a tight, protective scene. As we drank, a boy clowned on a unicycle in the main square. The police shouldered up, barking at him. He snarked back. They moved to cuff him. The patrons poured from the cafés, surrounding the police, screaming Catalan words I did not know, but still understood as "*Shame!*"

Alex swaggered like a boy, leading with her shoulders, turning down the corners of her wide, thin mouth. Originally from Canada, she'd been traveling for years, squatting, hitching, hustling, and telling fortunes—a skill she may or may not have believed she had. More important, she'd learned to project that silent message: "I'll cut you if you fuck with me." In Barcelona, we scanned outdoor restaurant tables for half-eaten meals abandoned on plates, then dove on them, shoving the food in our mouths until waiters shooed us away. We stayed up late in the graffitied alleys, telling each other dreams and secrets, and her confidence gave me a new sort of strength.

Alex wanted to go to Morocco, so we caught a ride south together. Outside the window, the hills of Andalusia rippled with wheat. They were dotted with spindly trees, their foliage round as dandelions.

I lay my head on Alex's shoulder.

In Seville's parks, we climbed trees to steal the oranges. They were dry and bitter, but we choked them down anyway. We made a salad in a plastic bag, ate it with our hands, and then slept in the same bed in a ten-

dollar room we'd found on the outskirts of town after walking in circles for hours, with Alex singing Ani DiFranco in my ear.

*"It's a long, long road and a big, big world, we are wise, wise women and giggling girls,"* sang Alex. She hid her hair under a knit cap, and she held herself bigger when any man bothered us. When I was with her, few did.

The morning we were meant to leave for Morocco, Alex changed her mind. Somewhere else was calling; she didn't say where, but it wasn't Tangiers. She was splitting in an hour. She dared me to go alone.

"Fear is a doorway," Alex said, giving me a crooked grin. Then she ditched me in Tarifa, a small town on the coast of Cádiz.

I decided to go.

I got off the ferry in Ceuta, a speck of North Africa somehow still owned by Spain. Crowds swarmed the border, dominated by stalwart middle-aged women in djellabahs, many bearing huge parcels of the electronics sold more cheaply in Spain. They fought their way to the front of the line at the wire border fence, yelling at any Moroccan officials who dared tell them to stop.

On the Moroccan side, the crush continued, with drivers trying to grab customers for the grand taxis that ferried passengers between cities. Seeing my confusion, one of the ladies yanked my arm. In French, she asked where I was going. "Fez," I blurted out. Patting my hand, she dragged me to the correct taxi, deposited me inside, and warned me not to trust any men who said they loved me, because they were all liars, especially when they were speaking to guilible tourists. More women jammed into the taxi until we were spilling over onto one another's laps.

In Fez, I understood what the woman had meant. Unemployment was high. With nothing better to do, bored young guys hung out on corners, hassling girls. They screamed that they wanted to kiss me or fuck me or be my lips. "Relax! Relax!" one boy screamed, and I turned and yelled at him in a tangle of French so fast, so ungrammatical and mispronounced, that he choked on laughter. I went to a café, ordered a mint tea. It came in a

small tulip-shaped glass, stuffed with fresh mint, the tea as thick as syrup. Bees converged. I swatted them. They came back. The owner laughed at me, then showed me how to put a plate on top to keep them off. Sipping the tea slowly, I took out my sketchpad. As I drew, bees walked across my hair. I barely noticed.

How could I? Fez was incomparable.

Students jetted in and out on motorbikes, through the old city's twisting alleyways chatting into the cell phones that caught fire in Morocco long before they did in United States, since Morocco lacked our landline infrastructure. Street cats scurried underfoot. Shopkeepers sold plastic back scratchers and mountains of rose petals, stacks of busted electronics alongside exquisitely gilded old books. Objects sprawled everywhere, in abundance and abandon. My pen darted to capture a woman in a sky-blue djellabah as she argued with a store owner. She waved a hennaed hand dismissively. He relented. She bought a stack of books. I drew her long braid as she walked away. A little girl sat next to me and watched me while I worked. I sketched her on the corner of the page, tore it off, and gave it to her.

In many Muslim countries, the Koranic prohibition on idolatry is interpreted as a ban on artistic representations of humans or animals. But creativity thrives on constraint. Moroccan artists had developed abstraction into something at once cleanly intellectual and sensuous. I stood in front of Bab Bou Jeloud, the gate at the entrance of Fez's old city. Its arch curved like a teardrop, surmounted by blue tile work. The tiles formed leaves, flowers, circles. They swirled, hallucinatory yet precise, mirroring the order that underlies nature's seeming chaos. Through the gate, I stared at Bou Inania Madrasa with its two gold domes, its walls colored like the sea.

Every half block, I sat and I drew. A black kitten rubbed against my ankle. I bought a bottle of water, filled the cap, and laid it next to her. I drew her as she lapped it up.

I slept on the rooftop of a hostel, alongside twenty other backpackers, each using our packs as pillows. There were few streetlights, so the stars felt close above.

Each day, I smeared on black eyeliner, tied my hair into a bun, and walked for hours in my shoes so battered that the heels were flapping off. I snuck past the Spanish backpackers who liked to sit smoking in front of the hostel— I was too shy to join them, or to make friends with any of the locals. Instead I wandered alone through the city. The Arabic language made my throat catch with its loveliness. The glottal stops, the "letters of pain," *ayn* and *ghayn*. The *h* in *uhebik* ("I love you") breathy as a gasp. I asked the café owner to write me out the alphabet, then practiced it over and over, spelling out English words in Arabic letters as if it were a code.

This new place focused my eyes as never before. Existing as a pure observer this way, I realized dimly, was yet another thing setting me apart from those who lived there—raw-nerved perceptiveness is unattainable in everyday life—but I loved it. Far from home, I never wanted to leave.

I got food poisoning almost immediately, but I hardly cared.

On the night train to Marrakesh, I fell asleep with my bag next to my head. The man sharing my compartment stole my wallet. Who could blame him? He needed the money more than I did. Luckily, I'd hidden my ATM card in my shoe. I reported the theft to the train's security. I didn't tell them anything about the man, but I wanted to use their phone, so I could call home and report the cards stolen. At first the head security guy was friendly. He was so sorry this had happened to me. Of course he would help.

Then the other officers left. I sat alone with the boss in my compartment. By that time, my food poisoning had turned into a full-blown fever. I was delirious. It was three A.M. I wanted to sleep. I lay down in the bunk. He pressed himself on top of me, his breath hot in my face. I didn't understand. Then I did.

I shoved him off, then stared in shock when he stuttered an apology.

He looked sheepish, as if the whole misunderstanding was more awkward for him than for me.

By the time the train pulled into Marrakesh I was nearly hallucinating. Nothing was open, but I knocked on the back door of a hotel. When it opened and a maid appeared, I begged her for a room. None were empty. I must have been a sorry sight, a teenage girl in dirty clothes, red eyes peering out from beneath a nest of oily hair, because the maid took my hand. She led me silently to the kitchen, where I fell asleep in a plastic chair.

Curled up there, I felt a strange delight mixing with the nausea. Something bad had happened. And yet I was fine.

In August 2001, I stepped off the plane in New York. After six months away, I had the swagger of someone who'd beaten down her irrational fear. Anthony stood waiting at the arrival gate. I ran to him, hugged him hard. I looked up at him, then at the crowds, the dirt of JFK, and the gypsy-cab drivers. Nothing felt the same.

On September 11, 2001, the air had the crisp sweetness of the new school year—that time when no one yet knows you, and you can create your whole life again. Nothing could touch you on mornings when the sun shone that bright.

I sat in a coffee shop in Chelsea, finishing a sketch I'd started in Paris. In two days I'd turn eighteen, and in a week I'd start classes at FIT. I was at the start of my new life—a real, adult life—and I was so excited my skin could barely contain it.

When we heard that the first plane hit on the café's radio, I thought it was an accident. A bomber once smashed into the Empire State Building, I knew, on a foggy day in 1945. But on September 11, there was not a single cloud.

Then the second plane hit.

I rose, walked out the door, then strode fast down Eighth Avenue. A single thought repeated inside me: *I have to see the towers*. As I ran south, white eclipsed the familiar buildings of Soho, along with the crowds, streaming north. I didn't stop till the smoke burned sour in my nose, and I saw a man, dust coating his office clothes, shuffling with fatigue in the opposite direction. "How are the towers?" I asked.

He turned to me, his face incredulous. "They're gone." He stopped, sobbing.

I turned around, and walked back to the dorms. Inside, the students

crowded around their TV sets. Again and again, the jetliners hit the towers, penetrating the glass walls. From each hole, fire exploded bright as funeral carnations. Papers fluttered from the offices. Then the towers began to fall.

I called Anthony in Howard Beach, an hour and a half away by subway. The phones were jammed. I dialed till my fingers ached. He picked up.

"I knew you'd be okay. Somehow I knew," he said.

I listened to the other students crying. I couldn't cry. There was a coldness inside of me, like from a puncture wound. The shock before the pain sets in.

I curled between my blankets and drew the towers streaming smoke.

In those days after 9/11, flyers bloomed on every wall in New York, posted by family members searching for husbands, sisters, and children. But the faces on those flyers lay buried beneath the rubble of the World Trade Center.

After a few months, the families who posted those flyers stopped hoping. But the flyers stayed up for years, fading until the sun and mold made them illegible; they became the city's scar tissue.

Then winter came and the country changed forever.

**4.**

$a$s New Yorkers breathed in the dust of their neighbors, the rest of the country threw itself into voluptuous hysteria. Politicians and the media both painted America as the ultimate innocent. The Muslim world hated us inexplicably—for our freedom, not for our bombs. How could this happen to us, the media cried. Death happened elsewhere; we inflicted death elsewhere, but this was America. We were supposed to remain untouched.

The city may have become a symbol, but we were still New Yorkers, practical and mercenary. Cafés collected blood donations. Street vendors sold vials of crushed charcoal briquette to tourists, claiming it was Ground Zero ash. American flags sprung up on halal chicken carts, frail defenses against the racist attacks to come.

Classes began at FIT, a grim complex of buildings from the 1970s so sparsely funded that the students didn't even have enough easels, with required classes in the archaic skills—airbrush, marker rendering, doing type by hand—that my mother had mastered, before computers made them irrelevant.

Most Fridays, I took the train out to Howard Beach to see Anthony. At Penn Station, national guardsmen stood by with AK-47s, grasping the leashes of bomb-sniffing dogs. I climbed the steps to the A train. A homeless woman sang "Ave Maria," her clothes and shopping cart stippled

with neon paint. She must have been a professional opera singer, I thought, and I showed her my sketch of her, grinning. I tucked a dollar into her cup.

An hour later, I was sliding beneath the blue comforter where Anthony was sleeping off his night shift. We fit well, in the room away from our lives. I still listened to him when he told me his dreams, and I lied to myself that they might come true. I didn't want to disturb our world. The room had no windows, so I could never tell what time it was. I tasted the sweetness of his sweat.

Winter came. On break from school, I bought a ticket back to Shakespeare and Company.

When I got there, the store was nearly empty. I had my own room, with a moss-green bed and a circular mirror, louche with age. The shower was broken, so we Tumbleweeds used public ones. My wet hair froze into icicles on the walk home.

One morning, on the way to get coffee at Panis, a little French boy stopped me.

"American?" he asked.

"Yes."

"America. Coca-Cola. Osama." He gave me a thumbs-up.

I worked the cash register on the last night of 2002. The European Union had just implemented the euro, and everyone was turning in old currencies for us to change. Irish punts, Italian lira, French francs. I pocketed a Greek drachma with the head of Alexander the Great, thinking it would give me luck. Afterward, an Egyptian boy took me to the Arc de Triomphe for the New Year's celebrations. We danced together, dodging the fireworks revelers shot directly into the crowd. The euro symbol shone in lights on the bridges, as a trademark for the new era.

We nursed our hangovers at a party on January 1.

As usual, I did not participate. It would be years until I learned how to speak at a party, to do more than whisper passionately with Anthony or Nadya, or with others as odd as myself. I sat in the corner, words choked down in my throat.

Instead, I read Omar Khayyam. It was the edition illustrated by Edmund Dulac, which I had first seen when I was fifteen at a Long Island library. Heart racing, I had cut out all the illustrations with a razor blade, then smuggled them out of the library, hidden inside my Spanish textbook. I was ashamed by the defacement—hurting a book was blasphemy—but the illustrations shone so exquisitely, I couldn't stop myself. Looking wasn't enough. I needed to possess them.

An American guy sat next to me and looked into my book. He was in his forties, blond, beaten around by life. His face was scratchy with graying stubble, and his pupils burned tiny in his sleety eyes. But we looked at each other with that outsider's understanding, and suddenly, I could speak.

His name was Russell, and he'd come to Shakespeare and Company the night before. I brought him over to Panis. We sat at the green zinc bar, drinking pale pastis that burned our mouths, and I read him lines from the *Rubaiyat*: *"He who harvested the golden grain . . . and who threw it to the wind like rain."*

I brushed the gold hair from his eyes.

Holding hands, we crossed the river to the Île de la Cité, and walked into Notre-Dame. Alone, with the church vast around us, we lit candles in the silent dark. We sat next to each other on the pews. I lay my head on his shoulder.

Russell had grown up mostly in group homes around San Francisco, but since then he'd traveled everywhere. He told me about dropping acid as a sixteen-year-old runaway, and how the hallucinations were the one

thing that could beat the pain in his head. He told me about buying the first Sex Pistols record when it came out, about beating a guy bloody on the streets of the Mission, growing up, getting sober, getting his masters, and ensconcing himself in the satisfying solitude of the Northwest mountains.

Hypnotized by his stories, I didn't notice that the church had closed.

"Think you can last till morning?" I dared Russell.

He nodded. I blinked. I found a priest, gave him helpless eyes. He led me out.

The next morning, Russell showed up at Shakespeare and Company, looking as sweetly wrecked as his old leather jacket. He'd spent the night at Notre-Dame, then hopped the fence in the morning.

I brushed his pale hair aside and kissed him hard. He'd broken a rule because I'd asked him. Kissing him just seemed like the right thing to do.

The next day, we walked side by side in the Paris catacombs. Long ago, monks had arranged the bones into patterns: spirals, crosses, hearts. Christians believed in bodily resurrection. I imagined the jumbled bones flying out of the crypt, ordering themselves midair, clothing themselves in muscle, then in skin, to ascend whole into heaven.

We walked through the frozen streets to the Oum Kalsoum Café. Over hookahs and sticky

*sahleb*, we decided to catch a bus to the south of France. On a cold Parisian night, whimsy can pass for magic.

We found a town too small to have ATMs. The sole hotel had decorated its reception room with butterflies in glass boxes. Above one, the proprietor had written, "I am sorry. I used to do this, but no longer. You're more beautiful when you are living."

Russell always carried a copy of *The Tempest*. When we weren't arguing, I lay in bed reading it to him. *"The cloud-capped towers, the gorgeous palaces, the solemn temples, the great globe itself, yea, all which it inherit, shall dissolve. And like this insubstantial pageant faded, leave not a rack behind."*

He wrote those lines on a notecard. Long after we parted, I hung it on the walls of every home I had.

Back in New York, school seemed even dimmer. During one art history class, the professor earnestly informed us that Titian sent a commission back to his client with a leg unfinished in order to express the fast pace of change during the Renaissance.

"No, he blew a deadline!" I wanted to scream.

Afterward, I wandered through FIT's library. In the art history section, I let my fingers trail over the spines of the books, hoping the greatness would rub off. My finger stopped on a history of Islamic architecture.

It was an old book, bound in cloth. When I picked it up, it fell open in my hands. The page it turned to showed a ruined castle nestled in the foothills of Mount Ararat. The castle was made of pale stone, a mass of domes and peaked arches, with a striped minaret that looked like one of Dr. Seuss's hallucinations. "Ishak Pasha Saray," the caption read. It was the most beautiful building I had ever seen. The castle was perched on the Turkish-Armenian-Iranian border, on the far end of a region still wracked by civil war between the Turkish government and the Kurdistan Worker's Party, a seperatist guerrilla movement more commonly known by its initials, PKK.

I felt a sharp tug in my chest. This building was so lovely, and so far away. I promised myself to draw it from life.

That summer, I boarded a plane to Turkey.

Anthony told me I was stupid for wanting to spend three months in the country. I could tour all of Europe in that time. I didn't tell him about my plan to see the castle.

I spent a month in Istanbul. Most mornings, I walked in wonder down the city's main commercial artery, Istiklal Caddesi. It seemed like the grandest boulevard in the world, lit by fairy lights. I walked past the chestnut sellers, the döner kebab shops, the men hawking tar-thick ice cream from Kahramanmaraş, past the street cats and bubble blowers, the crush of couples hand in hand. I walked down the hills to the Bosporus, where gulls swooped over the riverboats, each topped with domes that recalled the mosques of Sultanahmet. The words of Turkish are short, the grammar so logical that Esperanto cribbed its structure, and I began to develop a shaky faculty with the language.

After a few weeks, I boarded a bus and headed east toward the Iranian border. It took from five to eight hours to get between cities. The farther we got from the coast, the poorer the country became. Once we passed Kahramanmaraş, military checkpoints grew frequent. At each, the bus would stop and soldiers would stride through, checking our passports.

Just as Montana differs from Manhattan, eastern Turkey differed from Istanbul, being far more conservative. Men and women weren't allowed to sit next to each other if they didn't know each other. On the ride between Gaziantep and Mardin, I had a formidable older lady as my neighbor. She took a half-melted chocolate from a pocket in her modest raincoat and shoved it under my face. I ate it, oblivious that I might have brought some treats to give her in return. I stared through the window and sketched, tracing rolling green hills and silver roads connecting nowhere to nowhere. Turkey's pledge of allegiance lay written in block letters on the side of a mountain: *Ne Mutlu Türküm Diyene*. "How happy are those who can say they are Turks."

The conservatism played out in other ways. In Şanliurfa, a city near the Syrian border, I smiled too long at a hotel clerk. He pounced on me, trying to force his tongue into my mouth. I shoved him off. He looked embarrassed to have misread the situation.

The next day, I set off to explore the city. The old parts of Şanliurfa had an almost primal beauty: shades of gold and honey, domed and leafy, the buildings fading out into the hills. But there were no tourists here, and as an American teenager, I was painfully conspicuous. I sat down by the Balikli Pool, surrounded by walkways and old stone archways, and started drawing. Next to the pool was a shrine to the prophet Abraham. Old men sold fish food in the adjacent park. Religious visitors crowded by the water, feeding thousands of greedy carp.

As I walked out of the shrine, a group of police officers sidled up to me. They were handsome young men, tall and swaggering, with guns swinging at their sides. "Come with us," they tried, in English no better than my Turkish. They walked close beside me, walling me off. I followed.

At eighteen, I still trusted the cops, and I didn't realize I was being detained until we walked through the door of a tiny police station, past their laughing colleagues and dozing police dogs. They were probably *jandarma*, or military police, boys my age slogging out their mandatory military service. It would have been dull work, I can see now, stuck far away from the cities, checking passports in a region where, because of the war, most locals hated them.

At the time, I saw only their guns.

I was not handcuffed, but neither did I hope I was free to walk away.

Finally, one of the officers demanded, "What are you doing here?"

"Drawing," I offered, in Turkish.

"Show me your passport."

He stared at the battered pages. "I thought you'd be Russian," he smirked, referring to the Eastern European women who did sex work in the region. Then another officer offered me a glass of tea.

The cops seemed identical now: just men, and frightening because of that. I thought I'd be raped. Then one cop laughed. "Why are you wearing that long skirt?" he asked. "I see what American women dress like on TV."

I started to cry. The cops looked at each other. Suddenly they seemed young again, embarrassed as the clerk who'd tried to kiss me.

"Come with me," said the first cop. They piled with me into a van and deposited me back at the hotel. When he saw me, the clerk laughed heartily at my expense.

The next day, I called Anthony. I told him about being detained, how I had sat with those cops at the

card table, drinking tea, unable to leave, and how nice they'd been when I cried. I couldn't figure if I had been in danger, or if I had brought it on myself. I tried to laugh the encounter off, but I was nauseated with my vulnerability.

When I finished, Anthony stammered a few awkward phrases before saying good-bye. As I sat, listening to the unfamiliar Turkish dial tone, a guilty pride filled me. Till then, I'd always seen Anthony as far smarter than I was. For the first time, I realized, I'd seen something he'd never experienced.

The city of Hasankeyf had stood for eleven thousand years, built atop caves where kids still played. Cinder-block homes clung to the rock face, and Roman columns poked out of the Tigris River. In the summer of 2002, however, the Hasankeyf was slated to disappear under the waters of the Ilisu Dam. The government had offered business owners compensation, but at a small fish restaurant along the river, the owner told me it wasn't nearly enough for him to relocate. The restaurant's plastic tables were set down right in the river; our feet dangled in the water as we talked, and I sketched imperial ruins in the distance.

Overhearing our conversation, a short, muscular man strode over to us. He had a neat beard, and dark curls fell over his forehead. With a slight Bulgarian accent, he introduced himself as Victor. He was a photojournalist working with a crew on a documentary about water politics around the Tigris and the Euphrates, and as he spoke he pulled out a small portfolio and showed me his pictures. A Burmese monk standing stiff before a gold pagoda. Laborers in Chittagong, Bangladesh, breaking apart decommissioned ships for scrap metal. He'd shot the ships from a low angle, so they towered above the thin, diesel-smeared men. I turned the pages greedily, demanding more stories. With a gentle smirk, he lit up a cigarette and continued.

War journalists are some of the last macho archetypes we can lust after without ambivalence. They chronicle violence without being violent

themselves. Victor hadn't covered wars, but he had traveled to dangerous places, and in that Hasankeyf afternoon, I adored him and was jealous of him all at once. A photojournalist could see the world, meet all the people, and witness everything I clumsily tried to capture in my sketchbook.

Victor's crew was headed to Doğubayazıt. I hitched a ride. I'd been in Turkey for three months, and I wanted to see the castle I came for.

Victor found a small guesthouse. It was little more than a cinder-block cube, with the ubiquitous Ataturk portrait sandwiched between action-movie posters in the front room. The owner didn't have many tourists come his way, so he was glad to sit around with his friends and talk to Victor about the war. Many of his friends had lost family; some hinted that they'd been in the PKK. They were hard men, their faces clawed by the sun, and Victor loved shooting them.

But we'd been there only a day when Victor's editor called to say the assignment had been pulled. He and his crew left. I remained. It didn't feel like a choice. I had come this far to see that castle. I also had a low-grade fever, and I wanted to stay in one place. As I lay on the mattress on the floor of my room, growing sicker, a sensuous passivity overcame me. I was alone, escaped from my context. What would be, would be. I lay in bed, reading *Crime and Punishment*. Raskolnikov's fever grew worse, and so did mine.

The next day, I hauled myself outside, sat down on a plastic chair, and stared at Ishak Pasha Saray.

It looked nothing like the photos. Sometime in the last few decades the government had renovated the castle, and someone's relatives must have gotten the construction contract, because they'd done a hack job. Contractors had topped the whole thing with a metal roof befitting a suburban Walmart.

When I'd first seen those faded photos, I'd thought that drawing Ishak Pasha Saray in real life would mean something far more to me than just filling another page in my sketchbook. But after three months on the road

I didn't know what I'd been meant to find. Feeling nothing, I drew the castle anyway. In my piece, I ignored the renovations. With spider's lines, I set the building back in its past, among hills that could have been anywhere.

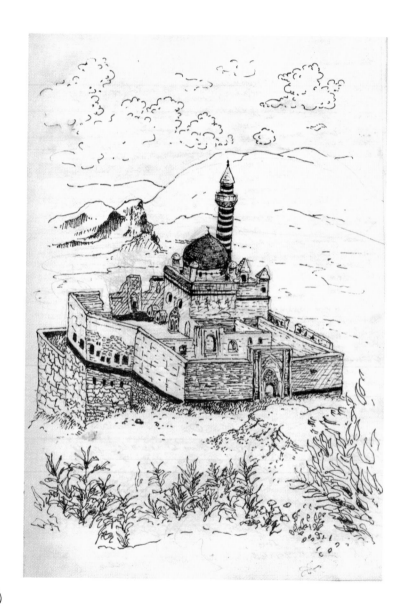

The guesthouse owner followed me everywhere. As I walked through the ruined impossibilities of Ishak Pasha Saray, he stayed close behind me. I ignored him, turning my gaze instead to the mountains. Snow dusted their tops, and the sky was vast above. Afterward, he insisted on driving me to see a crater near the Iranian border, through roads dotted with military checkpoints, while blaring quasi-legal Kurdish music from bootleg cassettes. It was a crater, but I looked at it politely, while he stared at me hard.

The next afternoon, he presented me with a set of plastic jewelry. I couldn't tell if he was being kind to a young foreigner who was alone, or if he wanted to sleep with me. But in the mountains it was just the two of us. My stomach knotted.

Doğubayazıt was six kilometers away, not that I knew enough to walk the complicated roads through the mountains. I forced myself calm. *I am going to die*, I remember thinking. It felt melodramatic, but not inaccurate. *Maybe now, maybe later, but it's going to happen someday. This has been an adventure. What's the point of being afraid?*

After handing me the jewelry, the guesthouse owner finally put his hand on my leg.

I burst into tears—not of fear, but of humiliation. No matter how far I'd strained against the rules for women, I was right back in my body, this fuckable, vulnerable shell.

I would never have the right to travel or to take up space. At best, I'd be tolerated by someone who'd demand sex as payment the second we were alone.

Butterflies danced, and Ishak Pasha Saray shimmered pale gray against the mountains. I looked at the guesthouse owner, ashamed to be crying. "We just don't . . . we don't . . ." I stammered.

He stared back, mortified. In those seconds, in those mountains, it was as if we'd seen each other for the first time. Not our preconceptions of each other, borrowed from pop culture—the dangerous foreigner, the foreign slut—but the flawed humans, who had each misjudged the other. It lasted only a moment before we both looked awkwardly away.

His face soft with concern, the guesthouse owner drove me to his home in town, and introduced me to his family. I must have looked pretty hapless; his mom hugged me hard, fed me lamb stew, and put me on a bus back west the next morning.

I love the adrenaline that comes with travel, the feeling of being tougher and braver than the men I knew. But on that thirty-hour bus ride, I realized what a sorry thing it is to use other people's homes as a proving ground. However violent the police, brutal the war, or recent or tentative the truce between the government and the PKK, I wasn't special just because I'd gone to eastern Turkey. If parachuting in for a few months implied I was tough, what did that make the people who lived there?

I pressed my forehead to the hot window, hating myself for being callow and young.

When there was nowhere else to go, I always had Shakespeare and Company. I headed west on buses and trains, hitching rides through Bulgaria and Bucharest, until I was back in those book-lined rooms. But the Tumbleweeds were a crop of strangers, and an encounter with mosquitoes left my left eyelid swollen shut. An email from Victor, the photojournalist, saved me: "Will I ever see you again?"

The next day, I showed up at his flat in Brixton. I stood in his shower for an hour, under water near boiling. It was a luxury I'd not had for months.

As I dried my hair, words spilled out of me. I wanted to keep traveling, I told Victor, and to keep drawing. I wanted to be like him.

he Lower East Side had once been *Loisaida*, a Latino neighborhood filled with community gardens tended by abuelas, and dominated by hole-in-the-wall Jewish shops where generations of immigrants bargained for discounts on weekends. As you walked east, letters replaced the numbered avenues, earning the neighborhood the nickname "Alphabet City." Mi padre taught me a saying from the city's more dangerous days: "A, aware. B, beware. C, caution. D, death."

Like many immigrant neighborhoods, the Lower East Side, and the East Village to the north, became magnets for rebels. Patti Smith lived there, and Allen Ginsberg. In the 1980s, a tent city of homeless youth filled the East Village's Tompkins Square Park. In 1988, when the police tried to evict the squatters, hundreds of protesters marched with banners reading "Gentrification Is Class War." The police beat them bloody, provoking a riot, and the park became a war zone.

By 2002, the year I moved out of the FIT dorms and into the LES, the neighborhood was poised on the cusp of gentrification. I was there as it happened.

My first apartment was a single lightless room in a tenement on Tenth Street and Second Avenue—a "junior one-bedroom," in real estate speak, with a shower in the kitchen—that I shared with two roommates. We divided the room with curtains and slept on mattresses My roommates

were two sisters, recent immigrants with sparkling good looks and a commitment to devout evangelical Christianity.

For the first week, I sat cross-legged on the floor of my side of the apartment, painting a self-portrait for school. It was supposed to be dark, like a Rembrandt, showing me drawing patterns on my own Spanish shawl. Carpet fuzz got into the oil paint. Turpentine stank up the air. I yelled at myself to do a finished piece each day.

When my hands got too tired, I wandered down to the East Village, chatting with the mosaic man gluing broken mirrors to Astor Place's lampposts, or leafing through foreign magazines at St. Mark's Bookshop. I walked down Rivington Street, past the anarchist art center ABC No Rio, its facade crawling with graffiti and women's profiles. Up the dilapidated stairs, they held letter-writing nights for political prisoners.

Further east, punk shows played in a tenement called C-Squat. Squatters had taken over the building in the 1970s and had held on to it ever since. A sign reading "This Land Is Ours" hung over the door.

Spaces like C-Squat nurtured a subculture of punk illustrators. Fly, with her red dreads and pierced dimples,

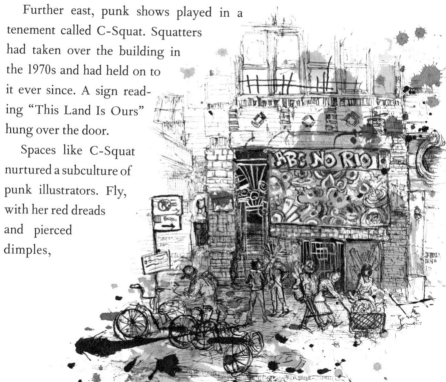

chronicled the neighborhood's inhabitants in a series of portraits, then wrote their stories in loopy script around their faces. The poster artist Eric Drooker wheat-pasted his work around Avenue A. Using woodcuts, or ink that looked like woodcuts, Drooker captured prisoners and brownstones, gardens and mechanization and death. In his work, hands reached through prison bars. Jazz exploded out of tenements. Office workers scurried beneath subways, their skeletons visible, united by the beating of their hearts. A girl in a white slip took on the empire. Under bare lightbulbs, artists painted phantasmagorias powerful enough to threaten armies.

When I needed to escape my claustrophobic room, I hid out in May Day Books. The anarchist bookstore was little more than a rectangle of shelves in the lobby of the Theater for the New City, selling Slingshot organizers and the reliably romantic anarchist newspapers put out by Crimethinc. May Day's walls were decked with huge pen-and-ink posters from the Beehive Collective, a group of artists who turned ecological disasters like strip-mining into Bosch-style allegories, with insects and animals standing in for humans. Thousands of animals built evil machines—or blocked their construction with their bodies. Like the paintings in medieval churches, these epic posters—detailed as jewel work—were legible even when no common language existed. A dozen volunteers might work on one poster. No one signed his or her name.

I was too shy to speak to most of the people who worked at the shop— Wrench, the crustpunk with his entourage of underage groupies; the Iranian cartoonist; the handsome carpenter; or the labor organizer who was trying to unionize Starbucks. Instead, I drew flyers for the store—spidery Emma Goldman, Sacco and Vanzetti, the anarchist's claw-hands holding up a banner with the store's name. The aesthetic too archaic for May Day to use.

To make someone love you, see them as the person they want to be.

I met John Leavitt during Professor Grey's art crit, in Book Illustration 101.

Art crit was supposed to shape our critical thinking skills. The ritual went like so: Students taped their scribbles to the wall. One by one, the teacher walked through them; then other students raised their hands and explained why the scribble was bad. With luck, a teacher could fill three hours this way, saving her the trouble of writing a lesson plan.

Professor Grey was in her late seventies. It had been decades since she'd last worked, but she liked to remind us that she'd once drawn advertisements for Gimbels, the long-shuttered New York department store. Sometimes she'd put on a movie for us to watch, then fall asleep in the back of the room.

During crit, I drew in my Parisian sketchbook. I was proud of that book: fat, jammed with drawings, it looked like the traveler's diary I'd dreamed it would be. As I scratched in cross-hatching on my drawing of a cancan girl, I heard a sharp whisper behind me: "Hey!"

I turned. There sat a boy wearing a shapeless green hoodie, his baby face flushed, half hidden under a tangle of brown hair.

"Yeah?" I tried to look indifferent.

"Where'd you get that sketchbook?"

"Paris!" I elevated my nose.

"What the hell were you doing in Paris?"

Our eyes met. He looked eager, and very young. His face was covered in zits and peach

fuzz. His khaki pants were stained, and his shoes looked like they might fall off his feet. But his eyes were the color of Listerine, intelligent and manic.

"Working at a bookshop. God, I wish I was back there. I hate this stupid crit," I said.

"Me too."

We must have stared at each other for a long time, grinning like conspirators.

John had never eaten Thai food. He'd never smoked shisha, though shisha cafés had become ubiquitous after Mayor Michael Bloomberg banned smoking in bars. After class, I remedied both conditions. After a cup of tom kha gai, we sucked mint smoke at Sahara East and I told him stories about traveling, inflating my own bravery with each telling.

"I'm writing a novel about a New York where magic is real!" John told me.

"I'm writing a novel about time travel," I replied.

John grew up with a single mom in the New Jersey projects. He was a year younger than me, gay and dorky, obsessed with computers, robotics, sci-fi, and the new phenomenon of blogs. John worked as the art director of a gaming magazine, once photoshopping a decrepit male porn star onto the cover as Super Mario. The magazine kept losing his checks in the mail. John had gotten into Princeton, but like me, he couldn't afford to go to the fancy school he'd pinned his heart on. We were stuck at FIT with our resentment.

At the shisha café, John stared at me through thick glasses.

"Isn't this a terribly bohemian place? Like nineteenth-century Paris?" I exhaled theatrically, half making fun of myself and half hoping it was true.

John looked at me and burst out laughing.

"Are we bohemian yet?" we asked together.

Later, he drew this moment as a cartoon and sold it to *The New Yorker*.

The next day, John sat next to me in class. He passed me a mixtape of songs glorifying the road: "Sheltering Sky." "The Passenger." "One More Cup of Coffee for the Road."

Back in 2002, we still burned our friendships onto cassettes. I played the tape over and over as I drew each day's illustration homework. I thought of standing on those roads. The wind would be in my hair. I'd be redeemed as a girl on a postcard.

After that, John and I never left each other's side. We were poor students, late to class and sullen. We spent our nights in diners, or bumming bagels at the corner café. We plotted grand futures, and we dreamed alternate, fantastical presents. One night, at one A.M., John and I ran through the sewer-steam gushers of Times Square. On Forty-second Street the billboards flashed, electric Apollos shining their artificial dawn.

"This is like Rome," John screamed, running the light. A car swerved to miss him. "And I will be a Roman god." We chased each other past comedy touts and peep shows in an ecstasy of words. At the end of the night, he'd go home to his rich boyfriend. I'd go home to my roommates. But on the streets we were crowned with capitalism's halo. John dove onto the curb before the light changed. "What will you be, Tartlet? Tartanian?" he asked.

We could never be ourselves.

s winter came, New York grew so cold that every trip to the laundromat became a death march. Our shared room shrank ever smaller. But I had nowhere else to go. Claustrophobia weighed down on me until I fell into a depression. All I wanted was to escape.

The previous semester, I'd taken a class in Islamic art history, studied Modern Standard Arabic at night, and haunted the Islamic art rooms at the Metropolitan Museum of Art after school. I leaned over the velvet rope guarding the entrance of the Damascus Room, a reproduction of the sitting room of a wealthy nineteenth-century Syrian family, and listened to the fountain sing. The walls of the Damascus Room were paneled in wood, inlaid with mother-of-pearl curlicues; the floors were colored marble, interlocking into spikes. On the poplar ceiling, gesso and tin formed patterns as intricate as mountains. I loved the abstract rigor that ran through most Islamic art, thanks to the prohibition against displaying living things. *How could anything be so intricate, and yet link up at the end?* I thought, trying to follow the patterns. It was art made religion made math.

Between the loveliness of those rooms and the hellish tundra of New York outside, I grew nostalgic for Morocco. There the streets were warm and labyrinthine. Around every corner lay some swooping archway, some bit of art history still alive and useful—or just some stray cat I could bribe.

In New York, I could barely force myself to draw. In Morocco, I couldn't stop. Of course, I was too shy to make any Moroccan friends, but aside from Leavitt I hadn't made many in New York either.

Besides, it was cheap. In Marrakesh, a showerless hotel room cost a dollar. It was ten cents to wash off at a bathhouse down the street, and another ten for tagine at a café.

My relationship with Anthony was slowly fading, and the gaps were filled by constant long-distance conversations with Russell. Since our weekend together in the south of France, we'd been exchanging emails, talking about travel, history, and art—things Anthony couldn't understand.

Though Russell was in his forties, he lived like a hippie. He had a cabin in the mountains of the Pacific Northwest, and he took frequent trips to Peru to drink ayahuasca, a brutal hallucinogen derived from rainforest vines, which makes its drinkers vomit and shit themselves. They often think this is a benefit—that they are purging some inner evil. Immersed in his spiritual discipline, Russell chided me for my decadent tastes. I would be much improved if I moved closer to him.

"I'm going to Morocco," I told him. He invited himself along.

Russell and I stood on the deck of a ferry crossing the Strait of Gibraltar. As we watched Spain fade into the distance, Russell described his last ayahuasca trip. "I went to the land of colors. Three beautiful women approached me. I thought they wanted sex, but they tore off my limbs and juggled them. They were laughing."

I tried to say something enthusiastic, but the hallucination just sounded like an allegory for his problems with women.

As the coast faded, my shoulders sagged with the relief that always hit me when I headed off someplace I had no business being. Far from Anthony, from John, from my city, I felt so calm. I rested my head on Russell's shoulder.

"Did you learn any French?" I asked him. It was embarrassing to expect others to speak English.

"A few words," he answered.

I frowned. "I really wish you'd learn some French." Then, trying to salvage the afternoon, I softened. "You should listen to me. I studied French at Pretensia University, Isle of Pretensia."

"You made that joke last year, Molly. You haven't grown up a bit." The boat rocked beneath our feet.

In an effort to save money, I told Russell, I'd spent the last year living off Snickers bars. He looked me up and down. He had a cruel way about women's bodies, once telling a lover that he couldn't get it up with her because the stretch marks from her pregnancy looked like signs of violence.

"It shows," he smirked.

We got off the ferry in Tetouan, a city on Morocco's northern coast. The place hit me just as it had two years ago. Its streets were filled with people: shopkeepers screaming; hustlers trying to sell you carpets or drugs; unemployed young guys hanging out under store overhangs, hissing at women like you'd hiss to get the attention of a dog; older women in djellabahs, faces framed by white hijab, elbowing through to run their errands; street vendors hawking gutted electronics off blankets. What looked to outsiders like chaos was the meticulous order of a city ferociously alive. I squared my shoulders and walked to the bus station—Russell behind me—afraid to look in any direction, lest someone take my gaze as an invitation.

"Don't talk to anyone," I nagged as we dove into the crowds. "They'll be drug dealers who want to sell you hash. They have deals with the police. They'll arrest you and you'll have to pay a bribe."

"That can't be true." Russell laughed.

At the battered plastic table of a café, a teenager poured us tea into a glass that was stuffed with fresh mint. The teapot was silver, incongruously elaborate, and he held it high, so that the stream of tea cooled before it hit the mint leaves. Two young men in soccer jerseys sat next to us.

"Hey," said Russell. He was so blond, so blue-eyed, such a gringo. I hated him.

"Welcome to my country," one of the men replied. "Do you want to buy some hash?"

We spent a month in Morocco, lying next to each other in cheap hotels in whitewashed mountain towns, where the doors were so blue they dreamed the ocean. I wouldn't sleep with Russell. No matter how far Anthony and I had drifted away from each other, I clung to the notion that, as long as I wasn't having sex with Russell, I wasn't cheating on my boyfriend.

Before we fell asleep, I read to Russell from a book of his about twelfth-century Europe, including the story of Abelard the theologian, who had a mad love affair with his brilliant student Heloise edging on blasphemy—they even fucked on the altar—until Abelard got Heloise knocked up. Then it all went south: Heloise's uncle cut off Abelard's testicles; Abelard joined a monastery; then he badgered Heloise until she joined a nunnery, where despite her disbelief, and her anguish at his abandonment, she ascended to the role of abbess. Russell listened and sulked, frustrated, meditating angrily in the mornings. "Either we make love or I stare at a wall," he said. I declined, without much apology, then left him so I could go sit in the streets and draw.

The tour groups clomped through Fez's medina, lugging huge cameras worth two months of an average Moroccan's salary. I watched one tourist jam her camera into the face of an elderly bookbinder, who'd been quietly working in his alcove. *Flash, flash.* Other tourists did the same with the metalworkers, local kids, harried moms shopping for groceries. I hated them. In my mind, drawing was distinct from photography. After all, I told myself, you take photos, but you make art.

One afternoon, I curled up on filthy steps with my sketchpad. Before long, a half-dozen street kids had gathered to watch. None of them was older than eight, but they had hard, smart little faces. They ran in gangs, sniffing glue and bumming cigarettes, using their cuteness to cadge a

few dinars from tourists. Drawing was my monkey dance to prove that, despite my dopey American face, I still had skills I could rock. I drew the kids, writing their names in careful, misspelled Arabic, then tore the pages out for gifts. They scampered away with my sketches.

I looked up, and my eyes met the disapproving stare of a vegetable vendor who wore the long beard and shaved mustache of the religiously devout. With a scowl, he walked over, tore the page out of my sketchbook, then shredded it with a self-satisfied grunt.

As he left, I started to cry. Like any self-centered tourist, I thought he stood for all Morocco—that the whole country had rejected me. Back at the hotel, I told Russell what had happened. "It's because you're an infidel," he told me, before launching into the story of his day.

Our hotel had no showers, so we went to the *hamam*, or public bathhouse. After paying an entrance fee, you received a bucket and some soap from an attendant. You filled your bucket out of a communal pool, then washed yourself out of the bucket.

Russell told me he'd tried washing off his travel stink directly into the pool. The other bathers, seeing him dirtying up the water source, shouted at him to stop.

"They didn't want to be made impure by an infidel," he declared thoughtfully. I rolled my eyes at him.

The next day, I returned to the vegetable seller's square. A teen boy stopped me. "Sorry about the guy who bothered you yesterday," he said in English. "He's crazy."

He shoved something into my hand. It was my drawing, taped back together like a broken arm.

Russell liked to fight. He'd liked to fight as a young street kid, and as he grew

older he channeled it into martial arts. He felt most at home when he found a martial arts gym in Fez's new city. He introduced himself to an instructor, and within five minutes they were on the mat, gleefully pummeling each other, then laughing and slapping each other's back. On the way home from the gym, we walked through a dark underpass. Russell held my hand. We heard footsteps behind us. A voice shouted, "Cover up your woman."

Russell turned, shifting his weight like he wanted to attack. They were three teenagers, handsome and lanky in their tracksuits.

"It's just how things are," I whispered to Russell, tugging his arm to get him to move on. Of course, that was how things were in New York too—this is how things are everywhere—but I didn't bother mentioning that.

Back in the hotel, he told me it was my fault.

It was always my fault—every time I got hissed at or groped, every time an old man eye-fucked me after leaving a bus station. At a café, we had tea with two Swedish backpackers. They were good girls, blond and windburned, wholesome as cheese. "They don't have these problems," Russell told me.

I was not good. My eyes were too intense. My hips wiggled when I walked. I wore a floor-length skirt and one of Russell's shirts, but the skirt still outlined my ass like a shelf, and when I moved the shirt gaped at my tits.

"Even Marilyn Monroe could turn it on and off," Russell said. "You can't." If I kept traveling alone, he warned, I was sure to get myself raped.

We took buses deeper into the south. The land turned treeless, an endless expanse of baked clay. The Modern Standard Arabic I'd studied bore nearly no resemblance to the type spoken in North Africa, but once an hour I'd pick up phrases. When I did, it had the thrill of magic.

Merzouga was a village on the edge of the Sahara dunes, filled with local guys hawking tours of the desert. They wrapped indigo scarves over their faces in imitation of the Tuareg nomads tourists expected to see.

"Don't wear shorts," I told Russell. "Shorts are for little boys here, and no one wants to see your knees." I pointed out how neatly most young Moroccan guys dressed, in button-down shirts and pressed trousers. Many of the older men wore loose djellabahs.

His first day there, Russell wore shorts anyway. A little girl threw a rock at his head.

Russell later wrote about the incident. In his article, the small rock turned into a near boulder, and the girl herself into an avatar of primordial evil, lusting to bash in his skull.

None of it was true. She was just a girl with her friends, seeing a gringo in shorts. He must have seemed teleported in from the *other* world, where grown men dressed like children.

He was weird. Kids everywhere gang up on weirdos.

She threw the rock. Her friends laughed. It meant nothing.

Russell hired a guide and we walked into the desert. I hadn't wanted to. I was broke, and I hated the idea of being guided. "Lawrence of Inania," I scolded him. But when we walked into the Sahara, we entered the landscape of dreams. This was the world Dalí had painted. I took off my shoes. My feet sank into powdery sand. The dunes stretched out before us, a blanket rolling into the infinite.

On our first night in the desert, I lay next to Russell, staring at the sky. The stars shone like holes punched into the dark. They were so far away. We would die and they would never know. The universe was vast, amoral. What was loyalty beneath that sky?

I turned to Russell, who was staring at me. I reached for him, sliding my hands beneath his shirt.

We stepped off the bus into Marrakesh. A muscular young man in a tight T-shirt passed us, followed by a couple on a motorbike, the girl's thighs, lacquered in skinny jeans, hugging her man. "Town air makes

free," Russell mused, recalling an old maxim from medieval Germany: if a serf escaped to a city, and remained there for a year and a day, he would be liberated from his master. Marrakesh did feel free. It was an electric, cosmopolitan city, with all the urban anonymity that implied. We stank like hippies, our clothes were torn and sun-bleached, but no one gave us a second glance.

The Square of the Dead is at the center of Marrakesh's old city. The storytellers and dancers in the square took the tourists' Orientalist fantasies and repurposed them into a machine for the extraction of foreign cash. Scowling young guys donned fezzes and held monkeys. If a tourist

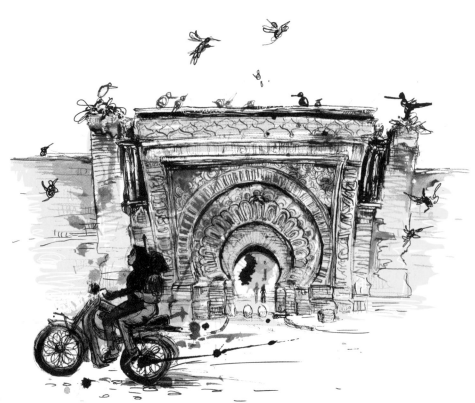

wandered too close, the monkey jumped on him, clinging until his victim paid a ransom. Dentists tended to teeth as entertainment. Berber acrobats piled high atop each other's shoulders, hoping to be noticed by talent scouts for circuses. Women painted palms with henna, squeezing miraculous curlicues from pastry tubes. The henna looked like Cheetos dust on white girls, but on brown ones it resembled dried rose petals.

Russell and I were no longer fighting. After our night together in the desert, he had a momentary affection for me, and as I saw him walking down the old city's streets, I recognized the swagger I'd once adored in France. I admired his ease, his grifter's smile, his violence in reserve.

Each morning, Russell wrote in a café, taking breaks to smoke hash with local guys. His was the public world, which is to say the male world, of bars, drugs, and easy camaraderie. I envied him.

On his last night in Marrakesh, Russell told me he wanted a future together. I could leave Anthony, move to the Northwest, we could travel. I didn't even consider it. After a month together, I couldn't help feeling that despite our twenty-year age difference, I'd outgrown him.

Once I'd thought that a man who was older than me must be all-knowing—braver, smarter, better. My head might have been a masochistic tangle, but if I could please a man like that, I'd thought, maybe I'd be redeemed.

But that older man wasn't Anthony. Nor was it Russell. That was a role no human could fill.

I kissed him ravenously and pinned him to the bed. Afterward, we walked to the train station. I looked at his blue eyes and broken nose, his shoulders strong in that faded T-shirt. Then I watched his car pull away.

As Russell disappeared, I grew giddy. I checked out of our hotel and found another one, free of memories. The walls were sky tile, the bedspread brocade; an orange tree grew in the courtyard. I sat on the rooftop, drawing the smoke that rose off the Square of the Dead. I was alone. I knew no one in the entire country. I was free.

abies are cute so you don't kill them. Young artists must be arrogant so they don't kill themselves.

When I wasn't at FIT, I devoted myself to gaining a foothold in the world of working artists. After class, I sat in the bookshop and copied down art directors' addresses from magazine mastheads, then sent them crumpled sample art, my cover letters marred with fingerprints, pleading with them to give me a chance. Whenever I opened a reply from an art director, I braced myself for the inevitable "Thank you for your submission, but . . ." I permitted myself twenty seconds to feel the pain.

My mother advised me to become an art teacher, so that after thirty unhappy years I could get a pension. I ignored this, as I did most of her advice. Nonetheless, she taught me three important things:

*1. Don't illustrate other people's books for free.*
*2. Don't move to the suburbs, because commuting sucks your blood.*
*3. Don't get into debt.*

Instead, I sought out trendier artists. One hot painter agreed to meet me for coffee. He sat across the table, his eyes crimson from a long bender, and told me he'd never done anything to pursue success—it just happened. I later learned that "just happened" was code for being rich, well connected, or surpassingly brilliant. I was none of the above.

After many phone calls, I nabbed an interview with Steve Heller, the art director of the *New York Times Book Review*. As I sat in the sleek *Times* reception area, my head swam. This was it. I was about to be discovered. But Heller just flipped casually through my portfolio without really looking at my work. He paused briefly on a drawing of a porn star I'd done for the *New York Press*.

"We tend to focus on commissioning intelligent art," he said.

Since I was fourteen, I'd consoled myself by walking the maze of the New York Public Library, and that's where I went then. I walked the stacks, letting my eyes glaze over, until one book's red spine snapped them back to the present: *Explosive Acts: Toulouse-Lautrec, Oscar Wilde, Félix Fénéon, and the Art and Anarchy of the Fin de Siècle*. It proposed an intoxicating history: Oscar Wilde was not just a dandy but a socialist revolutionary. Toulouse-Lautrec was a lacerating class critic. Anarchists drank with poets before setting up bombs.

I gobbled up one chapter after another, the afternoon's disappointment fading in the light of 1890s Paris. When a guard came to warn me that the library was closing, I borrowed the book. I kept renewing it for months, until its theses had stained my brain. Though I was the daughter of an artist and a Marxist, I'd always feared that politics had to be grim and art had to be frivolous. The book showed me another way. Art and action could infuse each other. A painting didn't have to hang in a gallery, dead as a pinned butterfly. It could exist in spaces where people cared, as a mural, a stage set, a protest placard. Art could be gorgeous, engaged and political, working defiant magic on the world.

Politics weighed on me that winter. The war in Afghanistan continued, and each week the White House announced a new enemy: Iran, Syria, North Korea, Iraq. Bush may have been a boy king dolled up as a cowboy,

but the bombs were real, and by February he'd chosen where they would land.

With an attack on Iraq looming on the horizon, antiwar groups called protests. News of these barely touched my school; unlike most other New York universities, FIT was largely apolitical. Instead, I found out about them from graffiti scrawled on subway billboards, or stickers slapped around lampposts near Astor Place.

I was the only student in my class who walked out when the antiwar groups called student strikes—and the only protesters I knew were the crew from May Day Books—but I marched every day I could, in New York and in DC. The first time I saw the White House was over the shoulders of the black bloc, as they masked up, linked arms, and prepared to tear down a fence. Some five hundred yards away, a gaggle of paunchy pink counterprotestors howled in spittle-flecked rage.

If I was going to oppose the war, one man screamed, I ought to be raped by Saddam himself in a dungeon built for the purpose.

I held hands with the boy next to me because we'd forgotten to bring gloves.

For the last year, politicians had been calling for blood in New York's name. Telling them to stop was our—*my*—obligation. Though the Iraq War endangered few of us, the protests filled all kinds of personal needs. Among other things, they were thrilling. Bonds formed running from cops are sweet with adrenaline and rage.

For the length of a march, we might have convinced ourselves that we could have an effect on geopolitics—and to the rest of the world, we proved all Americans weren't howling for war. Thanks to the media portrayal, our protesters had less effect on our countrymen. Middle America saw us as freaks. We sneered right back at them, blaming them for Bush's election. Outside the big cities, the carnival aesthetic of the marches played poorly. At one march, I saw a group of girls in fishnets and strap-ons calling themselves the Missile Dick Chicks, posing while fondling

their weaponized cocks. Beside them stood Reverend Billy, a performance artist playing an anticonsumerist televangelist in his dirty white suit. The puppets posed, too, because there are always puppets. After five hours, I returned to my East Village apartment, hands blue and heart pounding, to scratch out an assignment for FIT.

Missle Dick Chicks

On February 15, antiwar groups coordinated protests in six hundred cities. More than four hundred thousand people marched in New York. Police tried to pen us in, but there were too many of us. We unhinged the barricades and leapt into the streets, then ran, outflanking the cops, our legs pumping up Fifth Avenue until we reached the New York Public Library. Thousands more protesters had taken over the steps. We cheered them, roaring from our chests.

We took over Broadway until it was an ecstatic mash, our bodies moving to ubiquitous protest drums, drunk with protest's lovely and treacherous delusion: *There are so many people—this has to work.*

"Fewer people showed up to that march than attended the first weekend of *Kangaroo Jack*," Leavitt smirked. I was standing next to him at an

afternoon vigil in Union Square, awkwardly holding a drawing I'd done of Bush as an imperial slug. John's hands were empty. At that point he was still presenting himself as a kind of aristocratic conservative; he'd joined me because our anatomy teacher let us use the vigil as an excuse to skip class.

"I don't think that's true," I snapped back.

"They're just a mob, with no idea why they're here. They're dirty hippies and I don't like them."

"Why don't you join the army if you like the war so much?" I asked.

"I can serve my country better as an illustrator."

He started to walk away, out of the square and toward the art deco gates of a nearby bar. I ran after him. Neither of us had fake IDs, but the bartender didn't ask.

When I wasn't protesting, sitting in class, or drinking with John, I earned a little cash drawing smudgy pictures of people's kids. In the school's computer lab I haunted Craigslist, a classified ad website that exemplified the digital utopianism of the early 2000s. In that garden of text, you could sell a goldfish, a blowjob, an ottoman, your love. It was a place of entrepreneurship and freedom, as well as deep sketchiness, as shown by one early job I found there, doing storyboards for an indie horror flick. Thrilled to have a gig, I worked on the drawings while sitting next to John in the FIT cafeteria. Unlike me, he was on the meal plan. He ordered hills of French fries for both of us, so I didn't have to pay for food.

When it came time to pay me for the storyboards, the director presented me with a homemade coupon in lieu of cash. It showed his hands photoshopped over a woman's back, and offered one free massage, courtesy of him.

In March, Bush declared war on Iraq. I heard the news from the May Day crew, who sat eating foraged pastries in the courtyard of Saint Mark's

Church. On the cobblestones, they spread out cannoli and croissants in a pauper's banquet. Despite the promises of the White House, we had never believed the war would come. Now we blamed ourselves. We'd screamed and marched and waved our signs, but the bombs were all queued up to drop on another country, and we were still here, unable to stop the death.

I ate a donut slowly. The frosting was strawberry, delicious as something that was about to end.

One of Wrench's girlfriends started singing. "It's the end of the world as we know it!"

". . . and I feel fine!" we answered softly.

During the war's first days, CNN looped footage of American bombs lighting the air above Baghdad. The bombs looked like triumphal fireworks, but the news never showed what happened to the people below. As I kept up my attendance at the protests, John busied himself with a more personal rebellion. On his own at last, he started to turn himself into the person he'd always wanted to be. He strode straighter, combed his hair to the side like a Weimar rent boy, and drowned his working-class accent beneath a torrent of verbal posh. At first I mocked him, calling him Baron von Fullovit. He adopted the nickname with glee.

One night, after class, we walked through SoHo. The shops were closed, but we stared through our reflections into the Louis Vuitton window, our faces framing those bland bags inexplicably anointed as luxurious. The shop's allure had less to do with what it sold than with the meaning of its price tags: to shop there, you had to have enough money to waste. *I spent a year's salary on some cuff links*, whisper SoHo's demons. *Nothing can touch me.*

The Baron practiced sprezzatura, the aristocratic virtue of not caring. To be poor, as John was, meant to care too much.

We walked up a dozen blocks until I spotted a Goodwill in south Chelsea that was still miraculously open. Remorseful for mocking John's transformation, I dragged him inside. "We'll dress you right," I promised.

After tearing through the racks, I found him a polyester caterer's vest that seemed the height of sophistication, and a tailored shirt to match. The monogram on the cuffs read RLN.

"I'll tell everyone it means Rogers Long Nightly," John announced.

Fairy tales deal in sets of three, with the most miraculous event arriving last. That night was no exception. That winter, John owned a single hoodie to keep him warm. A sack of stained green flannel, it seemed more hateful each day, until it stood for awkwardness, for poverty, for the New Jersey projects themselves. From the back of the shop, I pulled a coat: long, tailored, with a nineteenth-century-style cape. John put it on and stared at himself in the mirror, transfixed. The seams emphasized his height; the cape broadened his already wide shoulders; the coat's body fell in a sleek single line. We said nothing as he handed his money to the cashier.

Outside the store, we threw the hoodie into a Dumpster, then kicked it for good measure. We whooped. We danced.

"Old John is dead," we cackled. "Baron von Fullovit is alive!"

*t*he winter dragged into a sleety New York spring. I walked to class past the mosaicked lampposts, their tiles peeling off. The community gardens were sugar-dusted with frost, their flowerbeds brown and dead. As I passed the Ukrainian church on First Avenue, I noticed a small parcel tied to the fence. When I looked closer, I saw it was a homemade doll. Its shiny black head was topped with straw, its eyeholes filled with glitter. Its body was wrapped in calico, sewn with charms, and it had a small bag around its neck.

Without thinking, I took it home.

Anthony had disappeared.

He no longer picked up the phone or answered his email, and when I called, his mother told me she didn't know where he was. I cried each night, deprived from the warmth of his voice at the other end of the line. I kept calling, increasingly desperate, until one day, I punched his number into a pay phone in Penn Station and he picked up.

"You've been calling a lot," he said. "We should talk."

We sat on my old bed, in my mother's house on Long Island, where we used to fuck for hours when I was sixteen and thought he knew everything in the world.

"I cheated on you with Russell," I said.

"Obviously. I cheated on you with Maureen." The name registered, vaguely: she was an ordinary girl from Long Island who went to raves, and would never, ever run off to Morocco.

I lay my head on his shoulder and cried.

"I don't know if I can do this anymore," he said. "I think you're too young for me, and all you want is to stay in this room and have sex."

I asked him for three months to think it over. We parted smiling. When the door closed, though, I wanted to die.

Devastated as I was for losing him, I hated myself more for the devastation I felt. For girls my age, the heart was the new hymen—the most shameful thing a man could break.

Our lease on the East Village room was running out, and each day the walls seemed tighter around me. It was time to move on.

I spent hours a day on Craigslist, wading through posts from men looking to rent to girls who would clean for them naked (the live nude maids would still have to pay six hundred dollars a month for their quarters). Domestic skills were never my forte. Finally, I found a place on Havemeyer Street in Williamsburg, Brooklyn. Too broke to hire a man with a van, I carried my great-grandparents' furniture the half mile to the subway, rode the L train seated in a busted armchair from the Depression, luxuriously reading, then got off at Bedford Avenue, and, shoulders screaming, carried the chair to my new home.

As Bedford ran south, toward the Brooklyn-Queens Expressway, the neighborhood became Puerto Rican, like the one mi padre had grown up in. Old men in undershirts played dominos outside, families barbecued, and young guys sat shooting the shit on the stoops. *"Ssss! Rubia!"* they

hollered after me. I ignored them. "Yo, white bitch," they shouted at my back. I kept walking, shoulders tense, furious less from the harassment than from the fact that they didn't recognize my latinidad. To the neighborhood guys, I was just another gentrifying white girl, pushing them out of their homes.

Only years later did I realize that I should have said hello back.

In September, Anthony asked to see me again. I'd long pictured that day: how beautiful I would be, how much he'd regret losing what we had. In the apartment hallway, he looked the same: with his black trench coat, pale skin, and absinthe eyes.

We fell into each other, kissing like we were the only drug we'd ever need.

He threw me onto the bare mattress, where he pushed himself inside me. I came against him, and he inside me, so hard we could have broken.

"I think I should leave," he said.

"I think you should too."

After, I lay on the floor with my eyes closed, imagining each moment with Anthony falling over me like a snowflake. Some were as innocent as water. Others were acid. I wondered how they would burn.

The next day, at the cafeteria, I told John what had happened. He mocked me kindly. Anthony lives in Howard Beach, he said. He spends his time smoking weed in his childhood bedroom.

I pouted. The girl he ditched me for was just some nothing from Long Island! Not a Great Artist like me.

John sighed impatiently. "Maybe you should try sleeping around."

Love makes you a character. Losing love kills that character. You lose all the shared jokes, the stories, and the self you were. So you decide to construct another.

If I couldn't be Anthony's girl, I decided, I'd be a famous artist. But my skills had so far to go. I took out a copy of Arthur Guptill's *Rendering in Pen and Ink*. Bound in brown linen, it had been given to my mother by a high school art teacher, and she had given it to me. Its spine was cracked, but inside it revealed the whiplash discipline behind the work of illustrators like Edmund Dulac, Willy Pogany, and Albrecht Dürer. I studied how to draw hair like a Gibson Girl's or to flick my pen till the ink sped like motion and blood. I used a crow quill pen, the modern implement closest to quills and ink.

The Havemeyer apartment came with two male roommates. One was in the midst of a vivid psychiatric decline. He quit his job, grew too obese to wear clothing, stopped flushing the toilet, and filled his room with rotting food. He sometimes chased the resulting roaches with a baseball bat. My other roommate was a bartender in his forties who seldom left

his room, except for the times he wrote erotic fiction about me and left it under my door.

Every morning, I sat at my small mahogany table—the one my mother had bought when she studied art at Pratt—trying to block out the sound of porn blaring from the moldy quarters of Roommate A.

My first attempts at drawing faces in crow quill looked like striated meat, so I forced myself to start at the beginning of the book. Guptill instructs his readers to fill a hundred squares in careful dots, checks, and stipples. I did each hatefully. When the ink blobbed, ruining the square, I'd force myself to do it again. After a month, I moved on to drawing folded fabric, then cups, then faces. I drew a demon balancing on old books, and convinced a small literary magazine to run the illustration on its cover. I worked with mute discipline, with stubbornness rather than pleasure. I wouldn't be happy, but work made my brain stop.

I grew better. I worked more.

In class, I proudly balanced my ink bottle on the edge of the desk. I drew imps, Victorian ladies, belly dancers. John peered over my shoulder. "They're so . . . detailed," he sniffed. With surprise or distaste? I wasn't sure.

John had just hustled a chunk of cash, and we were, as he put it, "drunk as poets on payday." We hurtled down Christopher Street, past the Stonewall Inn, where black and latino trans women had fought off the cops in the '70s, signaling one beginning in the fight for gay rights. We were talking fast, inventing pasts for ourselves that got us higher than drugs.

"You're Johnny Panama," I told him, flipping his straw-brimmed hat. "Johnny Panama, who came from Appalachia and made his fortune on the roulette wheel and threw himself into the Hudson when he saw his first wrinkle."

The lights of Lips, the drag bar,

shone lurid. Swarovski high heels, organ pink, blink, dazzle, shine. The bouncer was smoking around the corner, so John dragged me in, buying me a sticky-sweet grasshopper.

One by one the drag queens filed out. They were striking beauties, tall and leggy, their wigs towering to baroque heights, their slim waists wrapped in leopard print. They strutted, sang, and then went into the audience, where some middle-aged female tourists were having a night out. To the hoots of her friends, one woman sat on a chair on the stage. A drag queen gave her a bored lap dance, grinding the woman through her khakis.

I stared at the drag queen. She'd painted lime half moons on her eyelids. They glowed against her brown skin. Her lips sparkled with the red glitter she'd pressed into the gloss. She seemed bemused, shimmying her hips in the square woman's face—but she also seemed like she'd have no problem punching people who needed it.

The woman on the chair was not queer. She was neither desiring nor desired. Her friends shrieked at her audacity.

I looked at the tourist women, then at John, and rolled my eyes. Then I caught sight of myself in the bar mirror. I saw my rats' nest hair, my flaking lips, the circles under my eyes. I looked back at the drag queen. I was neglecting the possibilities extended to me.

As Simone de Beauvoir says, "woman is not born but made." I had attractive raw materials, but femininity is a construct. I practiced penciling my lips, marking my eyeliner with a confident swoosh.

"Are you trying to look like a whore?" John asked. "Because that *is* a look."

I scowled and kept troweling on paint. A new face felt like a defense, even if my makeup resembled my ambition: too loud, too obvious, all wrong. I dug through a box of trimmings I'd inherited from a great aunt, pinning silk flowers into my hair and fringe onto my cuffs. I bought heels

from Goodwill to replace my clunky sandals. Thinking it looked French, I tied a scrap of ragged chiffon around my neck.

As I rebuilt myself, I decided I needed a new name. Jennifer was my childhood name, but it was ugly and unwanted. Now was the time to start afresh. I looked in the mirror. In the corner was wedged a postcard that Edward, from Shakespeare and Company, had sent me in the winter of 2002. It showed Freud and his daughter Anna, drinking at a café. "To Molly Crabapple. This reminds me of us," he'd written.

When I first got the card, I'd stuck it on my mirror and forgotten it. Now I reconsidered. "Molly Crabapple" was a good name: short, memorable, cutely goth amid the Internet models I stalked online—the Annie Absinthes and Vanessa Vexations, clad in only their sneers and neon hair.

The name Molly Crabapple would fit in among them. Maybe I would too.

Every day, I passed a dive bar called the Rain Lounge on my way to the subway. Perpetually empty, it was painted purple, its vinyl sofas spilling stuffing. A disco ball twirled overhead, casting twinkles for a party that would never come.

That day, after class, I summoned up my courage and walked in. The owner grinned widely when he saw me.

"*Hiimmollycrabapple*," I blurted.

"What was that?"

"Molly," I said more slowly. "Molly Crabapple. I'm an artist! I was wondering, um, maybe . . . I saw your walls looked empty and I have some art and maybe I could have a show here if you wanted, please?"

He raised his eyebrows, not unkindly. "Sure. Want to do it next month?"

I ran down Bedford in ecstasy. It was just that easy. Next month I'd have my first gallery show! (In my mind, that bar was a gallery.) All my drawings would sell, and the Williamsburg hipsters would notice me, and I'd make my mark on the world.

I marched over to the dollar store beneath the elevated train tracks and bought every Virgin Mary painting they had. The paintings all came with elaborate gilt frames—plastic, of course, but I could paint them black.

The guy at the cash register looked bemused.

"You reselling these?" he asked.

"No! I'm an artist."

I carried them home and pried out the Virgin Marys with a screwdriver, cutting up my hands in the process. I framed my ink drawings with an astounding lack of craft, managing to trap carpet fuzz on each dirt-besmirched matte.

I printed out show flyers at Kinko's, using off-white paper I told myself was fancy, then cut them out myself to save a few bucks. Each was crooked. At the Read Café, I shyly told the adorable barista: "I'm having an art show. You should check it out."

She told me she'd be out of town, not waiting to hear the date.

Still hopeful, I left a few flyers by the window.

On the day of the show, I hauled the framed drawings the half mile to the Rain Lounge myself. The bags cut bloody grooves in my hands. I broke two frames along the way.

When I got there, the owner wasn't there. The bartender looked me up and down skeptically. "No one told me about any art show," he mumbled. Reluctantly, he let me hang the art.

Night fell. My "opening" was set for eight P.M. The bartender didn't turn on the lights.

John came down to support me. He wore a polyester silver suit.

"Tartlet!" he announced, grinning, sweeping his arms wide. Then he looked around. "It's a bit dark in here, no?" he asked.

I shrugged in my thrift-store prom dress.

"And the art is crooked."

We sat next to each other at the bar, both of us staring dead forward.

For the next five hours, patrons trickled in to watch a football game. Not one came for my show. John charmed a few of them into buying us drinks in exchange for drawing their caricatures. I scowled. With all the mental force I could muster, I willed them to look at my work. They didn't even have to buy anything. I just wanted them to notice it was there.

No one did.

By the end of the night, half the art had fallen to the floor.

Artists are told that we'll be discovered. That there is a meritocratic Yahweh on high, and if only we're good enough, he'll reward us with magazine spreads, collectors, and a white-cube gallery in Tribeca.

That night at the Rain Lounge, I realized that, if such a god existed, he didn't frequent dive bars. If I stayed humble and waited for my work to speak for itself, I'd never get the opportunity to do good work at all.

John begged off after a few hours. I stayed till four A.M., watching Williamsburg ignore me.

I never picked the drawings back up.

*d*uring my first year at FIT, I made the acquaintance of a cam girl. Rebecca worked out of a cubicle, mechanically fucking a motorized dildo that the guy on the other side of the monitor thought he controlled. She soon figured out more lucrative arrangements. She introduced me to her clients over a luxurious dinner, but sugar baby–hood wasn't for me. Filet mignon didn't taste like much in that company.

Still, her paycheck awed me.

I had only one skill: drawing pictures. But the tools that were required to become a professional artist—a website, a properly printed portfolio, a constant stream of quality supplies—cost more than I could make working retail. Meanwhile, in three hours posing for a webcam, Rebecca earned what she could have made in a week at a legit job.

We were young women, at a bad school, studying for a competitive, ill-paying industry. What did we have to interest people besides our looks?

It was money that drove me to the naked girl business. But I also wanted to test myself. I wanted to see if I could work in a field as fraught and stigmatized as sex work, and emerge unscathed. I wanted to burn off childhood.

I combed through Craigslist, looking for a way in. After answering dozens of ads—"Very Open Minded Models to Shoot Erotica 4 Art-

Exhibits"; "Highly Discreet"—the artist Cynthia von Buhler hired me to pose as a human statue at a loft party. I painted myself white like Venus, with my breasts out and my hips draped in a white sheet. After a night drinking absinthe with Manhattan's moneyed bohemia, I took home two hundred and fifty dollars in tips, and swore off honest employment forever.

I got my first regular gigs working as an artist's model. For ten dollars an hour, I shivered before roomfuls of university students. Poses started at thirty seconds, and by the end, we stayed frozen for twenty minutes at a time. Posing had all the fascination of sitting on a cross-country bus ride without a book. My eyes would blur and my back would scream, and I'd wonder how long time could possibly last, but it lasted longer. The students would not speak to the models directly, ostensibly out of respect, instead addressing us through the teacher. Professionalism meant objectification—not the sexy kind, but the kind that turns you into an object, like a chair.

I modeled for Michael Deas, the artist who'd created the image of the Grecian-robed woman holding a torch in the modern version of the

Columbia Pictures logo, and for Will Cotton, the famous painter of cotton candy landscapes. I posed for classes of adult amateurs. If an artist failed to capture my face, I'd tell him. If he yelled at me for moving, I'd flip him off. "If you were any good at anatomy, it wouldn't matter," I'd reply.

Inspired by Kiki de Montparnasse's style, I trawled the Goodwill store for the perfect kimono. I found one in red silk lined with white, embroidered with dragons, with a large rip down one side. When I posed for artists, I'd shuck it off on the stand, as though my body were a revelation.

But ten dollars an hour wasn't going to change my life, or even buy me basic artists' tools. So I returned to the Internet. Back in the 2000s, girls like me—who were too short, thick, or plain to be fashion models, and not willing to shuck off all respectability by posing in actual porn—could tap into a flourishing semi-underground business posing for amateur photographers. We called these photographers "Guys with Cameras," or GWCs. They paid a hundred bucks an hour.

For legit photographers—whether in porn or in fashion—the point of any shoot was the finished image. For GWCs, the point was the naked girl in their hotel room. We called ourselves models, but we were more like private strippers. Their camera was the lie they told themselves.

Because we worked on the margins, we Internet models all knew each other, and we extended one another what protection we could. We spread word about who was a good guy and who was a sociopath, knowing full well that the police would do nothing if one of these sessions ended in rape. I knew a girl who had worked as a bondage model. While she was tied up, the photographer threatened to kill her. She wept. He let her go. When she went to the police, they shrugged her off. Later, the photographer murdered a different model.

Stewart, the first GWC for whom I posed, met me in a coffee shop with what I can only describe as a binder full of naked women. They seemed so vulnerable, these awkward creatures he proudly thought he'd made sexy. The camera flash highlighted their razor burn, their raw red knees. This I could not abide. What I lacked in modesty, I made up for in vanity. My

tits could be on the Internet, but not my vulnerability. I took Stewart's hundred bucks and posed till my muscles wept, convincing him that black-and-white film would make his photos "artistic."

The first time I took off my clothes for Stewart, I thought the world would end. After a few sessions, I kicked my dress away impatiently, indifferent to my skin.

If I was going to be naked, I didn't want it to involve unflattering contortions in Stewart's living room. I took the best of his photos, jacked the contrast on my cracked copy of Photoshop, and put them on a website called One Model Place, which hosted models' portfolios for ten bucks a month. OMP's Floridian tackiness and dot-com pretensions came with an insistence that it was used by the fashion industry. It was not.

Within hours of posting my portfolio, my Hotmail started pinging.

I posed for a Hasidic Jewish guy in the Bronx amid hundreds of hard-boiled eggs. I was broke enough to take some home to eat later. I posed for sweet, shy accountants, and for fetish photographers who told me my tits looked like I'd had three kids. Each time, I loved two things: painting my mask in the mirror of a hotel room bathroom, and, a few hours later, counting the bills in the same bathroom. I was a sleek machine for extracting money. I remained untouched.

One GWC, rich enough that he had original Toulouse-Lautrecs in his living room, spent the whole shoot berating my tits. "The model before you had perfect breasts," he told me. He was in his sixties, and he looked like a hobbit: squat, hunched, and covered in unexpected hair. I'd walked by his wife on the way to his studio. Like him, she was petite and elderly, her finger weighed down by a massive diamond. She did not look my way. Before the shoot, the GWC showed me portfolios of his work. Most were photos of himself, crouching over bound models, holding a vibrator

between their legs like an eggbeater. He ran each photo through the sharpen filter on Photoshop until the pixels shook like static, convinced it made the photos "edgy."

I took his five hundred bucks and recommended him to a fellow model. "He's horrible," I warned her, "but he pays a lot." He insulted her too. "Your body is hideous," he told her. "Molly had perfect breasts."

One night, I worked a launch party for Café Bohême, a coffee-flavored liqueur. The ad firm in charge of the event wanted to re-create some ersatz Paris at the party. They tried to hire artists to paint, but found real artists too unattractive. Instead, I posed for actors, who spent the night drawing stick figures that the guests then tried to buy.

The agency's filmmaker put a camera in my face and asked if I wanted to live in the Paris of Henry Miller and Toulouse-Lautrec. I didn't bother to tell him the two men lived fifty years apart.

The company paid me two hundred dollars and a bottle of Café Bohême, whose every sip tasted as sweet as cash. I hid it in the back of the refrigerator, planning to savor it. As I shut the refrigerator door, my roommate came barreling into the kitchen. Apropos of nothing, he told me he'd figured out why men hit on me: because they liked ugly girls. "Low self-esteem," he said, flashing a knowing grin. Once he got back on his feet, the

roommate swore, he'd become an investment banker and fuck fashion models. Unlike me, he had goals.

The next morning, I looked for my bottle of Café Bohême. My roommate had drunk it all.

Once when I was very broke, an old client called me, asking if I'd model for a music video. Our previous gigs had been demanding: in one shoot, I'd spent hours silently screaming in the center of the Times Square subway station past midnight, while he filmed me across the tracks.

For the new shoot, the client spelled out the deal: two hundred dollars to writhe around in a bikini for a heavy metal video. While a grip poured live crickets on my tits.

I swallowed. "Just my tits?"

"Just your tits."

I hated crickets. But I needed the money.

On the set (actually an empty parking lot), I lay back on the concrete, closed my eyes, and thought of twenty-dollar bills, stacked in a neat pile. That was a quarter of my rent.

The grip poured the crickets right onto my face.

The crew laughed as I screamed.

Between shoots, I drew compulsively. I was working on borrowed time—I had a few years when I'd be firm and fresh enough to get by on my looks. By the end of those, I'd better have acquired some longer-lasting trading tokens. I drew pictures of all the glamorous alt models I loved—sea-haired Aprella, angular Darenzia with her half-shaved head. My sketchpads grew fat with portraits of New York's demimonde. I was obsessed with seeing, at the exact moment it most bored me to be seen.

Decades' worth of underground artists got their start doing covers for

*Screw* magazine: Joe Coleman, Dame Darcy, Spain Rodriguez. Its founder, Al Goldstein, was a legendary bastard: he stalked employees, abused his ex-wife, and once terrorized a former employee by showing up to harass him at his new job—at the *New York Times*—in a gorilla suit. Such bastardry came from someone who was also a free-speech knight in the Larry Flynt mold, fighting one court case after another, risking imprisonment, even building a giant middle finger on the lawn of his mansion. By the time I contacted the paper, Goldstein was gone, living in a veterans' home on Staten Island. He's dead now, like so many of New York's saints.

I found a copy at a newspaper stand at Penn Station, ignoring the scandalized vendor while I scribbled down the address. Then I went home and drew some porn.

I sent it in with a letter that read: "No one draws tits like Molly Crabapple."

A week later, *Screw* called me. They offered me a cover, for a hundred whole dollars. I thought I'd made it.

"Molly! I got a cartoon into *The New Yorker*!"

John phoned me while I was sitting in my mother's apartment. While I was having crickets poured on my face, John had been sitting in the *New Yorker*'s offices day after day, drawing cartoons and waiting for the cartoon editor, Bob Mankoff, to reject them. After a year, one of his pieces finally made the cut.

"How much are you getting?" I asked.

"Eight hundred dollars! And they might buy more."

"That's wonderful!" I said. *I hate you*, I thought.

I slammed shut my laptop. Back to work.

*w*ant to make three hundred bucks?" Julian asked me.

Julian was a photographer in his early twenties. He photographed alt models with fashion photography's glossy precision, but his work never got beyond covers for *Gothic Beauty*. Julian stood sixty-two resentful inches, with a smirk, a square jaw, and floppy hair he kept pushing out of his eyes. He told me I was too old to use for product shots of makeup. I told him he was too short.

I sat with him in a windowless room in his Village apartment, staring at the two computer screens that dominated his wall. He brought up photos of tattooed girls pouting coyly and pulling their nipples. On the corner of each photo was a logo I didn't recognize.

"Ever heard of SuicideGirls?"

"Nope."

Slickly branded in shades of pink and gray Pepto Dismal, SuicideGirls was a website featuring gallery after gallery of tattooed white girls making out with one another while wearing branded panties. But site members could do more than just ogle the girls: they could also talk with them. The website's promo copy assured viewers that this was totally punk rock.

"They pay three hundred dollars for a set of naked photos. I don't know if they'll accept you. You don't have tattoos or anything. But you do look like Wednesday Addams."

Three hundred wasn't bad for a few hours. The next day, I bought some

crocheted gloves and a handful of panties from Strawberry's fancier rack, and then spent an hour mashing my breasts together in front of Julian's seamless backdrop. He uploaded the photos, and my body became porn.

By posing for SuicideGirls, where guys paid $7.99 a month to download naked pictures, I was choosing to repurpose my body as content, to reframe it as porn. But one doesn't need to consent to porn to become it. On revenge sites, pictures of girls' bodies (procured through love, praise, desire, or coercion) are used to brand them as unemployable sluts. On message boards, men jerk it to surreptitious photos of fully clothed women. The violation of consent is their kink.

When I thought of every proposition or threat that I got just walking down the street in my girl body, I decided I might as well get paid for the trouble.

In the SuicideGirls origin myth, Portland, Oregon, was Eden, and Missy Suicide was God. Missy created SuicideGirls to do battle. Instead of clay, she made them from tattoos and skateboards and quotations from Chuck Palahniuk. She used a camera to breathe life into her creations. According to Missy, the company was hers. Woman made. Woman owned. Somewhere in the back, a dude named Sean coded. The PR copy made it easy to assume he didn't count.

SuicideGirls marketed itself not as porn but as a "punk rock pinup community." The models weren't blond dollies. They were razor-tongued vixens. With tattoos came the right to talk back.

SuicideGirls must have liked my Wednesday Addams look, because they responded with a link to their online application. As I passed through each step of the process (release, questionnaire, profile), a cartoon punk girl's head lit up. I didn't have to show anything explicit, the FAQ reassured me. By this they meant my labia. Please don't mention your significant other, it cautioned. My availability was a more valuable commodity.

SuicideGirls forbid "community members" (as those who paid to look at our photos were called) from criticizing the models. Most conflict

remained confined to the models' own raucous message board, called "SG Only." There we loved, gossiped, and shit-talked one another. The girls supported one another through abortions—but let one girl see a similar star tattoo on another's back, and suddenly it was the battle of Thermopyle.

When my first photo set went up, I watched the comments dizzily. "Lovely." "Perfect." "I'd eat you up." Hundreds of people posted about me, saying how beautiful I was, how they loved my eyes, my belly, my nipples, my hair. I gobbled up each one. My body was separated from me, rendered into image, untouchable yet tradable. The people on the other side of the screen might be admiring me, might be envying me, might be jerking off to me—I didn't care. But they'd never know the tangle of my brain, and I liked it that way.

I became a SuicideGirl in 2003. A few years later, marketing execs were scrambling to derive the formula for microcelebrity. How could nobodies become somebodies on the Internet? Could everyone be someone? SuicideGirls sorted that for me. I had my photos taken, had them posted, and distanced myself from them. And I held the avatars I chatted with at the same distance.

Having my photos on SuicideGirls came with unexpected consequences. Men bought me art supplies from my Amazon wish list. Girls stopped me on the street in Williamsburg. "I loved your photo set with the window," they'd gush. "Do you think I could be an SG?" I'd nod politely, arms sagging from the dirty clothes I was carrying to the laundromat.

On SuicideGirls, attention was money. The more clicks our photos got, the more photo sets the site bought, and thus the more money we made. We remained safe on our side of the screen—admiring our pixel ghosts, adoring the adoration they got us.

SuicideGirls dispensed pellets of ego crack. We were Pavlov's bitches.

But for all its promised egalitarianism, SG was a capitalist endeavor. Some girls were slimmer, fiercer, more desired. Their sets got more

comments. They brought in more subscriptions. They got flown out to LA to pose for the site's founders, or danced in videos with Dave Grohl, the former drummer for Nirvana. Some SuicideGirls were real rock stars. I was not.

I stared at the photos of my betters. They were feral beauties who gave no fucks. They smoked Lucky Strikes and cursed while famous tattoo artists etched lightning bolts on their ribs. My eyes traced the seams tattooed down the backs of their gazelle thighs. I ogled their heroin scars, their mouths like bitten plums.

Stormy Sicily Shera Katie Apnea Quinn, onward and always and replicating and forever.

There were always more beautiful girls.

Within six months of my joining, SuicideGirls blew up. They hired so many models that they had to resort to creative spelling to distinguish them: Absinthe, Absynthe, Absyynthyie. These models licked guitars side by side with Guns N' Roses, and wielded swords in their own comic books. Sean and Missy became rich.

As the list of models topped a thousand, however, the power of individual girls faded. Before long, the vision of SuicideGirls as indie heroines gave way to one of topless brand-bots who go-go danced at strip clubs for free. Worse, there were girls fighting for these gigs.

Once, I begged for a slot announcing no-name bands at the legendary

punk club CBGB. The club was a crumbling hulk by then, decades past relevance, but for punk kids like me it was a temple. The Ramones had played that stage. So had Patti Smith. And now me.

The gig didn't pay, and I'd be one of six girls, but somehow I was convinced it would make me a star. At CB's, we waited for hours for the band to get ready, jostled by the crowds, sober in our painful high heels. No one thought to give us drink tickets. No one even saved us seats. When the moment finally came, I mispronounced the band's name. Within seconds, we were back offstage. Whatever money changed hands went to Sean and Missy.

Walking home that night, my teased hair collapsing under the rain, it hit me: I hadn't said my own name onstage. All that tedious makeup application, those hours smiling in heels, and no one even knew who I was.

I thought back to those tapes mi padre used to play me of his fights at the university. *"Linda*, who has the power here?" he'd ask.

As I went into the subway on Delancey, I knew it wasn't me.

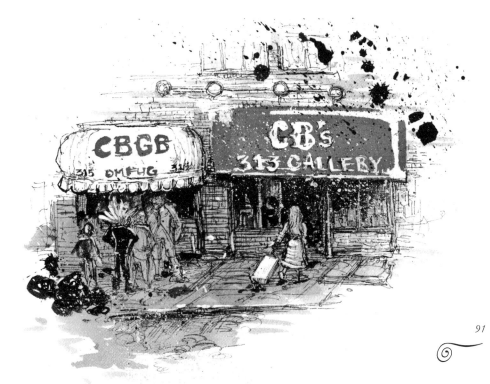

One day I was scrolling through posts on the Craigslist Adult Gigs section, past seven identical listings from Starfish Man. The alleged photographer had been flooding the board for months, pleading for volunteer female models to allow him to take pictures of their assholes—their "starfish," in his twee parlance.

Then another listing caught my eye:

Hello. I'm an art/fashion model who finds that, after a photo shoot or two, photographers have already taken all the images of me they'll need for their portfolio. I'm looking for a model working in a similar field to trade databases of photographers, so that we can maximize our client lists. Also, we could pose together. Xoxo.

"Jen Dziura," the post was signed. I typed her a quick email, telling her she was bringing too much professionalism to the field. It was the only coherent reply she got.

A few days later, we met at the Union Square Barnes & Noble. Jen had the precise nose of Sargent's Madame X and a black bob that was as sharp as her cheekbones. "I'm going to pose for lingerie catalogs," she told me. "I'm going to write a book. I'm going to . . . I'm going to . . ." She talked very fast, in a voice both certain and ostentatiously clever. I nodded along, staring into her celadon eyes.

Jen told me she'd graduated from Dartmouth, where she had been the captain of the coed boxing team. Since then, she'd landed—and been laid off from—a well-paying corporate job. But what did that matter? Cubicles were for cows. Now she was trying to make it as a comedian. Her voice grew faster, and her breaths sparse. She sounded like she might break right there in the coffee shop.

We thought we might pose together. We had complimentary looks—both pale as paste, but I had curves where she had angles. We talked till the café closed; then she invited me to her place in Harlem. On the subway, she whispered, "I don't know how to flirt with girls." It was the first thing she said that sounded soft.

We woke up next to each other on a mattress that took up the entire room.

Jen was dating a guitarist who worked in the stockroom at an organic food store, but he didn't think that her sleeping with other girls counted as cheating. I looked down at Jen. She was so small in that bed, bird-frail, her skin translucent over her temples. I propped the door open when I left, found some orchids at a flower shop, and placed them next to her sleeping head.

Despite her Dartmouth degree and brief stint at a tech company full of Ivy League men, Jen was more working-class than me. She'd grown up

in Virginia, the daughter of a housewife and an enlisted man in the navy, and she was the first person in her family to go to college. While she was at Dartmouth, the dot-com frenzy hit. White guys were getting millions in venture capital for ideas like Balls.com (*Balls! Online!*). Why couldn't she? But she never knew the rich people's trick of funding unprofitable companies with other people's money. Instead, she tried to turn a profit by offering design services to paying customers. Within two years, she was bankrupt. She put all her worldly goods in a car and drove to New York City to try to make it again. Her car was burglarized the day she moved in.

Why did we sleep together, dubiously queer girls that we were? Desire is fluid, but I think Jen and I fucked each other because we wanted to stand by ourselves. Were we not sweet enough for men? Were they put off by our ambition, how fast we talked, how needy we grew? We wouldn't contort ourselves for their desires. Our faces were the same size as we kissed. We were equals. We needed no masculine protection.

We would protect each other. We could protect ourselves.

The photographer Patrick Demarchelier had shot Cindy and Claudia, Naomi and Kate. His loft was one floor of a building in Chelsea, white, looming, adorned with blowups of his *Vogue* covers. When I stood in that loft, shivering in my kimono, the chasm between me and the women he'd shot loomed greater than it ever had on my midnights hunting for gigs on Craigslist.

Demarchelier's assistant, Wendell, specialized in photographing vulvas.

That's why I was there.

Wendell showed me his portfolio of vulva photography. Each was printed oversized in silver gelatin, and lit with the craft you'd expect from Patrick Demarchelier's assistant. Every follicle shone like chrome. I nodded, feigning interest. Who cared how he'd shoot this anonymous bit of my anatomy? I was there for the four hundred dollars.

Wendell had designed a bed for his vulva photography—velvet-

covered, rigged with stirrups, resembling a Victorian gynecologist's table. His camera was equally archaic. As I read a fashion magazine, he expanded the camera's bellows. Flash, then a puff of smoke.

I recommended Jen as a subject.

"When we are old and all our men die," Jen told me, "we'll buy a house and hang our vagina prints over the mantelpiece. If anyone guesses whose is whose, we'll give them candy."

I was not cool.

Cool is not needing. As I turned twenty, all I had was need.

I loved the profiles of careless rich girls that filled the pages of *New York* magazine. In their photos, they were all hip bones and rumpled hair and bitten, just-fucked lips. They wrote "Let god pay the bill," and quit their jobs to smoke angel dust. They abandoned everything for months and were not forgotten.

Every story left a knife of envy in my ribs. What I would have given to be one of those girls. They were so glamorous, these blank girls on whom you could drape salvation. In each profile, the reporter swooned with love. "Fuck the world," those girls could say, in their furs, their torn black stockings. Later I'd come by furs and stockings myself, but never that insouciance.

I didn't know the rules of the worlds I was trying to conquer. I showed up at art openings and tried to shove my portfolio into the curators' hands, always at the moment they least wanted to meet me. I got no shows. I printed up business cards on copy paper. Like everything I made, they

stank of desperation. I gave them to old men who later emailed requests to spank me.

Every time I encountered someone I'd heard of, I'd think, "This is my one chance. I must make them love me." They never did.

Maybe if I'd been from a different school or from a different class I would have grasped those rules. I would have known how to charm, whom to please. My path would have been less circuitous and hard. But my mom's family—clueless, broke artists—never knew how anything worked.

The more I posed, the more tired I became. The more I hated all the pointless portfolio drops, all the long subway rides in the cold, all the mold colonizing the living room ceiling. I needed to make it. I had to try with every tendon in my body.

Posing did not come naturally. To look good on camera is an acquired skill. In my first pictures, I was flabby and young, achingly human. Hating them, I spent hours in front of the mirror, trying to find the exact muscular configuration that contorted my face into hot.

I learned to turn my head toward the light (it hides wrinkles), to suck my stomach in and arch my back till it creaked. I posed in icy rooms because cold air makes your skin firm. Each time I posed, I felt the vulnerability of my own flesh, its infinite flaws. When I looked at my photos, I saw a stranger staring back. I learned that photos are lies.

Eventually, I got better at posing, and better known. French fashion photographers took my picture. I preened in lavender lingerie on the pages of the car magazine *Lowrider*. When the photographer was right, shoots could be creative and collaborative—a chance to play dress-up, to pose and act for his or her camera flash. But they were a distraction too, from the images that only I could make.

My photographer friend Brian had a room on the second floor of the Chelsea Hotel. His wife, Melli, did makeup for *Vogue*, but Brian mostly shot Internet

models. We'd writhe around in the checkerboard fantasia of the place while wearing pairs of heels from his own, improbable collection. The Chelsea Hotel was legend: the place where Sid stabbed Nancy, where Patti Smith lived and Burroughs shot heroin, where Janis Joplin once gave Leonard Cohen head on an unmade bed while limousines waited on the street. I loved the Chelsea Hotel, before New York killed it like it kills all its darlings.

One night, I lay on the couch with Vinyl Vivian and a friend of hers. Vivian's hair was neon yarn, her pitted skin plastered with pancake makeup. She wore yellow lipstick. She told me that men paid her to worship her feet. Vivian was relaxing after a photo shoot with Brian, while I was preparing to start one.

Suddenly, an older lady barged in, gray curls flying, back straight with all the imperiousness of the well funded. She was someone important, Melli told me, doing a documentary on the hotel, but now she stood over us, ordering me and Vivian into passionless contortions. Startled though we were, Vivian and I writhed around gamely, like professionals. After ten minutes, the Belgian was gone.

Several years later, I saw myself on the cover of an art book, frozen in time with Vinyl Vivian. We were entwined, topless, and intimate as we never were in life. The text inside described an orgy that had never happened, starring nameless girls who we were not. The photographer described herself not as a director of the scene, but an invisible bit of the background.

She never told us we'd be on the cover. Why would she? We were hotel room fauna. *National Geographic* would sooner notify a giraffe.

America still believes that if you work hard enough, you'll achieve your dreams. Go to college. Get a job. Put in the hours. The invisible hand will reward you with a home and enough money to take your kids to Disneyland. It's a soothing lie. Any strawberry picker will tell you that hard work is a road to nowhere.

But for my friends and me, fighting our way to moderate financial success, money came from transgressing society's norms. It might have involved fucking rich dudes you met on Seeking Arrangements. It might have involved selling hallucinogen-laced chocolates, or shucking your clothes for GWCs.

It always required doing the ambitious work everyone said you weren't ready for, then getting mocked and rejected for it, until, slowly, the wall of indifference began to crack.

Artists are not supposed to care about commerce. The lies told to artists mirror the lies told to women: Be good enough, be pretty enough, and that guy or gallery will sweep you off your feet, to the picket-fenced land of generous collectors and 2.5 kids. But make the first move, seize your destiny, and you're a whore.

Naked-girl money was my escape hatch. Without it, I'd never have been able to do the work that got me noticed. I'd never have had the materials, the space, or the time.

When I was twenty-two, I spent some of my modeling money on mailing postcards of my artwork to a few hundred art directors. Between the cards, stamps, and list of art directors' addresses, it cost me five hundred bucks—the entirety of my savings at the time. Days later, the *New York Times*' art director called. She'd liked my postcard, and she assigned me a small illustration for the wedding section. It paid eight hundred dollars. It was my first illustration job for a major publication, and it led to more newspaper work. Most career breaks come this way. Talent is essential, but cash buys the opportunity for that talent to be discovered. To pretend otherwise is to spit in the face of every broke genius. I *am* good, but it was never just about just being good. It was about getting noticed.

*i* met Fred a few months short of my twentieth birthday. I'm still with
him now. His body is hard and golden, etched with blue tattoos. He
holds me when I'm crying real, ugly tears, grabbing me hard like I'm a
little girl. He's the only one who can talk to me the way he does. I cry and
shake, and he's there. He is kind and he is beautiful and he is mine.

In the mornings, he'll poke me. "Get up, animal," he'll say, something
he calls me because I'm feral. I expect to die in bed with him serving me
coffee as he does each sleepy morning. I will be dead—and content.

I met Fred through Linda, his girlfriend at the time. Linda and I became
friends after a random encounter on Bedford Avenue. Linda was an art-
ist's model, with long pre-Raphaelite hair and a fragile face, pointing at
that vulnerability that fucks women over in the long run. That week, she
was couch-surfing. Twenty minutes into our conversation she mentioned
that she had no access to hot showers. I let her take one at my place. She
showed me the work of her boyfriend, Fred: brilliantly painted caricatures
for *Time* and *Sports Illustrated*, the colors juicy and the lines depraved. I
wanted to know how to draw like that.

She spoke to Fred, and he hired me as a model for the drawing groups
he held every Thursday.

Fred and his wife had an open marriage. Her boyfriend sometimes
lived with them at their loft on Pearl Street in Dumbo, its gray walls
piled with decades of paintings, orchids climbing the windows. One

Tuesday night, I posed for six artists while they drank wine. I wished I were drawing alongside them instead of holding painfully still on the model stand.

As I posed for Fred, I stared at him. He wore combat pants and an undershirt, worn thin and stained with paint. Fred had long blond hair that made girls confuse him with a romance novel cover model. His wide shoulders narrowed into the V of his hips. I liked men who were too tall to sit normally, so big they held themselves awkwardly in chairs, their legs splayed apart. I liked bruiser men who moved through the world with a paradoxical gentleness. Fred had long fingers, covered in calluses. He held his brush with great care. I couldn't help wondering how his fingers felt.

His studio was filled with art. Paintings of Johnny Cash and the pope stood on easels, the color stroked lovingly into every wrinkle and wart. Stacks of flat files, piled high with papers. Ink drawings stuck to the walls. By his desk, a low glass palette with a rainbow of paints, bleed-

ing into each other like someone had murdered My Little Pony.

Giant nudes, eight feet across, painted with brushes as big as heads. The women in those nudes were ugly and beautiful all at once, seemingly slashed open with each paint stroke, their lips full, their legs spread. Fred painted men with cocks larger than these girls' arms. The work had a machismo to it, and a violence. I wondered how it felt to be so unconstrained with paint, swinging my arm, slashing it, confident that each brushstroke would land right.

When it was time for a break, I stole a look at Fred's sketchpad. I regretted it immediately. He'd given me a hooked nose, sagging tits, and a swollen, pendulous gut. The other guys worshipped him, so they followed suit, competing over who could make me the most hideous. I mocked their drawings, while secretly wondering how accurate they were.

Fred grew up in Rust Belt Pennsylvania, shooting pool and working in his family's bar. His dad gave him his first gun when he was ten. He brought it to school for show and tell. This raised no eyebrows. Everyone had hunting rifles where he grew up, and the first day of buck season was practically a holiday. Fred worked his way through college doing caricatures at the carnival and as a muralist, adorning malls across the Midwest, with rococo clouds and vast hallucinogenic sunsets. The fumes made him sick every night, but he slogged till dawn drawing a comics portfolio anyway, until one day Marvel hired him to draw Conan the Barbarian. He'd been an illustrator ever since.

After I finished posing, I took out my sketchbook. I was still fighting between the rendered Victoriana I did for myself and the washes, vine charcoal, and oil pastels I was learning in school. The pages were unsure attempts, but I was proud of them, if only because I kept plowing for-

ward. Fred leafed through the sketchbook, spending time on each page, and giving me thoughtful comments.

"You can draw so well. Why did you make me look so ugly?" I asked, grinning at him.

He looked back incredulously, then broke out laughing. He told me that he liked big noses, so much that, during high school his French teacher had banned him from her classroom after spying his rendition of her nose as a giant hook. He swore he meant no harm.

Smirking, I grabbed a pencil off his desk and started to draw him. I exaggerated his brow ridge into simian grotesquerie, then gave him squinty cross-eyes under it. I made his upturned nose into a pig snout, with nostrils big enough to fit fists inside.

"How do you like it?" I asked.

He liked it very much.

Fred was a member of the Society of Illustrators. Founded in 1901 in the mold of an old-fashioned private club, the society was housed in a two-story townhouse on the Upper East Side. Its cherry lacquer door opened onto a collection of Rockwells and Leyendeckers. Within a week of our first meeting, Fred got me a gig modeling for their life-drawing nights. While I posed, a jazz band, fronted by a tough blond singer, played the defiant anthems I loved.

When I posed at the society, I wore black stockings, pretending I was Bijou in *Delta of Venus*. Being scantily clad implied a persona. Being naked meant being meat. But my devotion to costume didn't extend to work: I fidgeted during poses, or read books.

Behind the oak bar, an Irish bartender named Mike poured drinks. Mike kept alive the last hints of a decadence that had lingered since the society's birth, since the days of Winsor McCay and Norman Rockwell. By 2003, its past was visible only in the black-and-white photos hanging in its bathrooms.

After I finished posing, I sat at the bar with Fred and the older illustrators. I asked them about school. Most hadn't graduated. I asked what brushes they used, what paper, what ink. The illustrators were obsessed with art, but they saw it practically, like the working-class craftsmen they were. Fred bought me my favorite drink, the sticky, mint-flavored grasshopper. He then walked with me through the upstairs rooms, pointing out the color contrasts Leyendecker used to make his beautiful boys pop against the backgrounds. These were booze-fueled nights, overwhelmingly male. Most nights ended at three A.M., with Mike pouring us all free shots, and me passed out against Fred's shoulder.

The first time I slept with Fred, it was with his girlfriend Linda. I was dating a rich boy who repeatedly told me that he was entitled to a threesome, and that I ought to provide a female friend for the purpose. But Fred was so sweet that I told Linda we ought to sleep with him instead. We brought up the idea with dorky smiles, and soon we were having the impersonal sex that threesomes always devolve into—job-interview sex, cleansed of feeling, so no one would get hurt. People got hurt anyway. By the next morning, Linda was in tears, convinced that Fred liked me better because I was younger. A few weeks later, she screamed as much at him on the sidewalk outside CBGB after an art show where I had some work. He stared back, incredulous. He'd thought I was just another girl, who would be out of his life within a month.

Linda broke it off with Fred. I kept coming to the loft on Pearl Street, climbing the cement stairs and slipping behind him as he worked.

With each visit we grew closer. One reason was that we were both artists who were deeply committed to our work. Fred's wife nourished artistic ambitions she had done little to fulfill, and Fred's illustrations provided the vast majority of their income. Fred and his wife both came from the same rural part of Pennsylvania, and married young. After twelve years together, they had grown apart, and he retreated to his studio to avoid fighting with her.

Over bleary breakfasts, Fred taught me how to make art—not as a student, but as a professional. His were not the cookie-cutter lessons I still suffered through at FIT, but the hard discipline of seeing. He ordered me to draw hands across dozens of sketchbook pages, till my own hands ached. This repetition engraves itself as muscle memory—making art closer to ballet than writing.

But Fred also brought out what was individual about my work. He showed me mechanical pencils and ultrafine Japanese nibs that would work with my finicky style. He told me I didn't have to paint big, or force myself into the mold of what art school taught me I should be. If I liked the obsessive, kitschy detail of the Venetian painter Carlo Crivelli more than Tintoretto's cloudscapes, I should follow my compulsions. I began to find that my art came from my flaws as well as my virtues—that art was as intrinsic and unfakeable as handwriting.

In exchange, I modeled for Fred. It was hard posing in the house he shared with his wife. I felt small and stripped bare as I lay frozen on the model stand, telling myself he'd never be mine. He painted me sprawled across his white sheets like an odalisque. Afterward, I put on one of the kimonos he kept for models and looked through his ink bottles. He drew a naked girl next to each of them, to demonstrate the ink's transparency. I dipped a nib into the bottle, touched it to the thick cream Arches paper, and started drawing my demons across the page.

Slowly, I told him about my ambitions. But he didn't belittle me, as I'd feared. Instead, he promised to help. He guided me through the process of doing sketches for art directors, framing my work for gallery shows, polishing myself up to function in the adult world of commerce and craft. He believed I could make it. With his encouragement, I began to believe it too.

I told myself at first that this was a temporary thing. I liked having a lover who was also a mentor, but I was twenty and I had a world of living to do. Besides, he was married, and what man leaves his wife for a naked model seventeen years his junior? I slept with Jen some nights, and a

fashion photographer, and a beautiful Puerto Rican army vet whose muscled biceps were ringed with tattoos. I didn't realize that I loved Fred until one morning when I left him to head home. I sat in the High Street subway station, choking back tears so hard that I doubled over. He was so kind to me, but it was a gentle, goofy kindness that he extended to everyone. I wanted it for myself. I needed him so much, it shamed me. I felt stupid for letting myself feel anything at all.

I refused to let myself tell him I loved him—directly, at least. Instead, I started writing him notes in Arabic. "I love you I love you I love you," I scrawled, concealing my sentiments in calligraphic loops. I stared hard at him, hoping he'd somehow know what I meant, but he just smiled and told me how to better plan out my portraits.

One night, six months after we first slept together, on that bare mattress on the floor of my tiny room in Williamsburg, Fred brushed the hair out of my eyes and told me that he loved me more than anyone in the world.

A half hour later, I got up and walked to the bathroom. I splashed my face with cold water. In the mirror, I saw everything I hated in my face—my round cheeks, the bags under my eyes—but for a second it all flipped for me. I could see something else there now: a witch's glamour. He'd told me he loved me. I had wanted it so much.

"I won," I whispered to myself. For that moment, I believed it.

But Fred was still married, and every night he went back to his wife. I worked, I drew, I modeled, and I wondered how much longer I could go on being second best.

One night, I was working a go-go platform, wearing a lace bra and PVC hot pants. My fellow dancer had teased my hair before the gig, but it had long since collapsed. Glitter had melted into my cleavage. One fake eyelash hung off with *Clockwork Orange* precariousness. I danced as hard as I could under those strobes, and swallowed a caffeine pill when I got tired. The crowd danced around me without noticing me. Gasping, I wondered how many more hours I had left in the shift.

Then Fred walked in. With his wife. Jealousy gutted me. She looked so legitimate—this attractive woman in her midthirties, in a black tank top, confident, laughing, clean. She wasn't like me—shaking with fake desire, exhausted, her makeup leaking down her face. She was The Wife. I was a disposable slut.

I kept dancing, pretending not to notice. I felt Fred's wife glancing my way, but we'd reached an unspoken détente. Fred said hello to me briefly, then left.

My shift finally ended, long after midnight. Afterward, I stood alone in my room, my body singing with pain. I slowly took off the fake hair, platforms, bustier, and lashes. With each item I removed, more pain and tiredness leaked out.

The tangle of girl accouterments on the floor was almost as big as I was.

Broke white kids though we were, it took a year for us to fulfill our role in the gentrification process. By summer, the landlord kicked my roommates and me out of our Havemayer Street apartment.

I found a sixth-floor walkup two blocks away on Roebling Street, a dingy flat with black walls and no refrigerator, that the landlord described as needing a "woman's touch." There was no sink in the bathroom, and instead of a shower, a hose extended from the wall above the claw-foot tub.

Over the last year, I had gotten close to Richard, a Puerto Rican metalhead who worked at a bike shop nearby. On his off hours, Richard welded bikes into

Frankenstein-style war machines. He sold these double-decker monsters to hobbyists who jousted on them beneath the Brooklyn-Queens Expressway. When the store was slow, we sat on the sidewalk, talking about our families, about hipsters and Puerto Ricans and white kids colonizing the neighborhood, and where we stood among them. I asked if he wanted to be my roommate.

Fred helped me move in. He was spending more and more time with me, and fighting more and more with his wife.

I installed checkerboard linoleum, hung up a baroque mirror inherited from my grandmother, and stapled up dollar-store plastic flowers to hide the cracks in our crumbling walls. Richard installed a shower. John and I hauled furniture off the street and painted it gold. Over a desk abandoned by a former tenant, I hung a portrait of Napoleon I'd bought at a thrift store when I was thirteen.

One drunken night I forgot my keys. The super showed me he could pick my lock with a credit card. The same super looked through my trash. He found naked Polaroids of me smeared in jam—detritus from some modeling shoot. "I'm saving them," he said with a grin. "Now I know what you look like with no shirt."

The landlord hung flyers in the hallway that read "Stop urinating in the stairwell. We know who you are." Each was adorned with an inverted photograph of an eyeball. The flyers were part of the landlord's attempt to upscale the building. One night, the super painted the forest green hallways white, the better to see every building code violation. "Like SoHo," he told me proudly.

I was part of the building's gentrification, too. My pale face would lure yuppies like another coat of whitewash.

Our first year together, Fred refused to take me to the Society of Illustrators' awards show. He wanted to bring his wife instead. Going to the awards show was their tradition, and he wanted to demonstrate that their marriage still worked.

I resolved to go anyway. I may have been his girl on the side, but I was also an artist, and I refused to hide in my room. That year, the society was presenting an award to the illustrator Michael Deas, for a painting I'd posed for. He invited me as his date. I blew my savings on a white Marilyn Monroe dress. I wanted to be as conspicuous as possible. But when we walked into the room, I saw Fred alone by the bar, drinking his third whiskey. His wife and he had been fighting. She never showed up.

At the next awards dinner, six months later, Fred invited me instead.

The society was honoring the cartoonist Jack Davis, from *Mad* magazine, and Brad Holland, a famous illustrator from the 1980s. Both men received rings representing their lifetime achievements. Over drinks, Brad took out his new ring to show his friends. It slipped from his fingers. I saw it bounce across the carpet.

Instantly, I dove for it. I stood up, slipped the ring on my own finger, and grinned like a monkey. The society's photographer snapped a picture.

Brad was the only one in the room who smiled for real.

*I* sat in the bathroom of Barnes & Noble, squinting in disbelief at my second pregnancy test. I'd been throwing up for two weeks, unable to hold anything down but mint ice cream, and yet when I saw those indisputable two lines again, I had to force myself to acknowledge they were true. My mother, though prochoice, had always conveyed to me that abortion was for stupid girls, teens who didn't know how babies were made, not clever girls like me. This passivity is baked into the grammar: "impregnated," "knocked up." Yet no matter how free or clever I believed myself, there I was. Knocked up.

I leaned against the wall of the stall and let the pain hit me like a punch. Then I hyperventilated till I calmed down, and started planning what I'd do.

For me, whether to have an abortion was never a question. The only question was how soon. I have never had maternal instincts. Babies were alien to me, so fragile that when an aunt passed me hers I thought its neck would break. And there were other considerations: Fred was still married. I was eking out six hundred dollars a week by virtue of a relatively pert body.

But it was more than economics. Unwanted pregnancy feels like womanhood at its most hateful and cowlike: the broodmare inside the

bombshell. You are yourself, full of wit and dreams and adventure, until you discover that biology has been conspiring against you, to sicken and trap you. Nature cares nothing for individuals. The embryo in me felt like an invader; it represented the end of any future I might have dreamed.

In that moment, I understood why women pre–*Roe v. Wade* stabbed knitting needles into their cervixes. Abstract debate meant nothing while I was throwing up every hour, just wanting to be the way I'd been before.

Before it happened, I'd resolved that I wouldn't tell Fred if I got pregnant, that I would tough it out by myself. But I was so ill that I knew I'd need someone just to take me to the clinic. I called him up. He paused for a second. I could hear him running through the script: not wanting a child, but knowing that a good man tells a woman he supports her choices. I could sense how scared he was that, despite everything he knew about me, I might decide I wanted a baby.

I told him not to worry. I'd get rid of it.

School got harder. Frustrated by a dean who wouldn't transfer his credits, John quit. He was my only friend at FIT. I sat alone with forty aspiring artists in an advanced illustration class, gessoing brown craft paper, then soaking it in turpentine. The turpentine made the brown transparent, and the white even brighter. The fumes left me so dizzy I had to support myself against a chair. I waited for the turpentine to dry, then, carefully, as our teacher had taught us, crosshatched a self-portrait, half on the white gesso, half on the oily brown craft paper. The materials wouldn't obey me. The ink bled on the brown. The nib caught on the white. It looked like everyone else's self-portrait.

This was so futile. Our professor no longer illustrated professionally, yet here we were, her forty clones, mimicking a style that had failed her.

I came to class later and later. What was the point?

Pregnancy felt like a mixture of stomach flu, clinical depression, and a damp gray blanket wrapped around my brain. Every day on the freezing

subway platform on the way to school, reeling with fever, I'd think about throwing myself on the tracks.

The day before my abortion, I posed naked for a series of pinup skateboard decks. Before the shoot, I sat with the other models in the cavernous studio eating stick after stick of gum. By then, it was the only thing that wouldn't make me vomit. Stylists shellacked my hair, painted my mouth, and propped my body into the painful contortions favored by classic pinup artists like Gil Elvgren. It was a demanding shoot, but I was glad for the candy-hard artifice of it. I would be tough and cheerful. Smile fixed. Shoulders back. Willpower over biology. I would brazen it out against my own body.

The next morning, Fred and I headed to a Planned Parenthood clinic in Manhattan. Outside the building, two old men were standing on the sidewalk, one faded cut-up fetus placard between them. It was hard to tell which was more tattered, the men or their sign. A girl entering before me flipped them off with relish. I grinned, then flipped them off too.

Planned Parenthood was the city's cheapest, best-known clinic, and it was run like a combination assembly line and prison. Hundreds of women filed in past metal detectors, mostly broke, mostly brown.

Fred came with me, paid for the procedure in advance, then left. Because Planned Parenthood is a terrorist target, no one is allowed to accompany you past the clinic's front room. You sit surrounded by other women. You wait for your abortion alone.

It took seven hours to complete the full round of blood tests and ultrasounds. In between, I waited. The long delays and bureaucratic tangles just made me angrier—not at the clinic itself, but at a country that could put such facilities under constant siege. I was determined to be cheery and cordial. The receptionists may have barked at us while we gave them our four hundred bucks, but they were risking their lives.

Finally I spoke to a counselor. She was an older black lady with dreadlocks and a gentle, practiced smile. "Is anyone forcing you to do this?" she

asked, reading from her checklist. "No," I mumbled, forcing back tears. She was the first person in the clinic who had been kind to me.

In the changing closet, I took off my clothes. I looked down at myself, seeing my red knees, pale nipples, every blemish and hair. A standard-issue, knocked-up female body.

*There are only two ways out of this*, I told myself. *Some pain now. Or all the pain later.* I put on the paper gown.

"I'm not taking my sneakers off," said a woman outside my little changing cabin.

"Then you'll get your baby on your sneakers," a nurse responded.

Holding my possessions in a plastic bag, I walked to the operating room. I got onto the table and put my legs in stirrups. The doctor was the first man I'd seen in the building. He asked me about my job. It seemed so trivial, this bit of humanizing banter. I now know that it's a technique doctors use to distract their patients from pain. "Artist," I tried to answer, but the nurse kept stabbing the back of my hands with the IV. He missed the vein, hit bone. I jerked away. He yelled at me to stay still. That was the last thing I remembered before the twilight anesthesia kicked in. Later I replayed that moment with hallucinatory vividness: hating myself for how I'd yelped. I'd wanted so badly to be strong.

Then it was over. I was on a gurney, one of many, each with its own female cargo. Then I was stumbling off with a bloody pad between my legs, holding myself up against the wall, wobbling as I changed back into the clothes that reminded me who I was. In the recovery room, a receptionist gave me a painkiller.

I sat down next to a young Dominican woman. She was beautiful, her pale eyes catlike on her smooth, dark face, her cheekbones high and her hair slicked back. We smiled at each other sheepishly. "How are you?" she asked.

"Fine," I said hopefully. "And you?"

She told me she had two children, whom she loved like hell. The fathers of both had pressured her to go through with the pregnancies, but both men were in jail now, and she was working two jobs. When she got

pregnant the third time, that man had also wanted her to keep it. "I'm never trusting one of them again," she told me, laughing. "They say they'll be around, but they're not."

"Men," I laughed back. Men, even the sweetest men, poison us. For the next generation to exist, we get sick and swollen and our ribs stretch outward; finally, our bodies are torn apart to get the baby out. Some of us die in the process. The man? He has his orgasm, then walks away.

That feeling, as we sat chewing our graham crackers and exchanging pleasantries over pain, was one I'd recognize again when I was sitting with fellow protesters in a Manhattan holding cell. It was solidarity.

The process lasted a full workday. After I was steady enough to walk, Fred picked me up, ushered me into a taxi, fed me lentil soup, and put me to bed. John dropped by, looking miraculous in a white suit, bearing flowers and anecdotes about the fictional abortion in *Cabaret*. My roommate Richard poked his head in my room to tell me I'd done the right thing. I tried to make conversation, but I could barely lift my head. Then the men all left: Fred to his wife, John to his boyfriend, and Richard to his job at the bike shop. I was alone.

I lay in the dark, trying to fall asleep. But my mind started spiraling. I was so stupid. So fucking stupid. Stupid trash, splayed on an operating table, the nurse thinking I was pathetic for moving my hand. At least it was out of me. But I had failed, because it was in me in the first place. I was stupid trash. I had failed. I remembered a photo I'd seen of a woman who had needed an illegal abortion in the days before *Roe v. Wade*. Without a doctor, she and her boyfriend had tried to do it themselves. They had some surgical tools, a textbook, and a hotel room. The wire he threaded up her cervix punctured something. Once she started hemorrhaging, the boyfriend fled. She was found dead by the hotel maid, lying on a berber rug, thighs caked in blood made black by the film stock. Her face was hidden. She was as vulnerable as a dissected frog.

The woman loomed in my head, crucified because she'd wanted plea-

sure or love and to live on afterward. I put on some Ella Fitzgerald. I wanted brave music. I saw that woman, saw myself in that woman, gigantic behind my eyelids, and the music sounded hollow. I screamed into the pillow, tears pouring from beneath raw eyelids.

A week after having a surgical abortion, all patients are supposed to get a follow-up exam. I never did. Haunted by memories of the nurse yelling at me as he tried to insert his needle, I couldn't make myself go back.

I should have gone. The hallucinations I had the first night turned into a fever that left me barely able to stand. I took a week off from modeling and school. It was winter. When I forced myself to walk through those ice-slick streets, I'd have to rest on a lamppost just to keep going. "Be tough, you stupid bitch," I'd tell myself. I stopped handing in assignments.

"School is a reflection of the real world," my editorial illustration teacher lectured me one day after class. "If you can't succeed here, you won't succeed there."

"I was . . . sick," I told him, but from the frown on his face I knew he didn't believe me, and I didn't want to tell him what *sick* meant. Without John there to mock him after class, I groused alone, pacing fluorescent-lit halls hung with clumsy oil paintings cranked out by the previous semester of failures.

Two weeks after my abortion, I dropped out of college.

My mother worried when I quit. In her world, a college degree still guaranteed a future. I didn't want to worry her further, or have her see me as irresponsible, so I never told her how ill I was, or why.

John and Jen congratulated me for ditching FIT. "You're already working as an artist," Jen said matter-of-factly. I fixed my mouth into a hard red smile. "Art school is a scam," I said with a shrug. "FIT was horrid anyway. We should get its accreditation pulled." John smirked.

Despite their words, I still feared entering the future without a

credential the world told us meant so much. FIT itself I wouldn't miss. A few of my professors had taught me things: Dave Davries introduced me to Victoriana. Sal Catalano berated me for the anatomical failings in my work until I knew how the fibula joined the tibia. But mostly I was relieved to no longer have to show up.

Instead, I spent my time on Craigslist, emailing shadier listings, showing up at bare apartments to be photographed naked with cheap disposable cameras by guys who browbeat me to spread my legs. After each gig, I counted the twenties, then folded them neatly in the bottom of my purse. I was still running a fever. On the subway, I sometimes fell asleep and missed my stop.

After a week waiting in lines at offices, I assembled the forms I needed to quit FIT. As I dropped the envelope in the mailbox, I thought, *This is me giving up on middle-class employment. There's only one thing left—to make it as an artist.* For luck, I whispered Cesare Borgia's maxim: *O Cesare o Niente.* Caesar or Nothing.

When I wasn't working, I lay in bed, talking to female friends on the phone about our abortions. One woman told me about the pill she'd taken to induce a miscarriage. The doctor at the clinic had lied, telling her it would just feel like cramps, but the blood and pain lasted fifteen hours, shocking her so much she thought she was hemorrhaging to death. Another woman spoke about the relief she felt as soon as the pregnancy was terminated, clear as a runner's high. I was myself again, she said.

All I wanted was stories.

I balanced the phone in the crook of my neck and drew with my other hand. I focused on the dirty clothes left in piles on my bedroom floor. Drawing crumpled cloth is an old and demanding exercise, once ubiquitous in French ateliers. When you draw cloth, your mind has no preconceptions to fall back on, as it does when you draw a dog or a strawberry. Each fold must be observed, measured, and then rendered fresh. This teaches you how to look at the rest of the world.

The concentration took me out of my head, in the same way drawing ferns had done years ago when I waited for Anthony. As I lay there drawing, I knew I never wanted to be broke again. It's easier to be broke when you're young and strong, and even to fetishize brokeness (a state fundamentally different from poverty) as artistic and pure. The fever burned that romance out of me. Being broke just meant I didn't value myself enough to pay an extra three hundred dollars for a private clinic where I would have been treated nicely.

In New York, bohemia has become a tagline—as real as the condo ad over the Bedford L stop. "Grit meets glamour," the ad reads. Artists, for all their wildness, have often been the unwitting shock tropes of gentrification—at least to the city power brokers who dictate everyone's living conditions. Once the real estate market no longer needs them, they're erased as thoroughly as the graffiti that once covered 5Pointz, the outdoor art exhibit space in Queens that was razed by developers after artists made it famous.

The art scenes that defined New York were joyous and feverishly creative. In the moment, they felt like everything that mattered. But as their participants aged and got sick, they found that the only ones who derived any security from those scenes were their exploiters. Andy Warhol won, not Candy Darling.

I didn't want to be cast in that stock role. I wanted to stay in this increasingly expensive city where I had been born. I wanted a stable apartment with heat and air conditioning and no rats. I wanted doctors who were nice to me. I didn't want to be precarious. I didn't want to be erased.

Lying sick in that bed, my politics became personal. My anger over the Iraq War was nothing compared with my hatred for the decaying old politicians who would force me to give birth. Fifty years ago they would have succeeded, would have made me risk dying in pain and shame.

As I recovered slowly from what must have been an infection, I marveled at the treachery of my body. Being ill made me a stranger to myself. I didn't know the fatigued, weeping, vomiting girl I'd become. My body was a prison, not a servant. Though Fred was dealing with his divorce, he

came sometimes to take care of me; he later told me I was like an animal who doesn't show sickness until it finally breaks.

My roommate, Richard, cooked me soup. John and Jen listened to me with love. They made me feel healthy, beautiful, and strong. Even with them nearby, though, I was still alone in my body, as they were alone in theirs. If I didn't take care of myself, no one else would. No one would be there to catch me. Not even the kindest lovers. Not even the best friends.

Lying in bed, I promised myself two things: I would do my best to help anyone as powerless as I was at that moment. And I would never be that powerless again.

## 14.

**W**hen the fever finally broke, I celebrated by accepting a gig to go-go dance at Goodbye Blue Monday, a thrift-shop bar in Bushwick, Brooklyn, with a stage in the back. Out front, pulp novels and beaded lampshades were piled on tables and chairs, a goiter of junk. Five people sat in the audience. Finally able to hold down food, I bought a green cookie from the bar. Onstage, Ruby Valentine danced. Her body was soft, dimpled, a tumble of curves that never knew a gym. Her hair was red, her skin translucent white. She danced on her toes, winding veils around her to a Chopin mazurka. She moved so slow, with a sickly eroticism. I could not look away.

I danced badly, blinking in the lights. Fred walked into the bar. He was so big, his hair long and gold, and he walked right toward me like a savior. He held a bouquet of roses. I walked off the stage toward him, and let myself shrink near-naked into his arms.

Around that time, Fred finalized his divorce. He gave his wife everything except his paintings. Then he moved into my apartment.

His presence was as sustaining, and as difficult to write about, as air. We'd never be apart again.

After three years, I hated modeling. I came to each shoot expecting the GWC to rape me. If there's a beauty privilege, there's a good-girl privilege too, in which only white virgins locked in their rooms are presumed innocent. By working in the sex industry, I had thrown that out. Sex workers, like trans women, are believed to have brought violence on themselves. "Yes, officer," I imagined saying. "I was naked in his hotel room. For money."

No one ever tried. But I never lost the awareness of my own vulnerability. Driving home from one of my last shoots, a GWC begged me to fuck him. "My wife's pregnant," he said. "She won't sleep with me. She says it will kill the baby."

I stared ahead, willing him not to touch me until the road led us back to Brooklyn, where I could open the car door and run upstairs to my apartment.

For safety, models really ought to bring along escorts, but I asked Fred along only once. In that motel room in Jersey, the photographer showed us his ultrafast camera—*a thousand frames a minute!*—proud as a man with a sports car that he never took out of the garage. As Fred sat sketching in the corner, I gamely tried to pose in front of the vertical blinds, but in that moment I became obsessed by the cloud of societal judgment. I was not a good woman. I was not the type who deserved protection.

I posed faster for the automated flashes. But Fred's presence wrecked the photographer's fantasy. After an hour, the photographer gave up.

"It's just not working," he said with a frown, handing me my cash.

Afterward, Fred took me to a cafeteria in Chinatown. I ordered us both fried fish. It came wrapped in newsprint. Each bite tasted like chalk.

All this time, I was still posing for SuicideGirls. Though the site claimed to be a refuge for rebels, it had its in-crowd just the same.

On the models-only message board, girls tore each other apart competing for gigs as unpaid retail workers at the San Diego Comic-Con—the crumbs of nonopportunity that hot girls are told are their highest potential reward.

Then, in the summer of 2005, we SuicideGirls all got newly restrictive contracts. By signing, we gave away more than just the rights to our photos, as any client acquires in a shoot. Now we were banned from posing for other sites. SuicideGirls owned our stage names, our likenesses, even the copyright on our tattoos. They could turn us into characters, and we'd never see a dime.

Fuck the real woman. They had the Platonic concept. When our aging flesh was a shadow on their digital wall, they would still own our fresh, valuable pixel ghosts.

That fall, many of the most famous SuicideGirls quit.

First went Sicily. The SuicideGirls burlesque tour had spawned a DVD, and the DVD a special on Showtime. Before they knew about the Showtime deal, the dancers had been paid a pittance to appear in the video, and they were promised a small additional fee if they participated in a promo tour.

Sicily wanted a contract spelling out the deal. Sean refused.

When a SuicideGirl quit, the site declined to acknowledge the fact. Instead, they put the girl in the "archive," deactivating her profile and deleting her diary. Though the site lost the illusion of a girl's availability, in the archive she became content at its most pure. Each girl, upon archival, got her own message board thread, titled, obituary style, "Good-bye, ——!" Hundreds of members posted their well-wishes, but the site deleted any comments asking why the model had left.

Sicily blogged her disappointment on her SG page. Within minutes, she

was gone. "Good-bye, Sicily," read the thread. Her friends from the tour followed. Soon the message boards were nothing but good-byes. Good-bye, Shera. Good-bye, Stormy. Good-bye, Katie. Good-bye Good-bye Good-bye.

I wasn't friends with these women, but I decided to leave too. We were all naked girls. Sean was the tattooed Man. What would we have if we

Posing for Suicide Grls

didn't stick together? On my SG diary, I wrote about the ways the company misrepresented itself, underpaid its workers, and fired anyone who complained. I finished by saying that we had to stick together, and that I wanted nothing to do with the site.

I did not write that SG's problems were the same as those that bedevil so many indie companies as they get big, from clothing brands to magazines. Indie companies start out scrappy, telling workers that their low wages are justified by the coolness of their jobs. But as more money comes in, with it come the corporate bastards those workers were trying to escape from when they came to work at an indie in the first place. As the company expands, it exerts increasing control over the workers' lives and personas, but it preserves the cheapskate disorganization of its past. The start-up's former DIY ethos becomes nothing more than splatter on a logo and an excuse to ask for unpaid overtime.

During the press furor that later enveloped SuicideGirls, many journalists assumed the site was exploitive because it was porn. They were letting sex elide politics. SuicideGirls was exploitive because it was a corporation, and corporations are amoral by design. They don't get big without kicking someone down. Posing naked is generally a less abusive gig than waiting tables—but any gig can turn bad.

My post stayed up on SuicideGirls for seven minutes before the site's moderators deleted it. Then they locked me out of my account.

Good-bye, Molly.

A few months after SG's troubles hit the press, a new porn site appeared. The site featured Missy's outtake photos of former SG stars: Apnea, Sicily, Stormy, Shera, et al., pouting unretouched under flat lights and brand-new names. Whoever sold the pictures hadn't even bothered to edit out the ones taken mid-blink.

Photos once marketed as punk empowerment now ran alongside copy describing Goth Cunts Who Get Fucked in Their Holes. The Internet removes all context. We were all the same content soup.

# 15

*i* had met Albert, a burlesque producer, in a coffeehouse when I lived on Havemeyer Street. Since then, I'd spent many afternoons at his loft, listening to his jazz records and hearing his stories about New York's burlesque scene. He had no buzzer, so I had to call him when I was outside. While I waited for him to walk downstairs, I stared at the skyline. The waterfront was raw then, its rocks adorned with broken bottles. A torn wire fence was all that stood between you and the East River, and that tarnished water was all that separated you from Manhattan. Upstairs, as I sat in the soft light of Albert's loft, sketching the burlesque posters on his walls, it felt like New York was fading back into the city it had been a hundred years ago.

Sometimes Albert let me sit in when his burlesque troupe rehearsed. Honey Birdette peeled off a dress made of garbage bags to reveal a beaded gold bikini. Dirty Martini was as curvaceous as a Botero, her tiny waist spreading out to lavish hips. In her blond flip wig, Dirty was the queen of New York burlesque; I loved watching her after rehearsal, as she toweled herself off, while negotiating gigs fast and slangy. Then I'd draw her onstage, en pointe in her pink satin ballet slippers, her plush flesh aloft in the air.

I started going to more shows, drawing more dancers. I painted New York's stars—Tyler Fyre, the World-Famous Bob—in clumsy oils on my living room floor then presented the art proudly to Albert, who used the paintings on his show posters.

Just as Toulouse-Lautrec drew his cancan girls as warriors, I recognized something in these women that casual observers seldom did: Burlesque girls were alchemists. They were steel-tough performers who were willing to use kitchens as dressing rooms, haul their costume bags through the snow, and go into debt over fake diamonds, all for the five minutes onstage when they were goddesses.

I sat sketching the dancers, too afraid to talk. Before I knew it, I fell in love.

Burlesque started in Britain as working-class comedy that "burlesqued," or satirized, the elite. When it came to America, it mutated, as so often happened to old-world seeds planted on our soil. Burlesque in New York was vaudeville's disreputable sister, filled with dirty comics and dancers in body stockings, or less. These girls were less classically beautiful, less classically trained, or just less able to pass as high-class than the chorines who served as arm candy for wealthy men in the early 1900s. Burlesque girls were strippers, but they were paid as performers: they did not pay

their venue for the privilege of working there, as strippers are obliged to do now.

By the 1960s, burlesque was a ghost. My mother had seen it as a young woman in the Catskills, aging women in tassels jiggling next to Borscht Belt comics. They embarrassed her with their tacky frailty. But in the early 2000s, strippers like Dita Von Teese, Catherine D'Lish, and Jo "Boobs" Weldon willed burlesque back into existence, mixing strip-club bump and grind with drag and avant-garde performance art. During the height of the burlesque revival, TV people often urged performers to call themselves better, classier, or more artistic than strippers. They created a false dichotomy. Burlesque was seldom sex work, because it usually wasn't a job, more a hobby and a calling. But many dancers stripped to support their burlesque habit.

In 2003, when I started performing, burlesque had a distinctive aesthetic. Dancers painted on defiant masks: red glitter pressed into lips, white makeup lined tear ducts, false lashes so long they brushed the brow bone. These dolly faces sat atop bodies less perfect than would ever be allowed on Broadway—jiggling, human, muscular, sublime. Dancers coated themselves in Dermablend, and layered flesh-colored fishnets studded with rhinestones. At its best, it could be achingly erotic or disturbing as all fuck.

If stripping was hard work that paid okay, burlesque was hard work that barely paid at all. A few top performers made tens of thousands. They were conventionally beautiful women, like Dita in her rhinestone birdcage, with acts as subversive as Versailles snuffboxes. Others were able to piece together enough gigs to make a lower-middle-class living. Most got fifty dollars an act. Their payment was in glamour, a word that once meant *witchcraft*. Burlesque gave dancers a chance to embody everything—perverted clowns, shimmering angels, all of existence compressed into the space of a song.

I lurked for three months before Albert asked the obvious question: Did I want to join his troupe?

I started dancing burlesque when I was twenty. I stopped when I was twenty-four. In those years, New York nightlife became both my finishing school and the home to which I'd return. I learned to make my face up like a French pastry, gluing on crystals in a snowy alley that doubled as the backstage for the Galapagos performance space in Brooklyn. I learned to walk on glass, to eat fire, to stalk around in platforms with my back straight and proud. I danced next to contortionists and drag queens on a beer-soaked stage where every transgression was permitted as long as it was wrapped into three minutes and you showed your tits at the end.

I stood topless, and the applause hit me like a wave.

The first time I danced was at the Manhattan dive bar Arlene's Grocery, in a show produced by the underground party promoter Editrix Abby. With my dollar-store lingerie, I was a clear amateur, but the screams from the audience spun my head. I hit my marks. A girl tried to grab my ankle. I kicked her hand, hard. I grinned. I was onstage. I made the rules.

I kicked her hand again.

Those nights bleed together in my memory now, like the acts of a long burlesque show. In Albert's troupe, I played the Greek goddess of Astronomy. I held a rotating disco ball I bought in Chinatown, pretending the flickers it cast were stars. I spent hours in a trimmings store in Hasidic Williamsburg, buying fringe, tassels, appliqués shaped like eyes. I glued hundreds of crystals to my corset, one for each polka dot.

On Coney Island, I watched from the wings as Remy Vicious fucked herself with unicorn lollipops. She lay on her back, spread her legs into a horizontal split, and shoved the eight inches of candy in and out, in time with Marilyn Manson. Nasty Canasta stripped elegantly to the sound of car alarms. Peaches and Cream strutted back and forth in angel wings, periodically slapping her own round ass. We finished the show with a wine bath, climbing all over one another in the claw-foot tub, red with rotgut. Then we washed off in the Atlantic Ocean. Dino's Wonder Wheel outshone the moon.

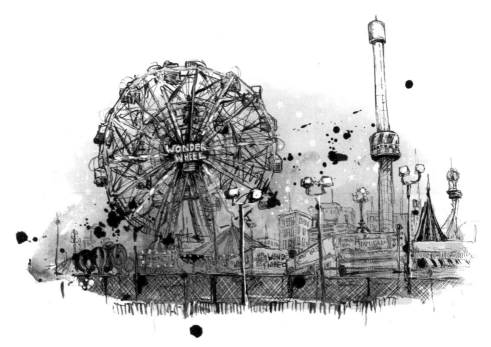

At Galapagos, I gave a guy at the bar six dollar bills to throw at me, trying to encourage the habit in others. No one followed his lead. But the guy was a publicist, and he liked my initiative. Later he repped my first real art show, at a comics shop.

I learned to eat fire from a friend who'd toured with a sideshow. It's an easy trick, not to be confused with fire breathing, which is far more difficult. Fire needs oxygen. When you put the torch into your mouth, you gently close your lips, cutting off the oxygen. If it burns your mouth, it's no worse than drinking a too-hot cup of coffee.

The day after I first ate fire, my breath tasted like gasoline.

I walked on glass at the Pyramid Club. As with many sideshow stunts, it's not so much a trick as a willingness to hurt oneself for attention. Before the act, my fellow performers and I rolled the glass in a pillowcase, to blunt the edges. It cut my feet anyway. We kept the glass in a leopard-print sheet to hide the blood.

John and I created acts to perform together. In one, he played Andy Warhol, and I was his aspiring protégée. *"I just want to be loved by you,"*

Marilyn cooed behind us onstage. Who didn't want to be loved by an art star? Burlesque works in caricature, so I wore a beret with my long black dress, an oversized portfolio flopping in my hands. I presented the portfolio to John. He scowled at one of my drawings, then tore it in two. He took out another drawing, then another, tearing each to pieces in contempt. I stripped. He showered me with bills. When the act ended, he slapped a price tag on my forehead.

One of my fire-eating gigs was on New Year's Eve at an illegal warehouse party. Someone had called the cops on every other illegal warehouse party that night, so this one was packed. Thousands of bodies danced, high in the crimson light. I drank hot chocolate with peppermint schnapps, leaning on Fred's arm as he elbowed us through the crowd to the dressing room. Before me, a sideshow girl let the audience staple money to her: her arms, her forehead, her breasts. A woman on stilts stood next to a giant wheel that read "Kiss, or Pain." For five dollars, guests could spin the wheel. If it landed on "Pain," she tased them. Guys lined up anyway.

At six A.M., the promoter counted out his profit in the dressing room. Tens of thousands of dollars lined up in stacks on the concrete floor.

I got two hundred and fifty.

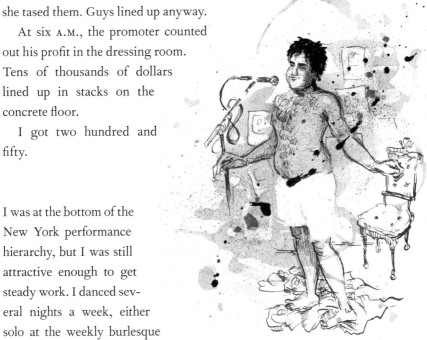

I was at the bottom of the New York performance hierarchy, but I was still attractive enough to get steady work. I danced several nights a week, either solo at the weekly burlesque

nights held at many dive bars, or as a go-go dancer in the background of a party. Only occasionally did I perform on a proper stage. While burlesque padded out the money I made modeling and from my illustration work, it was less a job and more a love. Whether I called myself an artist or model or dancer felt irrelevant. Dancing was an entrée into the world I wanted to capture.

Experiences blurred together. Wake up, draw all morning while speaking to my mother, pose in the afternoon on some guy's fire escape, then throw my G-string into a shopping bag and take the train to the Lower East Side, to squirm through a song at the Starshine Burlesque show. Each gig fed the others.

And yet, for all the hours I spent onstage, performance was never natural to me. Performers need to be present in order to dance. For three minutes, they need to embody rage, passion, or grace—to be in the moment, not in their head. But my head was where I lived, and this suited me as an artist. Lining up my nibs, sketching in sloppy outlines with a mechanical pencil, then flicking the pen over and over on the page for fourteen hours until the contents of my skull had spilled out: that was where my talent lay.

*b*y twenty-two, I was disillusioned with modeling and exhausted from the late nights at burlesque clubs. I managed to claw out illustration work, but what I produced only made my failings more obvious—especially compared with Fred's virtuosity. I never drew a job I didn't want to destroy.

Posing one night at the Society of Illustrators, I grew frustrated that my name wasn't even on the flyer advertising the event. Many artists there told me I was their favorite person to draw, but on the flyer I was merely an anonymous "female model"—a gender and a body, interchangeable with any other. That interchangeability gnawed away at me whenever I posed. Long ago, models like Kiki de Montparnasse had been queens of their art scenes. But my model friends and I might as well have been flanks of beef. As I posed with glazed eyes and aching feet, I started imagining how things might be different.

I first thought up the idea for Dr. Sketchy's on a train to DC with Fred. The concept was simple: a live-drawing workshop where models would be muses. I'd hire my friends from the underground performance world and pay them sixty dollars plus tips to pose for a roomful of artists. The models would wear the costumes in which they already performed, they'd pose in a way that expressed their character, and they'd be encouraged to talk back. John and I came up with the name on my living room floor.

Instead of a teacher, each Dr. Sketchy's class was run by an emcee, just like a burlesque show. At first, A. V. Phibes, the illustrator with whom I founded the class, hosted. Then John and I took over the hosting, and eventually John did it alone. The emcees encouraged anarchy more than art, handing out shots in exchange for increasingly obscene drawings. Drawing on the lessons I'd learned from SuicideGirls, I churned out flyers for our first class, and promoted it using ideas I'd gathered from burlesque, modeling, art, comics, and underground nightlife. Even before it started, Dr. Sketchy's had grown into a glittering pastiche.

We threw our first Dr. Sketchy's in December 2005, at the Lucky Cat, a Williamsburg dive bar run by a friend. We filled the room with twenty acquaintances we'd begged to come, and my ever-supportive mother, who came to everything I did. Dottie Lux posed as a topless clown. We played music and talked and drew, passing a tip jar during breaks. The artists

loved it. "It's so different from other drawing classes," one girl told me. As she spoke, I realized I didn't know her. She was the first stranger who'd ever come to something I'd produced.

Afterward, John and I were giddy. We had thrown a party and people actually came. We took our forty-dollar profit and drank it at the bar.

Our second Dr. Sketchy's was better attended than the first, and by the third class, a hundred artists showed up. We seated them on the arms of chairs, even on the stage itself. We turned no one away. I stared out at them from the wings, swooning with glee.

Before too long, A. V. left to tend to her own art business. From then on, John and I ran Dr. Sketchy's together. I took care of the business end: booking models, sending out press releases, and leaving stacks of flyers at every hipster café in Williamsburg. It was mostly drudgery, but it kept the class running. John made mixtapes, built palatial stage sets out of balloons and tinfoil, and hosted with style.

John and I worked with the models to create a theme for each new Dr. Sketchy's class, usually based around the models' interests. We did classes based on the Beijing Opera, summer-camp slasher films, Marie Antoinette, and *Star Trek*'s Uhura.

We threw a Dr. Sketchy's that was a mashup of a dozen different dystopian futures: *Brave New World*, *1984*, *V for Vendetta*. John plastered the walls with dozens of posters he designed, one reading "Dr. Sketchy's Is Watching You." Miss Pandora posed as a Soviet commissar. Lithe, red-headed Gal Friday costumed herself as Queen Elizabeth I, with a bald cap to mimic the queen's tweezed-back forehead. I hired a handsome waiter to pose with her, as Shakespeare, and John pulled on a black robe and a ruff made of doilies to preside over the whole mess as Oliver Cromwell.

Dr. Sketchy's gave me the chance to hire burlesque dancers I'd long admired. Dirty Martini blew a kiss to Dr. Sketchy's artists while covered in white roses. In another class, the seaweed-haired alt model Aprella encased herself in only transparent latex. Akynos, a professional dancer who

had just started in burlesque, looked like a 1960s pinup illustration—a massive afro atop her tiny, curvaceous body. Sometimes she modeled as a pan-African goddess, dripping with feathers and gold. Perle Noire painted her face white and posed like a geisha, while Stormy Leather painted her body blue and posed like X-Men's Mystique.

John took more and more of a directorial role, scripting performances, building elaborate sets, even learning theatrical lighting techniques. Conspiring with a staffer, we snuck into a prestigious science lab to shoot *Reefer Madness*–style comedy shorts, with Dr. Sketchy as a mad scientist and me in a beaded bikini, disappearing in a puff of smoke.

After Dr. Sketchy's first few classes, Syd, a fan of Jen Dziura's comedy, started helping out. Others followed. Over the next year, a crew of helpers gathered around us: videographers, artists, set designers, programmers, and photographers—the "art monkeys" who made so much of what we did possible. Eventually, three punk kids started coming to every class: two guys and a girl, covered in tattoos, who mostly kept to themselves—at least until John fired vodka from a water gun into the guys' mouths. That broke the ice.

The girl had a voice so soft it was nearly inaudible, and purple hair, half shaved, framing her much-pierced face. Her name was Melissa Dowell, and she was an artist in her own right. She started working with me soon thereafter, building Dr. Sketchy's sets with the two guys, Tim and Foley. Soon she'd become my right-hand woman, the enabler of all my art.

One day, during a class with Lady J, an old friend from my Internet modeling days, thunder crashed overhead. The sky broke open. All of us—John, Syd, Lady J, the art monkeys, and I—ran outside, stripped off our shirts, and danced in the hot summer rain.

To spread the word about Dr. Sketchy's, I turned to the social blogging network LiveJournal and the witty, emotional subculture in which my fellow grown-up goth girls and I had bonded. I started spamming LJ illustrators' groups, many of which had international readerships.

At first there was little interest. But after a few months of posting about Sketchy's, one man in rural Denmark commented, "I wish I lived in New York. Nothing happens where I am."

This got me thinking. Why couldn't Dr. Sketchy's happen in Denmark? Or anywhere else, wherever there were artists and models? Why should anyone have to feel jealous about the scenes in other places, when they could create glittering trouble where they lived?

In a defiant mood, I wrote up a short list of rules for anyone who wanted to start a Dr. Sketchy's chapter in his or her city:

- *Treat your models well. Ravishing, interesting models are the foundations upon which a good life-drawing class is built. Show them respect. Pay them a good wage. Encourage artists to tip. Bring pillows and space heaters. Remember, models are stars. If you treat your models badly, the ghost of Kiki de Montparnasse will come back to life and beat you to death with a violin.*

- *Don't hit on models, creep out artists, or act like a jerk.*
- *Make a webpage, even a MySpace page. Exchange links with me. The Internet is our generation's Gutenberg. Without a website, you don't exist.*
- *Email me first. I am a megalomaniac who enjoys seeing her ideas reach fruition, and I want to keep an eye on you.*

I followed this with some basic advice on lighting, choosing a venue, and finding models. Then I posted the whole thing on the LiveJournal illustrators' community.

Before long, an apprentice tattoo artist in Melbourne emailed me to ask if she could run a Dr. Sketchy's at a local bar. Then I heard from an art director in Detroit.

Then a fourth person asked me. A fifth. A sixth. A zine wrote about Dr. Sketchy's. Two art students in Toronto read the article, started a branch, and hired a drag queen from Hamburg. She started the first branch in Germany. A theatrical producer visited it while on vacation. She started a branch in Sydney.

By the fall of 2006, there were twenty Dr. Sketchy's branches around the world. They were "branches" in only the loosest sense. Anyone could try. I didn't charge anyone money to host a Dr. Sketchy's, nor did I even interview potential hosts at first. Many people who requested Dr. Sketchy's branches gave up before even hosting their first class. Other branches, like the one in Melbourne, are still running nine years later.

Dr. Sketchy's spread with the burlesque scene. As burlesque festivals bloomed from South Africa to Zagreb, Sketchy's branches followed. People loved it because it provided a nonintimidating way for those who had once drawn to start again, and it introduced two communities, artists and performers, who had long been artificially separated. Its ethos was populist; it made people want to draw, and it dared some to live more bravely.

At their best, the Dr. Sketchy's chapters around the world awed me. In Paris, an American costume designer named Sorrel Smith produced elaborate tableaux vivants for artists to draw. On Bastille Day she styled

zombie aristocrats, their throats slashed by sansculottes. Dr. Sketchy's in New Zealand ran classes for female prisoners. After having acrobatic pole dancers pose for artists, Dr. Sketchy's Kansas City was raided by the vice cops. The branch came back only stronger.

As Dr. Sketchy's spread, media attention grew. "Expect to find clowns, glitter, pasties, swords, hula hoops, and more to inspire your next masterpiece," the *Village Voice* wrote. "As many varieties of depraved humanity as three hours can hold," said the *Phoenix New Times*.

Rip-off events came along with this attention. Every time I saw one, I sulked hatefully. *Mine*, I fumed, ignoring the fact that Dr. Sketchy's was the effort of many people and that being ripped off meant we'd changed the way things were done.

Over time, Dr. Sketchy's spread to Shanghai and Chile, Singapore, Johannesburg, and Peru. Eventually we had classes in one hundred and forty cities. After five years, I passed Dr. Sketchy's on to Melissa Dowell. And as I write this, it's spreading still.

The same December that I started Dr. Sketchy's, Fred moved into a loft in Bushwick. In all but name, I moved in with him. We slept on a foldout couch. His cat woke us up each morning by clawing its way across our backs.

When I wasn't at Dr. Sketchy's, I hung out at Fred's place and drew. I did T-shirt designs and a children's book about a boy who had collected all the world's raindrops. I drew logos for roller derby leagues, burlesque posters, and pornographic comics for *Playgirl*. I drew anything that got me paid. I grew better in slow increments, without ever feeling that I'd become good.

I wanted my drawings to be universes. I wanted to pack each page so full of life that it resembled a Bosch fantasia or a Persian miniature or *Where's Waldo*. I wanted each piece to be one you could stare at for hours and be rewarded. I never made detailed plans for my art, but started with doodles on the backs of envelopes—legible only to me. Then I rolled out

my paper and began making shapes with a mechanical pencil. I could feel it, when they were right. I drew lines on top of lines. They looked like scribbles, but behind them I could see a world emerge.

Then I took out my crow quills. I had two nibs. One was flexible metal, to create a variable line, the other a frail tube that made marks as thin as eyelashes. I started drawing a girl. No one looking at the page would have guessed her existence from the pencil, but I did. As I drew her face, it felt like peeling dried glue off your hand to reveal the skin beneath.

As the girl emerged, she told me what would surround her.

This wasn't donkeywork. It was ecstasy.

Everything had changed in my art. After years of helplessly watching my ink lines drag, I found that the pen had become an extension of my hand. Drawing was as addictive as drugs, as natural as breath. I could make any picture I wanted. This freedom dizzied me, and I drew compulsively, until not one more creature could fit on the page. I stared. The curls, the girls, the animals, the flowers. My eyes couldn't focus. The lines looked like lace.

If I needed to color the drawing, I poured some gouache onto a piece of foam, filled a jar with water, and sparingly dabbed my brush into the paint. I was scared of paint. I loved my lines too much and didn't want anything to overwhelm them. Slowly I filled in the piece, as if it were a coloring book, the hues raw from the tube. When I was done, I ran bright red along some of the edges to make them pop. I shaded in shadows with complementary colors so they would recede. Then I propped up the piece against a wall. No matter what else I had to do, my eyes would keep involuntarily returning. For the next day, that piece was my world.

In 2006, after I'd been running Dr. Sketchy's for six months, an independent press named Sepulculture Books messaged me through MySpace and offered to publish a Dr. Sketchy's book. I was so excited at the prospect of publishing my art that I didn't care that Sepulculture did not strictly exist, except in the mind of its creator.

Scott, Sepulculture's CEO, was an underling at a major publisher. But when we met, he seemed confident that he could revolutionize the book industry with his own side project. Who wouldn't want to be in on that? I signed up, bringing John with me.

John and I made *Dr. Sketchy's Official Rainy Day Colouring Book* together. It was a fragmentary thing, filled with drinking games and half-remembered art history gossip. Like us, it was maximalist, snotty, and occasionally clever, but it was the first cohesive piece of work either of us had ever done.

Scott told me he wouldn't sell the book through bookstores, or even through the major online retailers—these were old-world venues, and he intended to swashbuckle into the future. It didn't even occur to me to ask him how he intended to sell the book until perilously close to the release date.

He paused nervously. Then he summoned the masculine chill I later learned could conceal vast reservoirs of fail.

"My friend's band is playing a show next month," he told me. "I thought we could sell it on a card table afterward."

At that moment, I realized any hope that book might have would be up to John and me.

I started a death campaign to sell out the small print run. I set up a launch party, then a signing at Bluestockings, the Manhattan feminist bookstore. I took the Chinatown bus to Boston with a backpack of books, walking in the snow from comics shop to comics shop. I begged for interviews. I sold copies off barstools after my burlesque gigs. I held my head up and grinned hard and pretended that I was scrappy and that this was fun, but in my heart I believed that if I was any good, I would have a real publisher that took care of this for me.

John attended signings and made cocktails, but selling the book took over my life. I begged him to work hard with me, but John was in Baron von Fullovit mode, busy trying on the new bespoke suits his wealthy boyfriend gave him.

One night, after a signing, I asked John to do some more book drudgery. He stormed out. The next day, he emailed me to explain himself. "You have really got to stop resenting people who aren't as productive as you," he wrote. "Do beware of 'life is permanent warfare,' as Umberto Eco said. It will stunt your work."

It was a while before we spoke again.

C osette was another model for the SuicideGirls who quit in the fall of 2005. She was a stunning, muscular woman with ice-colored hair twisted into spikes—a tanned punk Barbie who looked like she could punch. Unlike me, Cosette had few political motives for leaving SuicideGirls; she just thought it was a good time to go.

In early 2006, Cosette and I agreed to meet in person at the opening of an underground gallery. Amid the chopped-up robo-chicks and paintings done in the artist's blood, I recognized her at once. We were both shrink-wrapped in black, our portfolios in our hands, hustling as hard as we could to force the curator to acknowledge our existence. We were two sex worker shards washed up on the art world's shores, and everyone legit was trying to kick us back out to sea.

"Molly!" "Cosette!" we cried, hugging each other and pawing through each other's portfolios. I'd made mine myself on my living room floor; its corners were bent, and there were thumbprints on several reproductions of my drawings. Hers was expensively printed. The first image was a painting of a lily, running with perfectly rendered drops of blood.

"You're amazing," I told her sincerely. "I usually hate it when people I like say they're artists, because they're always awful but I have to lie to them and say they're good."

"I know what you mean. I hate people who can't paint and front like they can. I busted my ass for this. I stripped all through art school. All I want to do is paint."

I stared into her eyes. They were cold blue, framed with swoops of liner. She had high cheekbones, full lips with dimples at the corners, and acne-scarred skin she covered with thick foundation.

"We're so alike," I marveled.

"Um, sure . . ." she said, looking away.

Cosette spoke with a South Philly rasp, tough and warm. She'd run away from home as a teenager, dancing in peep shows, squatting, getting tattooed, begging for change on Saint Mark's Place with the crustpunks I used to worship. By the time she was nineteen, she was showing at galleries. Cosette was built like a cartoon sex symbol: a stylized figure eight that makes the wolf scream *va-va-VOOM*. When she danced she was Pam Anderson–perfect, as long as she hid her tattoos beneath her gloves. After Giuliani closed half of New York's strip clubs, the remainder became as competitive as the Bolshoi, but she could still net a thousand bucks a night.

Cosette always fell for the worst guys—including one who had a tattoo of a woman with two black eyes, in front of crossbones, over the legend "You already told her twice." During art school, an abusive boyfriend stole her money, she ended up back in Philadelphia, showing oil paintings in upscale galleries, oil wrestling for money at bars. At twenty-four, she bought a dilapidated house.

Cosette borrowed her aesthetic from 1992. She wore platforms and PVC miniskirts showing off her dancer's legs. Her best friends were dealers, tattoo artists, and party promoters with cerise dreads who hired her to go-go dance at their raves. Between the drugs and the men, she lived in chaos, but her art was her ballast. No matter how wrecked Cosette got, she staggered to her easel every morning and picked up her brush.

Cosette could paint with such liquid beauty that I wanted to gouge holes into my arms. She painted like an Old Master, blue mists layered with a patience that was indistinguishable from torture, every eyeball limpid, every hair defined. She forced her damage back into those paintings. Cosette painted dicks bound with diamond rings. A woman's foot, its pedicure shining, nailed into a Lucite heel. When we started showing together, collectors would jump for her work, while mine hung ignored on the wall.

Cosette was no frail flower: she'd beaten many boyfriends into mash. When she told me these stories, my stomach sank, but they thrilled me too. I hadn't hit anyone since I was thirteen, and even that had been part of a ritualistic white-girl slap fight. When men screamed at me on the street, I shrank back, knowing I was helpless. We love the violence in others that we cannot do ourselves. We imagine what it would be like to be that brave.

Cosette and I soon became inseparable. I took the Chinatown bus to Philadelphia and sat in her crumbling house, listening to her tell me about strip clubs and drug dealers. We went to shows together, delighting when we could get on VIP lists. We talked endlessly about feminism, beauty, and art. Cosette ran painting ideas by me, elaborate plays on vulnerability and artifice.

We told each other our fears as well as our desires. "I think I have nothing in me but the ability to work," I said one night during an hours-long phone call. "If I got cancer, everyone pretending to like me now would abandon me."

She assured me this wasn't true.

We were women in public, and that meant stalkers found us. Some guy fixated on MySpace photos of me walking on glass, and messaged me obsessively, asking about my feet. I blocked him. He sent me an ejaculation of death threats: dozens of emails with variations of "FUKKKKKK BITCHHHHHH DIEEEEE ON BRRRRROKKKEN GLASSSSS."

I ignored him. Cosette harassed him till he quit the Internet. "This kitten has claws," she wrote on MySpace.

I loved her for hitting back.

Soon, Cosette was splitting her time between New York and Philadelphia. Her home was there, but in New York were all the artists and curators and press—the whole hissing, biting, kicking world we meant to conquer. Also, New York meant money.

One night Cosette invited me to a hotel bar to hustle guys for drinks.

"I don't want to drink that much," I told her.

She scowled with disgust. "You're missing out. When I worked with another girl at strip clubs, we always made so much more money. You and me could be such a good team, too. Blond and brunette."

We never made it to the hotel bar. Instead, we lay curled next to each other in my bedroom, planning shows we'd paint, the galleries Cosette would run, a magazine we could publish together to promote female artists.

"Why should I feel bad for using my looks? Or the fact that I'm a woman?" Cosette asked. "Think of all the things I *haven't* gotten because I'm a woman."

Despite our ambition, we had almost no entrée to the New York art scene. There, art was a hobby for trust-fund kids. The road to getting a gallery started with an MFA from a prestigious school—preferably Yale—which would cost you around fifty thousand dollars. Tack on a staggering sum for studio space. In New York, money was the silent grist for the creation of art. To talk about such things was to cheapen

oneself as an artist. But the system was there, subtle and undeniable as a wall.

I woke up the next morning and made Cosette coffee, Café Bustelo in a stovetop pot.

"I need a sugar daddy," she sighed. "Why can't I get a rich guy?"

"Your voice is too low class," I told her. Cosette and I told each other everything. We were so close that we used the toilet in front of each other. We admired each other so much that—as if to avoid being entirely swept up into each other—we started to let a bit of poison creep into our friendship. We used words to wound the other in the places we knew it hurt most. (I was wrong about her voice: when she did temporarily land a wealthy man, her voice was one of the things he adored.)

I had a burlesque show that night, debuting a new act. It was ill-rehearsed and identical to all the old ones, but a friend who worked fashion parties had saved me two veils from the trash. I shimmied through the number for Cosette as she lit a cigarette. I ended it with a flourish, pulling off a glove I'd filled with glitter, sending a cloud of starlight into the room.

Cosette grinned for a second, impressed.

"That's a good trick," she said. "I could do burlesque if I wanted to. Burlesque is basically stripping for fat girls."

Backed by a rich guy, Cosette opened a gallery in Philly. She quit stripping to focus on curating shows. In celebration, I drew a peep show booth from the dancer's point of view.

A friend who worked at a peep show told me it was a game among dancers to convince customers to lick the windows. "Lick me through the glass," they'd whisper. "It would turn me on *soooo* much." Clients did it, ignoring the crust of other men's semen—a peep-show version of the Vaseline on Hollywood's camera lens.

In my drawing, Cosette and three muses gathered in the booth. The muses gossiped around the pole. The peep show curtain was sliding open. Cosette was walking out of frame, her wig dangling off one finger. She was smiling.

Cosette gave me a solo show at her gallery.

It's not like I hadn't hung any work since that ill-fated night at the Rain Lounge. My work had been exhibited in group shows for years, and I'd thrown more successful DIY endeavors at hookah bars and comics shops, but this was different. It was a solo show in a real gallery, with all the legitimacy that implied.

My style was developing. I couldn't make a straight line, but it didn't matter. My pen swooped for curves, dove and sang around swirls. My hand moved naturally to delineate dancers' breasts and bellies, their lips and thighs. I gave them high Marie Antoinette wigs, each curl lovingly detailed, and goyish pug noses. My dancers were both cartoony and highly rendered, like a nineteenth-century American advertising poster from the era before illustrators got the hang of it. Mine was not a style that would generally be recognized as "fine art"—but then, the divide between fine art and illustration is for critics, not the people who deal with the mess and dross of creation. It also ignored history. Toulouse-Lautrec designed posters. Dalí did a cookbook. Michelangelo's Sistine ceiling illustrated the Bible—and served as PR for the mass murderers then running the Vatican.

I wasn't yet confident enough with color to leave it to its own devices.

Instead, I scribbled on scrap paper with watercolor pencils, wetted the scribbles with my brush, then stroked the candied pigment neatly across my inks. They were still so far from what I wanted, but I was getting closer. When I hung the drawings, they seemed like crude little things, staring back at me from the gallery's walls. Feather-clad homunculi, malformed but proud.

An hour before the opening began, Cosette and I took a picture. I wore a schoolgirl skirt, Mary Janes with platforms, and skull barrettes in my hair. She wore a tight black dress. She'd tried to hire an up-and-coming alt model named Stoya for the job. When Stoya got sick and couldn't make it, Cosette left her screeching cell phone messages, swearing she'd never work again on the East Coast.

We look so young in that photo—glittery trash angling for respectability.

I hoped against hope to sell out the show.

One piece sold, earning five hundred dollars for the two of us.

Cosette and I showed work in galleries that were labeled "lowbrow" by some, "pop surrealist" by others. The style was a blender, stirring together tattoos, comic books, hot-rod art, big-eyed girls, and cartoons. Looking at these paintings was the visual equivalent of gobbling ice cream with all the fixings. They were lush, bright, meticulous, funny. *Juxtapoz* magazine was the bible of the scene.

Pop surrealists painted with lustful detail and a blue-collar level of craft. They had often started as illustrators, though many hid this background; galleries considered illustration low-class. Some were little more than ponies repeating a sole, tired trick, but at their best, pop surrealists beautifully deconstructed the culture that had shaped them.

One of the scene's top painters, Travis Louie, mentored many young artists, myself included. He hung my work in shows he curated, and taught me tricks with acrylics, pencils, and washes. A Chinese American artist who grew up working-class in Flushing, Travis had a thick Queens accent and grease burns up and down his arms, proof of the time he'd spent working in restaurants.

Travis painted monsters. But that trivializes his work. His paintings were daguerreotype gray, with pencil and paint mixing as delicately as fog. His creatures posed with intense dignity in Victorian outfits—as his grandmother once had at Ellis Island, when the Chinese Exclusion Act was lifted and she was permitted to come join her husband in New York. In her best dress, she waited to be photographed, cataloged, and renamed. To be remade, by an indifferent bureaucrat, as an American.

Travis signed his paintings in Victorian script. At a decaying Hester Street restaurant, he tried to teach me to write in this style, coaching me to press the pencil deeper when I wanted the lines thicker, then hold it lightly when I wanted them thin.

He waited patiently, then took the pencil from my hand and signed his name.

His letters were fine as spiders. They looked like they might crawl away.

After a few months, Cosette's gallery began to falter. Her shows didn't earn much money, and her backer was getting frustrated. To calm herself, she smoked heroin after-hours. I told her she should move to New York full time.

Moving into a cubbyhole in a hipster flophouse in Bushwick, she got a job filling in paintings for a pop surrealist painter, doing all the meticulous detail he was too famous to have time for. We showed together in small Lower East Side galleries, and dressed carefully to go to bigger art openings at white-cube palaces like Opera. We wondered why those galleries didn't show us.

"I'd rather whore out my body than whore out my art, I always say," Cosette told me as we painted our lips in the bathroom of a Fancy Gallery.

"I don't want to be just pretty. Too many girls can be pretty," I responded. "I want to be Hollywood perfect, so I always look good in photos."

"Yeah, guys will fuck anything. The point is to be media hot," Cosette said, then asked me what plastic surgery she'd need to achieve that.

I thought for a moment. "A nose job," I offered.

"Fuck you." She scowled, then continued. "I know I need a nose job."

"What do I need?" I asked, hoping to restore her smile. "I need a nose job too."

"No, no! You need a boob lift and some liposuction."

I gave my hair a nervous pat as we left the bathroom. Backs straight, our bodies presented in tight black dresses. We needed to be noticed. We opened the gallery's glass door. The room was hot white and packed with humanity: women whose frail shoulder blades poked from their designer sacks; tattooed rich boys pretending to be poor; a famous comedian; collectors holding price lists; the artist's shy father; the artist herself, a tall redhead with cupid's-bow lips.

Her show consisted of tiny pencil portraits of women. Each perfect. Each polished. Each a mirror of the last, meaningful mostly in repetition. But only a puritan demands that art have something to say. The pieces were in elaborate frames, spray-painted white, dust and spiderwebs caught by the paint. Besides a few collectors, no one looked at the paintings.

"Let's grab the *Juxtapoz* photographer," I said.

We snapped into our kabuki pose for the camera: lips parted, chins lifted, backs arched, tits thrust forward. With the right muscular configuration, we could be perfect.

Cosette and I sat in Lit, an East Village dive bar with a gallery in the back. I was sandwiched between an art journalist and Louis, a curator I wanted to work with. Cosette massaged the journalist's knee. The bar was blood dark, the walls covered with graffiti and band stickers glazed with beer. I couldn't hear anything over the music. I wanted desperately to leave. *It's good for my career to be friendly with these people*, I told myself, smiling hard.

*If I can just sit close enough, long enough—if I can tolerate enough of these nights—eventually they'll like me enough to put me in shows.*

I forced myself to stay.

Cosette cut me with her brilliance. The eyes she painted were gray, clear, and bloodshot—I could fall through the wood panel into her world. But for women, talent was never enough. Cosette had talent, but she got most of her shows by charming people.

I felt neither brilliant nor charming. No matter how long I worked on a piece, I saw only my defects: the cartoon lines, the hands like flippers. Every time someone insulted my work, the words looped through my brain.

I kept drawing anyway—by now I knew I had no other choice—but if I wanted to keep making art, I had to win the favor of the gatekeepers of this world, like the one sitting next to me. *How do people do this?* I thought. *What do you say?*

"Did you see the John John Jesse show?" I screamed.

Louis moved closer to me. My heart leapt. A month before, he'd put me in a big group exhibit upstate, but my piece hadn't sold. Maybe, if we could talk like humans tonight, I could redeem myself.

"I have a question," Louis said.

*He wants to know about my art! I'm going to get a solo show! I'll quit modeling and draw full-time and curators won't snicker that I'm a whore. I will be famous!*

"Are your tits real? 'Cause everyone says they're fake."

I forced myself to laugh.

"When you're thirty," he continued, "you'll be really ugly. Your boyfriend will leave you. But I'd still fuck you."

I tried to smile again. I wanted to look chill. I wanted to be the cool girl who could take a joke just right. *Cool girls get shows. Uptight bitches don't.* I would never get a show by telling a curator to stop talking about my tits.

I inched toward Cosette for protection. I didn't want to sleep with him, but it might hurt me more if I didn't. If you reject a powerful man, you can end up blacklisted. The man wouldn't see it like that, of course. He'd

just feel awkward and stop inviting you to important parties. Then where would you be?

*Better to force a smile. Save the hate for later.*

Whenever an eminent man is accused of sexual harassment, a flood of new allegations appears. The media asks why the dozens of women he harassed didn't "come forward" until that first case made the news. I remember that curator. If I'd complained (where? MySpace?), the art world's ranks would have closed around him. I would have been accused of leading him on. "What did she expect?" his peers would say. "She was drinking with him. She was using her looks. She was asking for it."

Coming out against the powerful can render you powerless.

But I remembered. Years later, drinking whiskey with younger women, I'd listen as they told me about the bosses they had to push away—all those drinks, all those nights when they walked the tightrope between avoiding having to sleep with a powerful man and avoiding hurting his feelings so he wouldn't destroy them. It gets better, I tell them. You get older. You get powerful. Men get afraid. But it takes a lot of nights to get there.

*Smile. Keep a list for later.*

The next morning, I called Cosette and told her what Louis had said. He'd never speak to famous female artists that way, I fumed—the kind who showed with Fancy Gallery Owner, beauties with white-blond hair and tattoos up their slender arms. Louis wouldn't dare insult them. They had power.

"He probably thought you were into it," Cosette said. "Your boobs were hanging out of your shirt."

Louis was sheepish when he saw me at the next opening. As an apology, he stuck me in a few group shows. He never gave me a solo.

"I'm doing a show of young female artists," he told me once, as I came

to collect my percentage from a piece of mine he'd sold. We sat in the gallery's back room, where he counted out my hundreds on his desk. The curator rattled off the names of the female artists he'd chosen—all of them very young women who painted girls as fragile as he imagined them to be.

"I'm a young female artist!" I cried, still hoping to force my art onto his walls.

"Not like them," he said, handing me the bills.

I was twenty-three.

"I want to try cocaine," I whispered into Cosette's ear. Coke was omnipresent, and I felt ludicrously innocent never having done it. I wanted to check off that experience box.

We were sitting in the corner booth at Lit, where she'd dragged me along to keep her company on her date with Famous Gallery Owner.

"Oh my god, this is your first time!" Cosette beamed, then turned to her date. "Babe, get Molly some coke!"

We piled into the graffiti-encrusted bathroom. The gallery owner cut three bumps on the back of the toilet. We each did one. I lowered my head. The line vanished. Bitterness bled down my throat.

"Clean your nose," he ordered. "You don't want to look like a"—he drew it out—"*coke whore.*"

In Lit's back gallery, we met up with a graffiti artist who'd tagged trains in the 1970s. He was just back from a commission tagging Louis Vuitton in Paris. I clenched my teeth, awake and electric. I would have given anything not to have to speak.

"You're the only one who doesn't talk talk talk when you're on coke," Cosette gushed. "Want another bump?"

I shook my head.

The next morning I woke up barely able to move, my throat burning and my head stuffed with chemical snot. "Coke flu," Cosette said with a laugh.

After she moved to New York, Cosette's drug use became more obvious. New York tolerates only fuckups who have trust funds to back them up.

One night, curled up next to me in a booth at Lit, she asked if I wanted more coke. Ever since I'd tried it, she wanted nothing more than to do it with me again. At first I thought she was joking, but then she started going from one Lit patron to another.

"Do you like to party?" she rasped, her words slurring from whiskey. "I mean, snow. Party."

"No!"

She whirled around, almost falling.

"Do you like to party?"

"You already asked me!" the man snapped.

I scooped my arms around her tiny waist, and pulled her outside onto the curb. The cold wind slapped us awake.

"You need to be more discreet," I hissed.

A cop car blinked across the street.

It never occurred to me that we might be arrested. More than half the prison population is in for drug crimes. But blonds don't get stop-and-frisked.

"I fucking know how to score coke!" Cosette shouted, storming back inside.

When Cosette was sober, she was deeply charming—tough and vulnerable at once. She got another job in New York, running a gallery for a famous tattoo artist. She started making friends with better-known pop surrealist painters, even posing for one who was renowned for the organ-red lushness of his canvases. She arranged solo shows in LA. Her paintings sold as soon as she hung them. But the more she succeeded, the more she ricocheted between depression and rage, and the more she resented me for my comparative stability.

One night, Cosette begged me to go with her to a book launch at

Lincoln Center, for an art book by a painter with whom she worked. The crowd was filled with all the artists we knew. As the night drew on, she drank more and more free wine. She clung to my arm for balance. Her nails dug into my shoulder. I was suddenly exhausted.

"I've got to go home," I pleaded with her.

She looked at me with betrayal. *"Nooooo,"* she whined.

"I'm really going," I said, shaking her off. I staggered toward the door. I'd been drinking too much myself.

She followed me outside onto the street.

"Fuck you!" She was hunched over, pointing one black nail at me. "Fuck you, you fucking fake. You look like a drag queen. Everyone just laughs behind your back. You just want me to get raped." She staggered down the block, like a doll whose joints had been loosened. I watched her get smaller.

I bit my lip, hard, and flagged a cab.

I wrote Cosette an email saying we couldn't be close friends anymore. It was a prissy, middle-class note, filled with *I care for you*s and *I wish you the best*s, and I cringed as I hit Send.

She wrote me back instantly. Our friendship wasn't working for her either. We came from very different backgrounds, and in hers, abandoning a drunken friend was a betrayal, far worse than standing outside an event screaming insults. "I'd rather be punched in the face than in the back," she wrote. And yet she insisted that she wanted to preserve a "business relationship" with me. "I know that sounds cold but I know you feel the same way—we are both women that will put our careers over emotions." She promised always to be nice to me when we saw each other in public, as we inevitably would.

I spent the rest of that day in bed. I admired the email she sent, and that made the end of our friendship hurt all the more. I remembered how she

looked when she painted. All the world's compulsion, its beauty, its redemption and pain, were hidden in her panels, until with brushstrokes she coaxed them out. I remembered how we walked through Philly at night. She grabbed my arm. Her strength made me brave.

Cosette was so talented, so strong, and, sometimes, so true. I remembered standing in the cavernous darkness of a gallery's bathroom, painting on our new faces. All the kindnesses we'd given each other, now lost. Then I remembered her shouting at the receptionist who had done nothing to deserve it, and how kindness can be a fleeting thing.

I hauled myself over to Fred's drafting table. I unrolled a three-foot piece of paper. I started to draw. I drew hundreds of tiny girls, piled atop each other—each of them a stylized, eyeless self-portrait. As I drew, I imagined myself picking scabs. Beneath them would be new skin: pink, shiny, and smooth.

It was a few months before I had the courage to start going to art openings again. Cosette's job as a curator, and her friendships with influential artists, established these openings as her world. She started showing Fred's work at her gallery, but I couldn't even bring myself to attend his events.

Fred finally got sick of my hiding. "Dress up," he ordered, and he hauled me into Cosette's gallery. She stood in the room's center. She looked the same, coldly beautiful, her platinum hair spiked, her waist wrapped in black. Despite her promises, I feared a scene.

I shouldn't have worried. There was one thing that Cosette cared about. It was what I cared about. We'd be artists, do or die.

I met her eyes across the room. I walked up to her.

"Cosette!" I cried.

"Molly!" she answered.

We air-kissed. Our smiles were hard and false.

hen Julian first shot me for SuicideGirls in 2003, he pointed out one of the models in his photos. She was a blue-haired girl, dressed as a peacock, raising her arms as if to fly. "That's my friend Amber Ray," Julian bragged. "She's the most famous burlesque dancer in New York."

If a woman's power is her capacity for self-creation, Amber Ray was woman extreme. Amber's corseted waist was impossibly narrow, her eyes impossibly wide, her body as stylized as a *Playboy* drawing, surreal even beneath her elaborate costume.

I saw Amber again in *Heeb* magazine, smirking in fascist dominatrix gear. Then on LiveJournal, with her husband, Muffinhead, wearing suits made of hundreds of stuffed animals. She was a different woman each time. In

costume, she was a butterfly, a peacock, a golden god. She was Ishtar and Betty Boop. Her wigs towered. Her lips made a hot pink moue. She was everyone, all at once, the whole spectrum of female existence. She was unrecognizable. She was herself.

Over the years, Amber and I brushed against each other in New York's art underworld, and she once did my makeup for a shoot in LA, but it was backstage during the last days of my burlesque career that we first had a chance to speak. Most bars' backstage spaces are cramped, with eight women leaning over one another for a slice of mirror, and the one at the Slipper Room was no different. Though chaotic, backstage was Amber's chrysalis. As she rouged her cheeks, she raised up a shield of unapproachability. She looked like she'd eviscerate anyone who interrupted her, so even in those tight quarters, other performers gave her berth.

By the fall of 2005, I drew so much that I could barely summon the effort to prepare for gigs. Amber sneered at my costume bag, a plastic shopping bag disgorging wrinkled capes and stockings. She kept her gowns neat in garment bags.

I eyed my G-string skeptically. Half the sequins were missing. The stage manager was panicking because the CD I'd given him wouldn't play.

"You should try looking through your stuff before a gig, to make sure your costumes are in one piece," Amber said, rolling her eyes.

Fair enough, but I barely had the time. "I think you and I know someone in common," I offered, changing the subject. "Cosette. She said she knew you in Philly?"

"Oh, her. Yeah, we had some friends in common. What a crazy bitch." Amber's lips parted into a mischievous smile. For a second, she looked six years old.

Then it was showtime. Amber walked to the curtains with a queenly slowness. I peered through a gap. On the center of the stage sat her most elaborate prop: a girl-size, crystal-encrusted lotus. She stepped daintily into the center. She knelt, pressed a button, and the lotus began to spin.

The curtains parted. She emerged, plush and pearly. Her eyes narrowed in joy.

I asked Amber to pose for Dr. Sketchy's. She came dressed as a clown, cloud white, crying rhinestones, petticoats high on her thighs. Seeing her model in such finery for thirty-odd artists showed me what Sketchy's might be. Afterward, I helped her carry her bags to her apartment on the other side of the BQE.

Amber lived with her husband on the fifth floor of a tenement, at the far end of a chipped marble staircase. Inside, the apartment exploded with costumes. A headdress shaped like the solar system dominated the kitchen table. Glitter coated each planet. Her multiple Golden Pastie burlesque awards lined one bedroom wall. Wigs teetered upon wigs, and boxes of paste jewelry stood stacked in towers. She draped her bunk bed in brocade. Whatever space wasn't taken up with makeup belonged to biographies of dancing girls: *Memoirs of a Showgirl* by Shay Stafford. *My Face for the World to See* by Liz Renay.

Then Amber told me how she came to be Amber Ray.

Amber grew up working class, raised by a single mom in Wisconsin. She worked as a hotel maid, as a stripper in Milwaukee and Philly, then as a dominatrix in New York. She never went to college, but she educated herself on the theory and practice of show business. Tweaked glamour was her addiction: she loved *Pee-wee's Playhouse*, Carol Burnett, *The Rocky Horror Picture Show*. She started styling herself to go to goth clubs, wearing kabuki masks, butterfly wings, black-light paint in designs drawn from horror films. When the burlesque revival hit, she became one of its first rock stars. Soon the broke club kid was flown to Montreal to perform for the notorious fashion designer Thierry Mugler.

By 2005, Amber was still broke, but she was also an ornament of New York's haut monde. She attended private dinners thrown by fashion designers, and museums hired her to show up at galas dressed as a butterfly. The guests at these events were mostly executives, but Amber supplied the style. As long as she was there, they could forget that people like Amber were being shoved out of New York by people like them.

She told me all this while wiping off her makeup. Beneath the paint she

had a round, wholesome, eyebrowless face. Her hair was thin, scraped into a sand-colored bun. She put on a pair of sweatpants, then took out a tackle box full of Swarovski crystals. As she spoke, she removed the Swarovskis one by one with a pair of tweezers and glued them onto a corset.

As I watched her skillful hands, I never wanted to leave her apartment.

Amber produced a burlesque tribute to Cole Porter at Galapagos. She hosted, of course, peeling herself out of a tuxedo while singing "Let's Do It." She invited me to dance, more out of kindness than anything. She even offered me two feather fans she'd manage to rescue from the trash after a party. To impress her, I sewed my costume extra carefully—a belly dancer's blue beading, blue satin gloves. I laid it out for Amber. She was not impressed, but not obviously disappointed either. "My little weirdo," she cooed, tugging my hair.

She ran through my number with me over and over. I always missed my cues.

"Raise your arms here!" she snapped.

I threw my arms up. My fans knocked over her lamp.

On the night of the show, Galapagos was as black as a womb. A girl ate fire in the reflecting pool. We huddled in the unheated backstage while Amber swanned around in front, her dressing gown dripping marabou, charming one older patron after another. She had a stable of patrons who'd take her out for expensive dinners. There was no finer arm candy than Amber Ray.

I finished my act, and the stage curtains closed. I stared at the floor. It sparkled with glitter fallen off a thousand other girls.

All through this time, the image of curtains kept reappearing in my art. They marked boundaries of space, of truth and falsity, of time. But at that moment in New York, they suggested the barrier between *us* and *them*—between underground artists and the patrons who had money to give them. The curtains were always black, heavy, and seemingly impenetrable.

Now and then, in real life, they parted. The burlesque dancer Darlinda Just Darlinda showed up to a Deitch Projects opening wearing nothing but a mink coat and body glitter, her lips organ red. Her costume was a visual nod to Anita Berber, the notorious Weimar dancer who loved to show up naked at parties, mink slung over her shoulders, monkey on one arm, locket of cocaine around her neck. Two girls in thousand-dollar shoes stared at Darlinda, their eyes daggers behind fishnet veils.

The performers I knew were poor. For a while, Amber had worked cleaning hotel rooms, though she cheered herself up by fetishizing her own uniform. These performers had no health insurance, no savings, and no stability. They darned their stockings while their apartment ceilings caved in. They risked getting chucked out of New York the moment the rent got too high. Yet with sheer style, they made themselves the center of attention in rooms that they'd never have been allowed to enter without their personas. They smashed through, armed with little more than will and window dressing.

But their acts ended, as acts always do. Afterward, the curtain closed again.

Every Christmas, Marc Jacobs's production company hired New York's spangled weirdoes to attend his Christmas party. My friends hung out in scanty theme costumes, serving as wallpaper for the real guests. The gig paid three months' rent. This year, the party's theme was "the Orient"—an ersatz mix of Egypt, Venice, and Hollywood. Marc hired Amber to create costumes for the occasion: hundreds of ruffs, codpieces, and chiffon face veils. Collapsing with sleep deprivation, she begged me for help. My task? Ironing ruffs. Each bit of lace had to be arranged into dozens of

precise folds, like an accordion. I ironed them crookedly, burning both the fabric and my hands.

"What are you doing? This is awful!" she screamed, yanking the lace from my hands. I tried cutting fabric for her instead, but I'd never learned to hold scissors properly, and I ruined the expensive brocade. Amber just shook her head. "How can anyone manage to hold scissors wrong?" she said with a sigh.

After that, more dexterous performers did her ironing. I was exiled to tea.

At the party, Marc showed up dressed as a camel's toe.

Amber had booked us to model for a party hosted by the restaurant Nobu. I spent the day trailing her around Times Square accessory shops. Rain soaked us as she ran from store to store, assembling the paste jewelry and feathers that would effect our transformation. She bought me shoes that, despite being my size, pinched immediately. At the party, the guests were mostly Japanese, mostly in sweatpants. *They must be billionaires to dress like that at a Nobu party*, I thought. *Look how few fucks they give.* It turned out to be a holiday party for the kitchen staff. We slunk like chimeras, handing out fake money for a pop-up gambling parlor. To pass the time, Amber sweet-talked the cooks into doing one-armed push-ups, bribing them with the money we were supposed to give out for free.

The next night, we danced go-go dressed as Bettie Pages, then shoved dumplings in our faces in the neon Chinatown dark.

Amber worked a birthday party thrown by a fashion publicist who had lost a hundred pounds. He called it "Half the Man I Used to Be." She invited me along. Two burlesque stars sat on pedestals, naked, forcing cannoli after cannoli into their mouths. They were so blond, their curves so opulent. They licked the cream from their fingers as starving PR girls stood nearby, staring. Was it with disgust or envy?

We worked another party alongside Ruby Valentine and Dirty Martini. Amber styled us all as showgirls: corsets, sequined Thai bikinis, feathers

slung about our hips. We squeezed our asses into beige fishnets and wore heels that pinched.

Amber painted my eyes with white and black, drag-queen style. They looked giant from afar.

Supposed object of desire myself, I had only two desires: to sit down, and to scratch beneath my wig with a chopstick.

"You're the spirit of joy," Amber hissed at me, as we minced onto the glittering rooftop. "*Smile!*"

The host ordered us to give out trays of classic candies. It was a Sisyphean task. The South Beach Diet had just hit, and the fashion girls shrank from the carbs. The host stared with disappointment at the garbage bags of treats he'd hidden in the basement. "Make them eat more!" he demanded. Starving, I gobbled handfuls, hiding behind a fern.

After the party, we piled in a banquette around Patrick McDonald. An old New York eccentric who'd been embraced by the fashion industry in one of its rare good turns, McDonald wore his Savile Row suit, shellacked hair, and beauty mark. We angled our boas. We kissed, we cooed, we feigned our joy. *Click click click* went the Getty cameras. A woman finally took one candy cigarette, holding it to her injected lips. The lights of the city shone in her lip gloss. All I wanted was to take off my shoes.

Amber taught me that glamour is armor. With feathers and bling, the queer, broke, and brilliant rigged themselves for battle. Glamour was rebellion against the role society prescribed for you. A rich kid in the same

costume would bear the same relation to Amber that a plastic Halloween sword does to Excalibur.

But those rich kids paid our bills.

We worked an absinthe party at the Bowery Hotel. There were flip-book makers and a girl turned into a candelabra, clad only in melted wax. I dashed off portraits. Amber stood on a podium, swirling blue fans, wearing her peacock dress. But all that art was for the benefit of a bunch of drunk liquor executives.

Reeling with exhaustion, we ducked into the back room to peel off our painful costumes. A buyer staggered in. He leered as Amber undid her corset. I tried to puff myself bigger. "We're changing!" I wanted to shout, but my voice came out a squeak. He stayed, his face blank. Why were we protesting? This party was for him.

Amber and I flew to Las Vegas for Miss Exotic World, an international burlesque competition. Women with names like Kalani Kokonuts and Immodesty Blaze spent thousands of dollars on costumes, and they planned acts that might begin with them descending from the stage in golden wings, then jumping through gymnastic backflips, blinding the audience with crystal and tulle. Amber was performing, and I was running a Dr. Sketchy's.

Though she was broke, Amber bought a lavish history of burlesque at the Miss Exotic World bazaar. It included several photos of her own performances. I leafed through it while snacking on potato chips. Crumbs fell into the book. My greasy thumbprints marked up the pages.

"Oh my god, you animal, what are you doing? That's my history!" Amber shouted, grabbing the book out of my hands. She wouldn't speak to me for the next hour.

What a history it was.

In 1955, the burlesque performer Jennie "the Bazoom Girl" Lee started the Exotic Dancers League of North America. At their first meeting, the

nine assembled dancers threatened to strike over low pay. The league developed into a cross between a labor union and a social club, and Jennie kept throwing reunions for her colleagues. But the league had another purpose: to preserve burlesque's fragile history. Jennie began to assemble the art form's flotsam—G-strings, fans, show programs—finally moving them to a forty-acre goat farm in the Mojave Desert in 1980. She planned to build a museum and even a place for impoverished dancers to retire.

She dreamed of calling it "Jennie Lee's Miss Exotic World."

It took cancer to stop Jennie Lee. During the ravages of chemo, her friend and fellow exotic dancer Dixie Evans moved into a trailer on that goat farm to take care of her. After Jennie died in 1990, at sixty-one, Dixie decided to throw a pageant to bring attention to the burlesque museum. She sent out press releases, promising a reunion of the greatest burlesque performers in the world. The first year, it was only Dixie and the cameras.

But that press was enough. The next year, the pageant exploded. As the burlesque revival caught fire in the 1990s, young dancers seeking their heritage flooded Dixie's trailer, posing in boas in the California desert. The pageant moved to Vegas, where Dixie celebrated her former colleagues. Some were legends, like Tempest Storm, Tura Satana, and Satan's Angel. Others were forgotten, earning their livings now as craps dealers or nurses. Others were unemployed or disabled. These were tough women, working-class, some with criminal backgrounds. Some started dancing naked as early as fourteen. They fucked celebrities and clawed fortunes in vaudeville's less-reputable sister industry, only to be discarded as soon as their scars started showing on their faces.

Conventional morality would try to convince us that these women brought their hardship on themselves. Glittering hussies are expected to end up broke, alone, and preferably stricken with some disease—their punishment for flouting society's dictates.

Exotic World proved this was a lie. The year we attended, dozens of retired dancers stood under the lights, evening gowns clinging to their small, wrinkled bodies. Some danced. Others just told us about their lives. They spoke about hootchy-cooch tents and Cuban burlesque halls; about sleeping with Elvis and dancing with Duke Ellington. They told us about the 1970s, when strip clubs supplanted theaters. After that, drugs and stage fees destroyed their industry. The women had frank, rough voices, and a raw charisma that showed what performers they must have been. When Tai Ping, who once stripped at the Follies Burlesque Theater, took the stage in a wheelchair, forcing her words out with great effort, the young dancers applauded her wildly.

Miss Exotic World was an act of cross-generational solidarity. The

women onstage, torn by time, were pioneers for us younger women in the audience. Saluting them was the least we could do. In the sex industry, we were all we had.

On the last night at the pool, Amber Ray danced to "Malagueña Salerosa," "the girl with the rose-petal lips." She wore layers of black and crimson, and held a bouquet of roses in one hand.

As Amber stripped, she smashed the bouquet against the floor. She beat it against her body. She deep-throated the roses. She tore buds from their stems and threw them at the audience. She bit into the flowers, then spat the petals from her dark red mouth.

I watched her dance and saw a grace I'd never have. Like all these dancers, she was an icon. I was something else, something watchful and silent—not a performer but a spy.

After Amber finished her act, I ran to her and told her how wonderful she was. She wasn't in the mood. She had put everything into the performance. The audience had taken it, and so had I. She had nothing left. As dusk started to fall, Amber held her head haughtily, but I could see the strain on her face. Wrapping a silk robe around her shoulders, she walked over to the poolside bar and ordered a drink.

You entered through a garage door on Chrystie Street, between Stanton and Rivington. Above the door hung a sign advertising lamps. The entrance was made to be hidden, but you couldn't miss the line. All the way to Stanton, they texted and shoved: giraffe-like fashion models, their high heels snapping beneath them; finance bros, growling that they weren't inside. A TV star, furious to be kept waiting, swung the post holding the velvet rope at a bouncer. He missed and took out a taxi window instead.

No one who waited in line at the Box got in. The only way in was to call a contact inside. The Albanian bouncer would step aside with a scowl and you'd pass through the hidden door, through drape after crimson drape— like reentering the womb. The door girl was six foot one, perfection with her Afro, her scant, sequined dress, her smile like maybe you belonged. The sign behind her warned "No Photography." Best to leave no proof of the goings-on inside.

You walked to the bar. It looked like a saloon, like a vaudeville hall, like the Moulin Rouge. This was the ur-nightclub you were searching for, of which all other clubs were faint carbons. There, amid the two stories of Krug Champagne, the walls covered with porn collages, the mirrors reflecting model flesh, you found the place to which all other clubs aspired. Even better, it's been decided that you belong there.

A naked woman spun on a hoop over the bar, lounging like the girl

in the moon. Then, fast, she flipped and hung from one muscular thigh. When a customer looked down at his phone, she swiped his twenty-five-dollar drink. Then she raised herself up, sipped the drink, candlelight soft on her bald head. She smirked.

This nightclub meant war—class war.

The bar, however, was only for peasants and cattle. You needed to get to the front.

Lucca guarded the second barrier. He was so tall, so square of jaw and plush of lip, that it was hard to look at him, but you brazened it out anyway, with all the entitlement you didn't have. Maybe there was space for you. There were two tables in the center lined with brocade couches. These were for invited guests—those hot or famous enough to increase the Box's cachet. They were not allowed to leave the table's perimeter. Booths lined the walls. To sit there cost five thousand dollars. A bottle of vodka started at five hundred. If you were a man, after you ordered a bottle, girls would descend on your table and drink half the liquor. They might have been paid by the house.

At the Box, customers were sheep, meant to be shorn.

The DJ spun. Models crowded the stage steps, thrusting their angular buttocks to "*It's Britney, bitch.*"

Down the white spiral staircase was the ladies' room, where you could buy gold-plated dildos. The men's room attendant gave you cigarettes, in defiance of the smoking ban. "Because you're worth it," he drawled. You were not.

Each stall had a small shelf, perfect for cocaine.

You painted a new face on in the mirror—something hot enough, edgy enough, rich enough, to let you climb the VIP stairs. Upstairs were small alcoves, curtained off. One of them housed the stripper pole where Lindsay Lohan had busted her nose. The crowds were thick here. You didn't say "excuse me." No one would have moved. You shoved your way to the booths overlooking the stage. They had brocade seats, mahogany tables, and curtains just sheer enough to reveal what you did but not who you were. They gave the best views in the house.

You parted the curtains. You looked out. The music ended. The room went silent. The show was about to begin.

In 2007, New York was exploding. Wall Street had worked out how to perform transactions in fractions of a second, computer-managed deals that sliced debt into air and air into money, and liberated money itself from matter. Cash would be pure math now, the market dictated: abstruse numerical schemes, as gnostic as the lives we were living mediated by social networks, as fast as the networks' churn. Superprocessor mathematics had liberated money from the uncertainty and sweat of real companies, real labor, the blood and muck of the body.

But if money has no body, the rich did, and after all their hard work those bodies must be indulged. The Goldman Sachs boys blew their money buying Louboutins for sleek, cat-eyed girls of my acquaintance, girls who babysat them as they came down from coke. Dominatrices who fucked themselves onstage with butcher knives (dull, don't worry, and the blood was fake) turned up as trophy wives. After the *New York Post* labeled me one of the "sexiest New Yorkers," a TV host made discreet inquiries through an escort friend. Did I need a patron, she asked.

"I have Fred," I told her.

She looked askance. "Oh darling, you're so terribly bourgeois."

The Box was the totem of New York's boom years. Ostensibly a supper club, the Box was run by Simon Hammerstein, scion of that Hammerstein, the one who wrote *Oklahoma!*, and that other Hammerstein, the one who built the grandest vaudeville hall in nineteenth-century New York. Simon co-ran the club with Richard Kimmel, a veteran theater geek. It was Richard who first dreamed the club, wanting to create an immersive art paradise, a Wagnerian decadence engine where everything would be permitted.

The Box would resurrect vaudeville in New York, Simon and Richard promised, as if vaudeville had not been resurrected a decade ago, and was not being performed at dive bars every night by all my friends. But the media loves a famous name for their origin stories. Poor kids never get the credit.

The Box stayed open till five A.M. every night. Beyoncé, Lindsay, Scarlett Johansson slipped out. I-bankers blew twenty grand on bottles of champagne. Onstage, Russian acrobats did backflips over chainsaws, drag queens in blackface shot fireworks out of their asses, and Broadway dancers shoved their bare breasts into the audience's collective maw. The singer Raven O presided over the nights like a god of sex.

My mom sent me a *New York* magazine profile of the Box. "Sounds like all the nudie dancing your friends do," she said. I just shrugged. We were glamorous in the old sense—purveyors of deception, our fanciness cobbled together from sequins and slap. The Box, though—that was real money.

When the Box opened, my friends clambered to audition. A dive bar burlesque show paid fifty bucks a night; at the Box, you could make hundreds. But with the money came a cruelty that was absent from the cheerful stages I'd once danced on. Simon would demand that dancers fuck themselves onstage, and magicians pull card tricks out of their asses. Backstage at the drag bar Lucky Cheng's, one of New York's most famous burlesque dancers told me that Simon had flicked her nipple tassel contemptuously during an audition. "I hate pasties," he had sneered.

Someone composed a song titled "Fuck You, Simon Hammerstein."

The Box was purchasing our culture, we thought. Every day, performers lined up, hoping to be bought themselves.

Then Flambeaux, a fire-eater I knew, invited me to check out a show. He wanted me to draw a promotional flyer with him and his partner as Punch-and-Judy-style monsters. Seeing this as a way in, I vowed to make the best drawing I'd ever done.

Flambeaux swore I'd be on the list, but, even so, the doorman almost didn't let me in. I wheedled, and soon the false door opened and I was shoved toward the front.

Flambeaux ran through the crowd in a top hat, stockings, and girdle, a leer cracking his thin Scottish face. He held a gas can. "Wouldn't it be fun

to ring the funeral bell/On our civilization, and watch it burn in Hell," the Tiger Lilies sang.

Flambeaux poured the can's contents madly on the audience, splashing liquid over their suits and evening gowns. It was water, of course, but they were too drunk to tell. One man tried to run. On stage, Flambeaux lifted a drape to reveal a hog-tied girl. She screamed. He shoved an apple into her mouth. He drew a circle with his torch, and flames leapt around her. Then, from his panties, he pulled another torch, like a penis, and lit the tip on fire. The girl writhed in terror. He pulled her up by her hair, leered, and grabbed the apple from her mouth.

The curtain lowered right before he forced the girl to suck the torch.

I was spellbound.

The next act began. Acantha, a blues singer from New Orleans, slunk out. She wore her hair in forties curls, her skin dark against her white silk slip. "*I put a spell on you*," Acantha sang. Around her, girls materialized. They wore slips. They were sleepwalkers, the lights blue on their thighs as they hitched up their skirts. They moved as if through gel. Then they ripped open their slips in unison to reveal small, upturned breasts, which they shoved in the front row's faces.

The curtain closed. It opened. An acrobat balanced on a dildo with one finger. The curtain closed. It opened. The performance artist Narcissister stood on a rotating platform, nude except for a mask, pulling her outfit out of every orifice of her body. The curtain closed.

It was four A.M. I was delirious, covered in sweat, having consumed nothing but stolen popcorn. My mind

swam with images. I was bursting with them, as if I'd eaten too much. I couldn't wait to get back to Fred's studio and draw. Broke though I was, I hailed a taxi from the line outside, tearing open the door in my eagerness to get back to the studio before the images fled from my head. As the cab sped over the Williamsburg Bridge, I scribbled with lipstick onto the back of a receipt. Crows. Dancers. The earth. The sun rose. The skyline shone silver in that humid dawn. In my excitement, I broke the lipstick.

This wasn't like the burlesque shows I'd danced in, where friends cheered no matter how badly I missed my mark. This was New York at its most fucked and glamorous. The rich and poor rubbed against each other until they bled. This was angry. It was louche. It was corrupt with millions of dollars. It was for real.

The car let me out at Fred's building. I waited outside for a moment. Bushwick was silent, the illegal spray shop closed, a cat prowling outside one of the warehouses. I breathed harder, to cover the ache in my throat.

The Box was my girl. My muse. My Moulin Rouge. I wanted in.

I knelt in the center of Fred's studio, spreading out the paper. Already I knew what I would draw. In that snowy field, I saw Flambeaux rising like a god. I photographed Fred naked for reference. Flambeaux's skin would be yellow, licked with flame, and behind him on a platform graven with the tree of life, a fire spinner would arch, bending backward, her hair flowing like water. At his feet, I drew the audience. They were small as insects, swarming, dancing, climbing, taking selfies. I drew a rich geezer, his arms draped around two models in their bubble dresses. On the curtains I carved out other worlds: the private boxes with couples fucking inside, the line of aspirants, the bouncer turning away a yuppie vomiting on the velvet rope. At Flambeaux's feet, this carnival fought for attention, enlivened by my hatred.

But the stage was Olympus, surrounded by clouds. Flambeaux didn't notice.

That night, Fred and I slept on the fold-out couch. I propped the drawing up so I could stare at it as I fell asleep. "Stop looking at it," Fred

chided me. "Your eyes aren't fresh." But I wanted to fall into it, and each morning I returned, drawing obsessively, populating my world. Then I painted over the lines in watercolor, till it shone warm like candle flame.

It took me a week to fill that three-by-four-foot piece of paper.

I finished it in ecstasy, scanned it, and sent it to Flambeaux.

He wrote me back a week later: "Saw the painting, darling. I was hoping for a Punch and Judy look, but this is more cartoony. Sorry, not really my thing."

I closed the laptop and looked at the painting. I searched it for flaws, but, for once, I found none. I loved it unreservedly. Its lines were tight. Its details swarmed. It came to me in a fugue, and it was exactly what I wanted.

*He's wrong*, I thought. *I'm finally good enough.*

Without Flambeaux's help, I wasn't getting past the Box's bouncers. I put the painting away and gave up all thoughts of returning to the nightclub.

Instead, I started illustrating for *Spread*, a magazine by and for sex workers, and got to know its news editor, a then-escort named Audacia Ray. *Spread* gave me my first taste of sex worker activism. Despite their differences, gay porn stars, street-based prostitutes, phone sex girls, and thousand-dollar-a-night strippers were all finding common ground: They were dismissed by the square world as victims, threats to public health, causes of "pornification," rescue projects, and idiots. They were a contagion, to be monitored, rescued, arrested, and caged. In the pages of *Spread*, they could try to push back.

*Spread* introduced me to an alphabet soup of organizations: SWOP-NY, PONY, the Sex Workers Project. Here, neither my low-cut dresses nor my naked model past was held against me. Instead, they were points in my favor. The sex workers I met were fighters, sarcastic, smart, tough as brass knuckles. In them, I found comrades for whom the naked girl industry was neither stupid nor shameful. It was family. In 2007, *Spread* included me in an art show titled *Sex Worker Visions*. The previous year's poster

Audacia Ray

had been illustrated by Cristy Road, who had silkscreened a stripper, ass in the air, her face ugly and smart. Behind her, tanks invaded Iraq. Her body was a challenge to the state.

I ran up to compliment Cristy. She looked like a Cuban punk Rosie the Riveter, pompadour swept back by a bandanna, script tattoos up her arms. She knew my work. I knew her work. She'd been professionally naked. So had I. The straight world had kicked us both. And yet we kept drawing. We hugged in recognition.

Besides editing *Spread*, Audacia eked out a living in a dozen different roles, including author, porn performer, community organizer, and curator. She invited me to do a solo show at Arena, a dungeon in SoHo that sometimes hosted exhibitions. More elegant than any gallery, Arena looked like 1890s Shanghai, all brocade, bondage chairs, and glossy red paint. One room was midnight blue, filled with geometric paper screens that concealed a cross on which dommes flogged submissives.

For the show, Audacia and I settled on the theme of demimonde. *Demimonde*, French for "half world," referred to the liminal space of prostitutes, journalists, artists, and hustlers. As the American safety net frayed, more and more of us turned to the demimonde as consolation.

Inspired by my painting of Flambeaux, I created more portraits of the demimonde's darlings. I drew Ophelia Bitz, a London burlesque dancer, as a female Dorian Gray. But unlike Dorian, who was just a model, my Ophelia was an artist too. She painted herself obsessively. She sat surrounded by discarded canvases, each of them showing a different stage of death, while tiny girl-things presented her with more canvases. Her old age watched her from a cage. It was even bigger than my Flambeaux portrait, and the lines even more apt. I stared at it afterward, drunk on my own capacity. Then I gave her a companion: Dusty Limits, a blade-slim London emcee. I drew him the same size but flipped, also painting to avert his own death. But he kept his youth in a cage, dressed as a Catholic choirboy.

I drew Amanda Lepore, a trans performer who'd been famous since the '90s. Amanda had gotten so much surgery that she looked like a rubber

Jayne Mansfield. Her lips were injected till they resembled nectarines, her nose nonexistent, her eyes stretched into slits—a Barbie woman in her fifties, skin smooth as ice. Amber Ray had taken me to her birthday party, held

in a half-gay, half-straight strip club. Ignoring the division, Amanda led her muscle boys over to the straight side, where lithe girls squatted over finance bros in recliners, letting the men suck their tits. But Amanda could have given a fuck about the finance bros' desires. She pole-danced with abandon.

I painted her eating men.

I painted Amber twice. In each, big Amber was a costume shell, and little Ambers crawled over her, gluing on crystals. I painted the dancer Gal Friday as a hot air balloon. I framed the painting of Flambeaux too, for good measure. Who cared if he wouldn't use it? I would.

The show sold well. I drew more and more demimonde surrealism. I locked away all thoughts of the Box.

Then Buck Angel showed up in New York and pulled me back through its doors.

Buck Angel advertised himself as "the man with a pussy." He was middle-aged and dangerously muscular, with a lined, boyish face, pierced nipples, and a tattoo reading "Irish Boy" across his massive back. Buck had been born with a vagina. Though his family had raised him as a girl, he knew he was a boy. While he was still living as a girl, he worked as a fashion model; with his platinum crop and catty eyes, he was pure tomboy sex appeal. But he loathed the feminine objectification that went with modeling, and he turned to drugs to cope. Testosterone fixed him. Suddenly, he was exactly as he should have been. Buck cleaned up, went sober, had his tits surgically removed, then pumped iron until he grew menacingly jacked. He worked security at the dungeon owned by his wife, one of Hollywood's most famous dominatrices. Then, after she left him for one of the directors of *The Matrix*, Buck started doing porn.

At first, no one wanted porn starring a trans man, even one who looked like Hell's own Angel. He fought for a space in the world, going to porn convention after convention, selling the DVDs he produced himself, under a banner he hung himself. Though mainstream porn companies looked down on him as a freak, more people came to his table at every event. By 2007 he was a star, flown to Europe to perform at massive gay sex parties, sneering on magazine covers with his trademark cigar. But he also spoke at universities like Yale about accepting himself as a man, and

his advocacy made him an idol for many young trans men.

I first saw Buck in *Bizarre* magazine. Delighting in his earned masculinity, I sketched him, then sent the drawing to his public email address. I yelped with glee when he sent me a thank-you note signed "woof."

I kept drawing Buck. Over the years, we became friends, smoking cigars together when he came through New York.

"Women are better at languages because they talk so much," Buck once told me.

"You're a sexist swine," I answered, and he laughed with delight.

Buck had starred in one of Richard Kimmel's experimental films, and in early 2008, he came to New York to perform at the Box. As he toweled off after his act, Buck saw a copy of my painting of Flambeaux carelessly taped up in a corner of the dressing room. Recognizing my work, he told Richard to invite me over.

At the Box, Buck hugged me hard before depositing me at his table. Forty-five minutes later, he appeared onstage as a strongman in a striped unitard. Smoke rose around him. "What makes a man a man?" Raven purred. Buck lifted a huge barbell. He put out a cigar on his tongue. Girls fell at his feet. Then he tore off the unitard. He sneered, flexing his biceps and thrusting his pussy at the audience. He was as gorgeously lit as a ballerina at Lincoln Center. *"Who has big balls? He has big balls!"* Raven sang. The rich girls in the balconies swooned. I drew madly.

"Hey! Draw me!" came from below the table. Someone poked me hard in one arm.

I looked down. On the floor stood Marilyn Manson's three-foot-nine-inch, far more handsome twin. "Move over," he snarled, shoving me aside and hopping up onto the banquette next to me. He wore a heavy metal shirt with the sleeves ripped off. His biceps, gym-swollen, were covered with tattoos of one of New York's most famous artists. His black hair hung in a pageboy cut. He had an angular jaw, wide lips, and arrogant, pale-blue eyes. He introduced himself as Nik Sin.

"Stay still, then!" I hissed back. Nik shoved a finger into my nose and then licked it, laughing.

In the dark, I drew him, swatting away his hand. I could barely see the paper, but I tried to capture the rays of contempt Nik was throwing toward the audience. *You fucking peasants*, he seemed to say with each curl of his mouth. Breaking his promise to stay still, Nik kept peering over at the paper. He scowled with disgust.

When he thought it looked finished enough, he snatched the sketch. He scampered off, I knew not where—until Richard Kimmel appeared in a tuxedo at my table. With his face hidden behind a beard and curling hair, he looked like a black sheep.

"I love it!" Richard cooed. I couldn't see how that was possible: the sketch barely looked like Nik at all.

"Come back tomorrow, gorgeous," Richard told me, before disappearing down the stairway to the dressing room. "We've always wanted our own Toulouse-Lautrec."

When you're a young woman, older men always want to help you.

There was Nathan, who walked into a fund-raiser for the Sex Workers Outreach Project and handed out a card listing the locations of his three homes. There was Adam, who followed me to a convention where I was speaking. He left messages with the hotel staff and had to be dragged out by security after trying to force his way into an event he thought I was

attending. Finally he caught up with me at Hooters, where I was drinking with a friend, the artist Katelan Foisy. She had just posed for Dr. Sketchy's at the convention, and was still painted blue like Kali Ma, with only a necklace of skulls covering her breasts. Adam glared at us from the other end of the room. Finally, a waitress passed me a note, in his wobbling hand, offering to "help me" whenever I was ready

There were the innumerable invites to dinners at clubs with friends' occasional sugar daddies. We'd doll up carefully, still wondering if the world might open to us that way, but we'd get only free lobster for our trouble.

All these men said they would take us out of our pitiful circumstances and onto the grand stage of life. They never did.

Richard was not like that. He was the first man who saw me as an artist.

I left the Box at four A.M. and fell into a waiting cab. As the car sped over the Williamsburg Bridge, the skyline shone like a promise. I left my apartment dark when I got home so I wouldn't shatter the magic. Lying on the mattress, I watched the sky turn pale. Roaches skittered over the linoleum. "I found it," I whispered to myself. "I found my muse. I just have to make them notice me."

The Box had many owners, but I knew only Richard and Simon. Whereas Richard was all wheedling kindness, everyone hated Simon. He had the sort of wealth that gave immunity—Daisy Buchanan wealth. No matter what someone like that snorted, whom they fucked, or how they failed, their grandkids would never have to work. So much of my life was

spent chasing money. It shaped my friendships, distorted my thinking. Money meant nothing to him. Compared with my grasping, Simon was a Borgia prince.

I huddled on the corner of the stage, waiting for Richard to notice me. My thrift-store evening gown seemed so cheap, and I felt the way I used to when I hid in the corner of Shakespeare and Company—small and unlovable.

Richard came over and embraced me. Then the curtains parted. A woman strode onstage in a high Mozart wig and a frock coat, naked from the waist down. She sat on a chair. Nik skulked onstage, in a wig and frock coat of his own, carrying a conductor's baton. He raised his hands.

The woman queefed Beethoven's Fifth.

"Le Petomane!" I cried, remembering a history of theater. A nineteenth-century performer at the Moulin Rouge, Le Petomane saved himself from life as a baker's assistant through his ability to fart whole symphonies. He toured the continent, performing for the Prince of Wales, King Leopold II of Belgium, and Sigmund Freud. Alas, times change, and the horrors of World War I caused La Petomane to grow disillusioned with his art. He fell back onto his first skill, baking, and died in 1945.

"*Yes!*" Richard grinned. "No one has ever gotten that reference."

Simon came up to us, shining in his white tuxedo. He was sweating profusely, and his beard was unkempt in the style of very rich men, who do not have to be attractive to sleep with beautiful women.

"What're you drinking?" he demanded.

"Gin and tonic."

He flew off. A waitress returned with a tray of seven gin and tonics. She placed the whole tray next to me. I stared at them helplessly. Richard had vanished again.

I drew.

The best art comes out of boredom, and in the hour-long gaps between acts, I was bored. I drew the dancing hedge-fund boys with sparklers shoved into their champagne bottles, like homing beacons for suckers. I drew the beautiful bartenders as crows, the lighting guy as an angel

perched high on the balcony, overlooking the dancers. His legs dangled overhead as he pointed the spotlight toward the stage.

I sat next to the stairs that led down to the dressing room. Stagehands slouched on the staircase, smoking. Richard never came back.

I waited for hours, working my way through Simon's gin and tonics. By dawn, I decided Richard must have moved on to better company—that I and my cheap dress and cheap historical references had failed. I snuck out, slumped with disappointment.

I woke up around noon, scratching a mosquito bite on my eyelid. My mouth tasted sour, and I had a creeping pain behind my eyes. My phone glowed. "Fuck you," I muttered, wanting to go back to sleep, to hide from last night's failure.

The phone beeped again. I flipped it open and saw four texts from the same New York number.

"Darling honey baby"

"so sorry I didn't get to say goodbye."

"Come back whenever you want."

"You're brilliant brilliant brilliant."

I came back to the Box the next night, and the night after. I claimed my own spot on the stage steps, summoning up the courage to kick off heiresses who stole my designated pillow. Richard told me that no part of the club was forbidden to me, and I explored each corner luxuriously. I could linger in the VIP rooms. I could draw the Hammerstein Beauties, as the Box's chorus line was known, as they stretched their legs over their heads in the blue light that shone moments before the curtain rose. We were all working, they and I. With my pen I traced their images over and over, tattooing the moment onto my sketchpad, dancing with my hands.

I hung out in Raven O's dressing room, watching him squeeze himself into his trademark skin-tight striped pants, flexing his muscles critically

in the mirror, twirling his starry hair into horns. Once one of New York's great drag queens, Raven now strode with cartoon machismo. A former ballet dancer, go-go boy, and stripper, he'd been using his body as a tool for more than thirty years.

I was too broke to buy a good purse, so I stowed my pens in a box from the dollar store. Before turning up each night, I slashed my lips with Wet n Wild, jammed my feet into stilettos, and held my chin up, so the doormen would remember I belonged. Though I could barely see the paper, I bent over my sketchbook and scribbled everything I saw around me. The next morning, the sketches were as indecipherable as cuneiform. I dredged up my memories, turned them into finished drawings, and then showed up back at the club.

No one mentioned paying me, and after the first night, no one asked me to come back. I just decided that the club was mine. If I stayed there long enough, they'd have to offer me a job. At Fred's loft in Bushwick, I shooed him away as I worked on a new watercolor each day, crying since it was never as good as the scenes I'd seen the night before. I'd make a print on Fred's printer and present it to Richard, who would coo, hide the print, and vanish.

Some nights I had to pry my fingers apart to keep my aching hands working. With my left hand, I curled my right palm around my pencil, forcing myself to draw the Italian acrobat Rudi Macaggi. The audience mutated into pigs on the page, snorting cocaine like truffles. The back-drops dissolved into stars.

Each night, if Richard came back to me, I'd be ecstatic. If he didn't, I'd want to die. I'd fall into a cab after the last act, get back to my studio, do a drawing of the Box, then hack out some children's-book work I'd hustled on Craigslist, working until it was time to take the rattling J train back to the Lower East Side, brazen my way past the door guys, and do it all again.

"Gorgeous, we have something to discuss," Richard texted one night. He always called me Gorgeous, a bit of asexual flirtation. He invited me to come over during the day. In daylight, nightclubs are beautiful in the

same careless way women are in the morning, eyeliner smeared across their cheeks, hair in pillowy knots. Lights in a club reveal everything: the stains from spilled drinks, the shortcuts where a decorator had thought, *Don't worry, no one will notice in the dark.*

The Box smelled like camphor. Richard lounged on one of the couches. On another couch lay a pile of silver dildos and giant commedia dell'arte masks. Onstage, two acrobats auditioned. They climbed a silk hammock, entwined themselves, and then unhooked their feet, dropping perilously close to the stage. Simon sat up front, wrapped in a blanket. He chomped away at a burrito, meat flecks falling from his mouth.

"You're Mickey Mousing it!" he hollered at the aerialists in his Anglo-American accent. They sagged with disappointment against their silks, then packed and left. Simon started trash-talking them before they were out of earshot. Then he noticed me.

"Who's she?" Simon asked.

"She's our Toulouse-Lautrec."

"Why haven't I seen her before?"

His eyes were bloodshot and there were bits of lettuce stuck in his beard. I didn't bother to remind him that we'd met.

"So, Molly . . . we have a big job for you," said Richard, ignoring him. "We're doing a big, big party, and we need a sixty-foot backdrop. We need it in three days. How'd you like seven thousand dollars?"

Seven thousand dollars was a fortune. The rent on my room in the roach-infested walk-up was five hundred a month.

Back at Fred's loft, I brewed black coffee and spent the next three days on the floor, hunched over a giant piece of paper, to create a drawing that printers would then blow up to sixty feet wide. I drew an elaborate border of pigs. Cheerful, plump and evil, pigs were my symbol for the Box. They had a coke straw in each nostril, a champagne glass in each hand. It seemed an apt symbol for the coke-dumb bankers who composed half

of the audience—oafs who shoved their way through the club, grabbing dancers' asses, but never deigning to watch the show.

The Hammerstein Beauties threw themselves at these men. Girls before swine.

After the Box cut my check, I took the subway to Bergdorf's. I entered that flower-bedecked palace wearing a filthy band shirt and a torn skirt. Striding past the glaring security guards, I took the escalator to the women's shoe department. The salesmen ignored me.

My eyes settled on a pair of brutally high black peep-toes. I shook the shoes in a salesman's face. His features softened. "Wonderful choice," he lied.

I tried on the shoes, heart pounding at the sticker. Nine hundred dollars.

*I will make money*, I told myself, *so that I can waste money*. I gave him my credit card. Then they were mine. I felt drunk from the carelessness.

Back in my roachy apartment, I took off all my clothing. I put the shoes on in front of the mirror. I could barely stand. Louboutin soles are as red as Dorothy's slippers (or a baboon's ass, but I am a romantic). I wanted to wear them while walking down my own gold brick road. They hurt, but the pain felt like discipline. I was different now. The Box had paid me. I had money. I belonged there.

These shoes were the disguise I wore to smuggle myself into this new world.

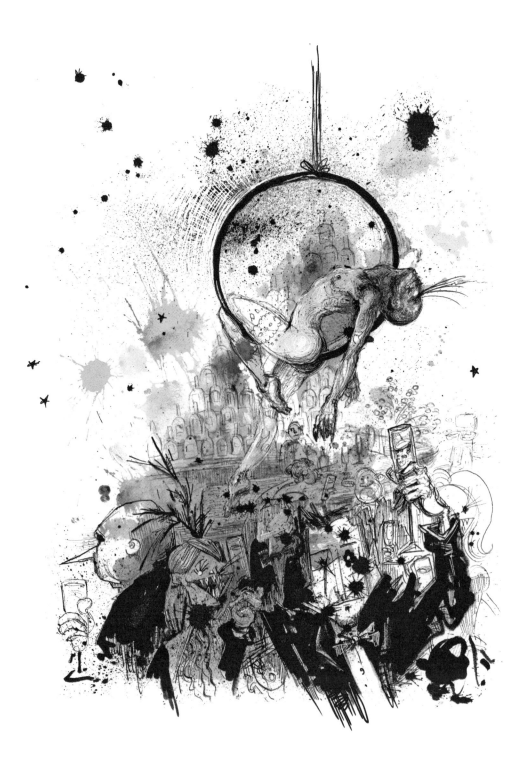

No one had ever understood my art like Richard Kimmel did. Where others saw a bunch of topless cartoon girls, Richard saw weapons. He saw the anger that dragged my pen across paper, the cynicism that narrowed my chorines' eyes. Richard saw the compulsion with which I filled each page with figures—stuffing in more and more life, until the paper swarmed like an ant colony. He saw my jaggedness, my insecurity. Neither of us came from money, but we lived in a world dominated by those who did. These people were born into a space far grander than the one we were able to occupy, and so we were forced to charm and flatter, to use our art to construct universes for their delectation. But I hated them for it. I suspect a small bit of him hated it too. Richard encouraged the knife edge in my work. I distorted my victims' flaws until they swelled like ticks, all their defenses ripped away.

Richard didn't see me as a girl—not in the world of spangled beauties who populated New York nightlife. He saw me as an artist—one who recognized the Box not just as a louche fantasyland, but as a kind of Roman colosseum of the downtown culture war.

Some nights I drank till the world sped before me like a cranked-up cartoon. My words came out slow and careful. I draped myself over the railing of one of the private VIP boxes and stared into the pit, where the bankers jerked and swayed. I hauled my head up. Onstage, Nik Sin performed naked with a three-foot-seven stripper, both of them painted

blue like Smurfs. At one point in the act, Nik pulled out a sketchpad, parodying the scene in *Titanic* where Kate Winslet poses for Leo. "Draw me like one of your French girls," the stripper mouthed. Nik scribbled her furiously. Then they pretended to fuck.

Nik sidled up to me during intermission, forcing his finger into my left nostril in way of greeting. "I was pretending to be a creepy artist like you," he said.

The light flickered. Nik left. A famous porn performer and dancer came into the booth with an aerialist and a customer. The customer poured lines of cocaine onto the back of his hand. We snorted it. I titled my head back and let it bleed bitter down my throat.

I was kissing the porn performer greedily while the aerialist kissed the customer. The light glowed around me, incandescent, the world rapid but the night feeling like it would last forever.

I left just before my legs stopped working.

"Good-bye, honey bunny," the customer said with a grin. In the veiled light of the booth, his face morphed into a demon's. I nodded and staggered out.

The Box was famous. All my friends begged for invites, and the *New York Post*'s Page Six guessed which celebrities did which drugs inside. The Box was envied, desired, and hated all at once. Everyone I knew wanted to hear about it. I had never been part of a scene where admission was so coveted, or the stakes so high. But with scandal comes reaction, and soon the community board began fighting to yank the club's liquor license.

I knew enough to refuse media requests, but *Time Out New York* asked to print pages from my Box sketchbook. That seemed innocuous enough. I sent them a watercolor of girls wearing gas masks, multiarmed and entwined.

When the magazine came out, Richard called me. Stress hollowed his

voice. A few days before, they'd had another meeting with the community board. The Box was licensed as a supper club, but it stayed open till four o'clock in the morning. When community members confronted Simon about this fact, he said that the class of people he knew ate supper at four A.M. This did not go over well.

"Are you a fucking idiot?" Richard hissed at me. "The city wants to shut us down, and you show we have nipples out in the club?" New York law required topless dancers to wear pasties. Burlesque dancers all over the city flouted this rule, but none of them were as high profile as the Box.

"I'm sorry," I said. "I didn't think about it."

"And for fucking *Time Out*! I want you in W!"

I held my tongue. I didn't want to be exiled from the club, or lose my frail hold on the high world. When he hung up, I lay on my stomach on Fred's couch, breathing hard into the fabric.

I spent more and more nights at the Box. Outside the club, I fell into New York's frenzy. I was photographed for magazines, staring into the camera's insect eye as I once had as a model. But I was no longer girl flesh—I was me. The morning news did stories on Dr. Sketchy's. A T-shirt company gave me my own line and flew me out to Hollywood to launch it. At the party, the publicist guided the starlet Bai Ling and the boy-starlet Boo Boo Stewart over. We embraced, letting go just after the cameras stopped. But Buck Angel showed up and hugged me for real.

A fashion blogger who had just moved to New York from Melbourne, Gala Darling had a posh voice, stick-straight magenta hair, and the characters of *Geek Love* tattooed on her biceps. During her first week in the city, I took her to the Box. She wrote about Raven's hymns to cocaine on LiveJournal. *New York* magazine quoted her post. Remembering how the drawings in *Time Out* had infuriated Richard, I begged her to delete her LiveJournal post before he could follow *New York*'s links to it and connect her to me.

Together, Gala and I went to a party for Louis Vuitton. I prepared with great care: sequined dress, Louboutins. Gala showed up on the corner of

Houston in a cerulean tutu. We had a tense moment at the door. Would the girl see our names on the list? Some New Yorkers were legendary door crashers: they viewed lying past guest lists as a test of fortitude. I was not one of them. When I wasn't on the list, all I wanted was to apologize to the door girl and slink away. But miracle! Our names were found! Gala and I strode into the room. Like all fashion parties, the Louis Vuitton party was a sort of video game. We had three goals: Gulp as much champagne as possible. Get a swag bag. Pose for photos.

I stood around, trying to look haughty, too scared to talk to anyone. I willed the photographer to turn his flash in our direction. Why even come if he wouldn't record our presence? Eventually, he noticed us. Hands on hips, Gala and I snapped into our glamorous molds. He took two photos and turned away.

After thirty minutes we left, toting champagne headaches and swag bags full of gummy bears and conditioner packets. I dumped them into the trash.

Later, Gala wrote up the party on her blog. On the Internet, we were chosen, enviable, fabulous. She sold back the myth of our enjoyment, sandwiched in between ads.

In New York, before the crash, this was all there was.

The media had become stupid with money. Web 2.0 brought with it the intoxicating delusion that we could all be wealthy microcelebrities. Thoughtful work was for idiots. There were gilded prizes to be seized.

Gawker turned a bland dating columnist into the era's Becky Sharp, making her famous by eviscerating her online for her naked ploys for attention, then scooping up all the clicks for themselves. Video editors donned white suits and were flown to Vegas on private jets, working-class craftsmen transformed into brands, traveling to a branded city on a branded plane. One friend made a Tumblr of crowdsourced photos of bacon. He got a book deal for a hundred thousand dollars. Facebook took over the New Museum and gave five thousand people panama hats and tiny apple pies. Where did the money come from? *Who cares?* I thought, stuffing a minipie into my face.

Outside New York, books like *Rich Dad, Poor Dad* spread the lie that, for the middle classes, money could come from nowhere. They didn't reveal that this trick only works for the rich. Buy a house on credit, flip it, buy another—so the pundits counseled. Don't think. Don't wait. Everyone was getting rich. You'd be an idiot to hesitate. Don't miss out. In New York, we were the credit we would draw against. We were no longer writers or artists. We were start-ups. Branding may have been for cattle, but we were all brands. We would get book deals movie deals angel funds venture capital cash cash cash and never think that someday we'd have to earn it back.

One night Richard ordered me to duplicate Raven O's tattoos on the bodies of the waitstaff. Raven's torso was a muscled wonder, emphasized by stars and tiger stripes, and the words *American Boy* stretched across his improbable abdomen. Each waiter would take off his shirt and stand, bored, while I daubed paint over his perfect back. The job took me eight hours.

I stuck around for the show. A guest came up to me. "I can get you into the VIP section," he bragged. He was rotund, with a bowl cut and a suit.

"I work here," I answered.

"Doing what?"

I gestured to a waitress painted with my handiwork.

He chortled to his friends. "Can you body-paint me?"

"Sure. If you give me a hundred dollars." I made myself sound bored. You always get more money if you sound bored.

He led me to a private box filled with his friends. I unbuttoned his shirt. His belly was a furry dome. His chest rose with anticipation.

I took out a Sharpie and drew a smiley face on his stomach.

Smiling, I shoved out my hand.

He dropped a hundred into my palm, too embarrassed to protest.

Rose Wood was dressed as a caricature of a sex worker: lime-green tube dress, clear platforms, pounds of fake hair. She'd just gotten her tits done, and the bags sat proud atop her well-developed pectorals. Beneath her glitter-caked eyelids, Rose had a handsome, stoic face. Her jaw was square, and you could see the tension of someone who had fought hard but wasn't going to show it.

During another act, Rose walked the floor, opening audience members' beer bottles with her asshole. While she did it, she wore the same cold dignity on her face.

For this act, Rose led an actor onstage. In his banker's suit, he looked identical to any man in the audience.

From the wings, Raven whispered the banker's thoughts.

*She's so beautiful*, the banker said to himself. *No one at the office would think I was wild enough to get a prostitute. But I am.*

Rose started to undress the banker. She unbuttoned his shirt with the movements of a lover, not a worker, with poetry and pain. As she removed each gray piece of his suit, she hung it up on a coatrack.

*She's so neat. Not like my bitch of a wife*, the banker thought.

Rose led him to the bed. She cuffed his hands to the bed frame, with his head pointed toward the audience.

"Naughty! Kinky!" the banker purred.

She straddled him. She pulled her dress up, over her breasts.

*Oh. She has a dick*, the banker thought. *But she's hot. I don't care.*

They mimed sex. The banker screamed in pleasure. The bed jumped.

Afterward, the banker lay back, stupid in his satiation. Rose pulled off her wig. She was bald underneath. Her gestures were graceful, slow, as if the blue stage lights were water. Her shoulders slumped with exhaustion. She lit a cigarette.

Raven began to sing.

*"This is not a love song."*

From behind the coatrack, Rose pulled out a knife.

*"I'm going over to the other side. I'm happy to have lots to hide . . ."*

Rose walked back to the bed. We couldn't see the banker's face, but we could feel him there, grinning with satisfaction. He was brave. He was a rebel. He had just been fucked liquid. He was a man. Rose straddled him, hiding the knife behind her back.

Then she raised the knife. The banker's head jerked with surprise.

Didn't they have a nice time? Didn't he pay her? Weren't they friends?

Then Rose brought down the knife.

The lights went to strobe.

In that confusion of smoke and flash, Rose stabbed the banker over and over. Blood flew. Rose rode the banker as she killed him. Her face shone orgasmic. She bit her lips with joy.

Finally, the banker's body lay flaccid.

Rose cut off his head.

The lights went back to blue. Spent, Rose rose from the bloody bed. She pulled off the tube dress to the rhythm of Raven's song. Then she stood naked in the middle of the stage and stared hard out at the crowd. She showed her

breasts, her penis, the cold dignity on her face. She stared at every motherfucker in the audience as if she had tied him to that bed and stabbed him too, and she wanted to let him know he deserved it.

Slowly, Rose put on the banker's suit. In class drag, she walked off the stage.

As she left, she tossed her cigarette onto the bed. It went up in flames, banker and all.

Then, in 2008, the stock market crashed. When it did, Simon Hammerstein was one of three people who rang the opening bell.

**21.**

ew York had been shiny the way a bubble is the moment before it bursts. The skin of the city was stretched taut. The colors were bright, and all we could see were our own reflections.

In that one morning in 2008, it all disappeared.

After the market crashed, the press started to turn on Simon. It began with the Porcelain Twinz, former star performers at the Box. The Twinz were near-identical, faux-albino sisters who penetrated each other with glass dildos while elegantly smoking what they claimed were herbal cigarettes.

One morning, they posted a blog full of accusations: Simon had pressured them into sex. The dressing rooms were filled with dog shit, and the Box's management snorted coke like they were vacuum cleaners. Soon, the *New York Times* ran a story about their accusations. Other papers followed. Simon denied it, of course, pointing to an HR handbook no one I knew had ever seen. As if to prove himself incapable of harassment, he teased news of his imminent wedding.

I sat drawing in a curtained VIP box. The stage curtains rose to show Raven, naked except for a cock ring, in front of a line of Hammerstein Beauties wearing trench coats and fedoras. They held yellow legal pads, like cartoon members of the press.

"*Rape me,*" Raven sang. "*Rape me, my friend.*"

In June, Barack Obama won the Democratic primary, and the U.S. presidential race narrowed to him and John McCain. Obama was America's first serious black presidential candidate, as well as being intellectual, urbane, literary, and dorky, qualities diametrically opposite to those of George W. Bush. In 2008, this seemed to promise an intelligent, transparent, even leftist way of running the country.

In retrospect, these attributes seem more like cultural signifiers, as vapid in their way as those of a Midwesterner who wanted to share a beer with Bush.

The Box threw Obama fund-raisers, despite the mockery of the press. My mother and I volunteered for Obama too, spending hours every week calling up people to ask them to register to vote. I knew how irritating we were, but I didn't care. For the first time, my mother and I agreed on politics.

It seemed that if Obama won, we could redeem our whole damn country.

After the crash, opulence fell out of fashion. Someone punched out the CEO of Lehman Brothers while he exercised at his company gym, and the *New York Times* ran articles claiming that Manhattan's gentry were now hiding their Bergdorf's bags inside plain brown ones. It was either modesty or fear. In this climate, bankers stopped coming to the Box. They still had their bonuses, but it looked tacky to blow thousands a night on champagne.

The Box fell on harder times. One by one, they laid off the Hammerstein Beauties. Then they laid off the band. Management slashed wages, but demanded more from performers. The Italian acrobat doubled as a bartender. Nik Sin was drafted as a host, though he had not an ounce of hospitality.

Once, Wednesday nights had seen the Box packed as tight as a veal pen. Now the club was empty. I sat alone on the balcony, squinting at my sketchpad in the darkness.

It was the end of the boom and we all knew it, as surely as courtesans

knew the end of the Belle Époque. On the Web, I read about the tent cities growing on the outskirts of Vegas. Medical NGOs set up makeshift hospitals, extracting teeth from Americans who couldn't afford dental care. The chasm had always yawned between rich and poor, but now it was impossible to ignore. And it was embodied in this empty nightclub. After the crash, what would happen to the human luxury goods who worked here, we sparklers illuminating the face of the destroyer? Where would we end up?

I stared down at the stage, where the two remaining Beauties danced forlornly. It might as well have been a funeral procession. But they hit their marks just the same.

Years later, I smoked weed with one of the Box's former drummers. As the sun rose, he told me that he'd never stopped adoring the club. No matter how badly they treated him, he loved the Box, long after it had ceased to be New York's darling.

As he spoke, he sounded like Humbert Humbert at the end of *Lolita*, when he finally reunites with an adult, pregnant Dolores Haze.

"I loved my Lolita, this Lolita, pale and polluted, and big with another's child, but still gray-eyed, still sooty-lashed, still auburn and almond, still Carmencita, still mine."

Humbert's words felt as real for a nightclub as for a girl.

On election night 2008, I sat with the rest of the Box's staff watching the results come in on the club's TV. As the

states went blue, the giddiness rose. When the announcer called the country for Obama, Lucca picked me up and spun me around while I squealed.

On the street, strangers gave me hugs and high fives. The whole city was dancing. We thought we'd done the impossible: our guy was now in charge. We'd proven that America was something besides the puritans and bigots. We were the real America. Not George Bush—*us*.

I called my mom. "Come over!" she demanded. I rode the cab through the joyous midtown crowds. I didn't want to be alone.

We danced in New York because we believed we'd shucked the nightmare costume that Americans had been forced to wear for the last eight years. The wars, the secret prisons, the torture, the spying, the hurricane that destroyed New Orleans—even the constant, humiliating public idiocy of US leaders. We'd proved those were anomalies. Beneath it all, we were good.

Was the sky ever as blue as it was that next morning?

Of course, redemption doesn't come from politicians. But not all of us knew that yet.

The Box was hardly my only client. I drew feverishly for anyone who'd let me. Leavitt and I created a pornographic comic book called *Scarlett Takes Manhattan*, and then a web series for DC Comics called *Puppet Makers*, about futuristic technology in rococo France. Each work focused on depraved rich people and scheming performers. Class obsessed us both—as did the worlds of art and sex, where class could be transgressed.

An heiress hired my friends to run one of her Halloween parties. These parties, in her Greenwich Village townhouse, were legend. The heiress filled her home with celebrities, earning lavish spreads in *Vogue*. She considered the events her form of art, but this was true only in the way that Jeff Koons's balloon dogs are "his" art. In reality they were the work of a huge staff of cleaners, costumers, caterers, art directors, and performers. My friends who planned the party were gods of nightlife, having performed for everyone from Madonna to Simon Cowell, yet they were not

allowed to take a whit of credit for the event; in the heiress's world, they were merely the help.

As part of the entertainment, they booked me to create a six-foot-tall painting over the course of the night. I'd make art before the guests' eyes.

I dressed myself as a glittery little moppet: teased-out hair, hands weighed with rings, corset winched so tight I could barely breathe. I roped Fred into helping me, not knowing how I'd finish the painting I'd promised to make.

Parties are supposed to be about pleasure; rich people pride themselves on being difficult to please. Before I got going, my friends spelled out the rules, promising they'd catch hell if I broke any: No drinking on the job (performers had proven themselves untrustworthy in previous years).

No networking with the celebrities, even if they spoke to us. We were to remain mysterious, decorative, and, above all, silent.

Before the party started, Fred asked the bartender if we could use his trash can. The heiress sent down a staff member to berate him. We were talent; they were waitstaff. The different classes of help were not to mingle. The Bastille had been stormed for less.

The staff member led me upstairs. We lined up, military style, in the heiress's bedroom. "Be kind to *Women's Wear Daily*, so they're kind to me," she trilled. Staff members guided us before Patrick McMullan's cameras. We were a parade of Pierrots, gilded ballerinas, fetish models turned into lions, hissing and twirling their tails. I pouted with my paintbrushes while the flash bathed us all.

Then I painted. When a painting is that big, and the time you have to do it is that short, you fall into it. You get obsessed with the rhythm of wiping drips, filling in blacks. Your hands race desperately to make it comprehensible enough that, even after an hour, people can tell that you know what you're doing—even when you have a little pink veil on your head and your feet are screaming and your corset is too tight for you to breathe.

"That's really good," I heard.

I turned around. Pierce Brosnan was smiling at me. His costume consisted of a plastic spider affixed to his nose. I wondered if I was allowed to say anything back, so I stayed silent. This was my friends' gig. It covered the last three months of their rent. I didn't want to get them in trouble.

"Pierce is a Sunday painter," said his companion.

I tried to make chitchat with my eyes.

"Molly! Molly!" A friend threw his arms around me. Jerry was a trust-fund artist whose greatest work consisted of filling a gallery with bouncy balls. To be fair, this made it more enjoyable than most fine art.

I shrank away. "I'm not allowed to hug you," I said. "I'm the help."

"What?" he asked, seeming shocked.

"Yes," I said, "the help can't talk with the guests."

"What do you mean 'the help'?" asked Jerry. "Can I get you a drink?"

"Nope, the help can't be trusted to hold their liquor."

Jerry backed away, spooked by my ferocity.

In the fall of 2009, Fred took advantage of the falling rents that came with the financial crash, and moved into a loft in Manhattan. I finally moved in with him, though I clung to the old rent-controlled place on Roebling Street. In the new loft, I felt like a princess in a tower—even when a mosquito infestation kept us awake all night.

Before we could even finish unpacking, the *New York Times* photographed me for a profile. The reporter followed me around for weeks, even calling up Leavitt to ask how it felt to live in my shadow.

I told her countless things. But the article's pull quote was a bit of cheek. "It's not how much you cultivate your talent, but how much you cultivate your name," they quoted me as saying, running the words beneath a photo of me in mint-green tulle, peeking through a picture frame. The comics scene was predictably scandalized—by now I had a bit of a reputation for being cynical—but I was just trying to counter the pious lie that good artists would automatically be recognized. Talent may be its own reward, but the rewards granted by the world were distributed in a less equitable fashion.

As if to prove my point, after the *Times* profile, curators started writing to me.

In January 2010, Richard asked me to do a poster for the Box's fourth anniversary. He and Simon were fighting. Simon fought with everyone who loved him. This time, he used me as Richard's proxy, asking for dozens of changes in the poster art. He kept me at the computer for days, sending and resending sketches, jumping to meet his shifting demands: *Paint the wall white, then black, then starry, then white, then add in two dancers, then Photoshop them out again.*

By the midnight before deadline, he seemed mollified. But at three A.M. I got the email.

Compared to the work you've done for us, this piece falls flat. It is too simple, too straightforward. So little detail, so little dynamism. We are asking for an entirely new piece of work. This one is not of any use to us now.

The email came from an assistant's account, but I recognized the hallmarks of Simon's style.

I'd stuck with the club long after the press turned against it. I thought of all the free drawings I'd done for the Box. I thought of all the love I'd poured into that place. But I've always clung too long to those I loved. I'd stayed with both Anthony and Cosette well after I knew it was doomed. I did the same with the Box.

I drank some whiskey. I felt a bit of ice inside me. It gave me strength. I coddled that sliver of hate. Then I typed: "Take my work off your site." I cc'ed everyone at the club, including Richard. I pressed Send and went to sleep.

*t*he crash did not reverse itself.

The government bailed out Wall Street, but the money stayed pooled at the top. Rather than an elusive ideal, eternal prosperity turned out to be a lie, and the houses people thought would secure their futures became instead chains around their necks. Those who wrecked the economy rewarded themselves with bonuses. Discreetly, bankers began to return to the Box.

Simon did not return my email, but a week later, Richard called to tell me they were using my poster. He

paid me, and I was grateful. We joked and flirted, as we always had, but I couldn't bring myself to go back to the club.

Once I stopped working for the Box, I lost touch with its New York. That city of excess had both obsessed and disgusted me, but it also drove my art. Now I had no muse. I told myself the loss didn't matter. I had my people. My geeks. My burlesque girls. They were talented, and unlike Simon, they were kind. They respected my work.

Melissa Dowell and I threw increasingly elaborate Dr. Sketchy's sessions. I churned out more illustrations: showgirls with curly wigs, stages, curtains, each piece swarming with detail, whimsical animals cavorting in the audience. The style I'd honed at the Box became popular, but all I did was reproduce my old work. The Box had cut me till I became razor-sharp. I was now swaddled in the cotton wool of my own success. My hands moved with confidence, creating book covers and advertisements. They were well done. They were fine. They were nothing new.

The money was good. I told myself I didn't care.

Back before the crash, at Miss Exotic World, a breast cancer charity had made plaster casts of the torsos of dozens of dancers, then distributed them to artists for them to paint. I received Amber Ray's. I sanded smooth those gravity-mocking breasts, then painted them ocean blue. Having no concept at the start, I riffed on the aquatic theme, painting two punk rock Little Mermaids, with their long red braids looping decoratively. Like most of my non-Box work at that time, it was allusive, slickly painted, and created to invite professional opportunity.

I posted a photograph of the piece on my MySpace page.

The first comment was from a band called Vermillion Lies, whose avatar showed two sisters sitting atop stacks of circus trunks. Zoe beat a drum. Kim strummed a toy guitar. They pouted like stowaways from one of my drawings. They wore striped stockings, rouge, and top hats; their braided red hair connected them.

Kim Boekbinder, who ran the Vermillion Lies' MySpace account, sent

me a cabaret song they'd done, "Long Red Hair," that reminded her of the characters I'd painted on Amber's bust. The sisters of the song were connected, like conjoined twins, by their hair. One of the sisters married. On the wedding night, her groom was unable to get hard under the sisters' dual gaze. Hoping to separate the two, the husband cut their braid. But it was not hair so much as vasculature. The two girls bled to death. I listened to the song on repeat as I worked on a flyer for a cupcake shop in Berlin.

Vermillion Lies toured the world. They made ten thousand dollars one night at Caesars Palace, and they bashed out songs on toy pianos for screaming fans in Moscow. Their tour van, rigged with red velour bunks, crisscrossed the United States. One MySpace photo showed Kim and Zoe vamping in front of the sign for Vermilion Parish, Louisiana. Vermillion Lies opened for the Dresden Dolls, and then their front woman, Amanda Palmer, after she went solo. Despite being independent, they were far

more successful than the majority of indie bands—something largely attributable to Kim's whip-cracking leadership. On stage, she might have been sex itself, but behind the scenes Kim was a businesswoman like I was. And, like me, she wished she could just be an artist.

We kept in touch, thinking of projects we could do together. When she invited me to create the cover for the vinyl pressing of their album *In New Orleans*, I drew both Kim and Zoe, their red braids framing their names.

We finally met in the spring of 2009, when we were both doing events the week of the South by Southwest music festival in Austin, Texas. I took a cab to a sinister clown bar on the outskirts of town to see Vermillion Lies play for an audience of teenagers. Zoe banged out a heartbeat on a marching drum, while Kim played accordion and sang, *"I have your heart. It beats inside. It's only three inches wide."*

In person, they looked far from identical. Zoe was a dark tomboy. Kim was taller and more angular. She wore a collar of red ostrich feathers, and her hair glowed artificial cherry. Her mint-colored eyes were huge, and lined with feather faux-lashes. Her cheekbones were high, her chin long, and she had a prominent nose above a wide, magenta mouth. I stood staring at her until the show was over. Then we hugged. I was suddenly self-conscious in my pseudoprofessional black—a sparrow to her bird of paradise.

When Kim sang she seduced and demanded. Offstage, she spoke so softly that I strained to hear. Even as our sentences trailed off, we stared at each other as if we'd known each other before and would know each other for a long time to come.

After Kim and Zoe finished, we retreated to the tour bus. Kim and I lay next to each other on a bunk. The night was hot in Austin, and their van had no air conditioning. Slick against my back, her sweat smelled like lemons. She told me how angry she was that the official festival hadn't accepted Vermillion Lies to play. I was incredulous. They were so brilliant. If the festival had rejected them, then who the hell did they accept?

"It's just hard being DIY," Kim said.

She told me about the years she and Zoe had spent in a van ricocheting around North America. Years in planes, on floors, on stages. Years of seeing their faces tattooed onto breasts and bellies and legs. Years signing stacks of merch, eating McDonald's, doing shots, then carrying their amps to their van, night after lonely Midwestern night. Doing it themselves. Years of wanting help.

I knew the feeling.

Then, to change the subject, she suggested we all do a children's book. Plotting always cheered me up too. It was as if we'd touched pricked fingertips, exchanging art instead of blood.

A few months later, Vermillion Lies hired me to do a poster for their show at the 2009 San Diego Comic-Con. I drew Kim and Zoe as superheroes, with Amanda Palmer in the center as a blindfolded goddess of truth. I was at Comic-Con, so I stopped by their show, early enough to catch the last song. Afterward, fans lined up in a neoclassical music hall to buy merch from Kim, Zoe, Amanda, and her husband, the writer Neil Gaiman. I signed hundreds of posters, holding Kim's hand beneath the table.

That night, they seemed unstoppable.

A month later, Vermillion Lies split.

After spending a few months in Berlin, Kim showed up at my loft in Manhattan. She stood in the door, wearing a velvet coat with lace cuffs like that of a young prince. The coat shed glitter hearts. She looked tired. I hugged her hard.

In the kitchen, Kim found a bottle of absinthe. She prepared it for us in the Czech style, balancing a sugar cube on a fork, pouring the absinthe through the cube and then lighting it on fire. Slowly, she trickled water through the cube. The sugar dissolved. The absinthe slowly turned white.

As she worked, she told me what had happened to the band. Touring

is brutal, she said. Touring cheaply is an intimacy few relationships can survive. Kim and Zoe fought as bandmates—and as sisters they fought more. Then Zoe quit the band. By torching Vermillion Lies, she was also torching a future Kim had counted on. Kim had put everything into the band and now she'd have to start again. But it wasn't just the band. She felt she'd lost her sister too. She was scared. She had no home. She didn't know what to do, or who to be, except that the past was dead and the future would have to be invented.

Kim burned with ambition; her creative urge was relentless. As she lay on the floor, she seemed suddenly the most precious and fragile of things. I loved her, with covetous girl love. I wanted her to stay. I wanted to fix everything. I wanted to help her, to make her my best friend and to make her happy.

To pull her out of her depression, I joked, "We should show your fans our absinthe party." I turned on my webcam, then tweeted that we were hanging out. Twenty people signed on to watch a livestream of us. We waved at them, holding our absinthe toward the camera. It felt like a small party, close-knit yet disembodied.

Then I had an idea: Why didn't Kim move into my old apartment on Roebling? She paused. I turned to the webcam. "Should Kim move to New York?" I asked the Internet. Then I loaded a poll in the chat window. "Tell her to move to New York," I wheedled. Our viewers checked their boxes and the poll bar slid over to Yes.

"See? The Internet is telling you to do it. You should listen," I told her, sounding more daring then I felt.

Then I kissed her. Her lips were soft and her mouth tasted like licorice and when we parted, we both wore conspirators' grins.

"Okay, I'll move to New York," she laughed.

Kim moved into the Roebling apartment a short time later, with a few stray possessions—an amp, a looping pedal, a battered suitcase spilling dresses she'd collected from Moscow and Austin and Berlin. She covered one wall of the room with butcher paper, then, in marker, started planning what came next. I sat and watched her.

At the top of the paper, she wrote in vermillion ink:

# THE IMPOSSIBLE GIRL

"The Impossible Girl came to me in a dream one night in Berlin," Kim said. "This song presented itself fully formed. When I woke up, I remembered every beat, every word."

Kim got a musicians' residency at Goodbye Blue Monday, the bar where I'd danced after I recovered from my abortion. On her first night, a dozen fans gathered in the audience, including me. The stage was crowned with blue fairy lights. Her red lips parted, and she sang.

Stripped of Vermillion Lies' cabaret trappings, Kim was a different

woman onstage. Gone were the striped stockings and tiny top hats of the Vermillion Lies days. Now she raided thrift stores, hacking together sequins, leopard-print fabrics, and beads into vagabond finery. She stood with her long legs planted wide, a cape of crow feathers over one shoulder, and looked into the crowd like a dare. Her voice was naked, sweet in its raw vulnerability. In some songs, she used the looping pedal to create duets with her own voice. She sang like she was heartbroken, like she'd break your heart. As she sang, I thought of the cities she'd played in, all the beds she'd slept in, and how soon she'd leave again. I missed her in advance.

That spring, Kim and I lived in a fever of creation. I drew her as a mermaid, and as Madame X. I inked her portrait, Kim smiling coyly, wearing New York's buildings as a crown. That spring, I made dozens of drawings for money, but Kim I drew for love. We worked like we wanted to fuck each other full of art. As a test for a stop-motion film, we videotaped our hands defacing a tablecloth. Against the dark living room walls of my Roebling Street apartment, a filmmaker shot Kim as she sang one of her looped songs. On film, her hair stuck up in a shock the color of Skittles. Her shoulders were bare. Around one bicep, she'd tattooed a ring of bees.

Kim commissioned me to make her into a paper doll. In the illustration, my rock star stood in a corset and stockings against a violet background; around her I drew a circle of objects: an old-fashioned diver's helmet, tentacles, antlers, and wings. None of the objects fit like proper paper doll's clothing, but that was the point. She was impossible, after all.

Kim had funded the first half of her first solo album, *Impossible Girl*, using Kickstarter, a new crowdfunding site that helped artists raise money for projects. On Kickstarter, artists offered rewards for fans who donated. It was half charity, half presale, and to succeed at it, you needed to foster an emotional interaction with your backers that was not unlike a cam girl's bond with her patrons. To help cover the remaining costs of recording the album, Kim sold posters of my paper doll.

She toured for months at a time, passing through Berlin, San Francisco, New Orleans, Montreal. None of these cities was her home, but neither

was New York. She'd show up unexpectedly, bearing gifts: mermaid pins she'd sculpted, silk slips from Oklahoma that were too narrow for any rib cage but mine. I stripped and tried everything on in front of her.

Kim and I both had brains that turned against us. We never thought our art was good enough. To fix ourselves, we made more art, only to decide it had failed us again. Art was our heroin, injected compulsively chasing a lasting high that never came.

"Is it good?" I asked, holding my drawing of Amber up for Kim to see.

"Yes, Molly."

"No, really, is it? Is it?"

"I already told you. But I'll tell you as many times as you need."

Crash or no, New York was more expensive than ever. Each week a new art space shuttered, and each week artists fled. Mars Bar, the legendary East Village dive, slowly shut its doors, and on Coney Island, glittering old boardwalk stores closed at the behest of something called Thor Equities. Developers even bought the Chelsea Hotel, hoping to turn it into a luxury hotel. Every day, the city found new ways to signal that it belonged to the rich alone.

Kim and I were artists, so we went places we'd never otherwise have been allowed. Publicists invited us to parties where we'd pose on a bathmat serving as a red carpet in front of a wall of sponsors' logos. Inside, we snickered over free drinks. Other nights we put flowers in our hair and hid in the cloud-blue booths at a private club called the Norwood, splitting a twenty-five-dollar hamburger. I rested my head on her shoulder. We made out till we dissolved.

In April, Kim and I wanted to make something bigger, something elaborate, laborious, and eye-popping. We ran through ideas—a print portfolio, stage sets, a giant painting—before settling on something I'd long dreamed of: an animated music video. I'd always wanted to see my creatures move.

The first time I'd met Kim, at that Austin clown bar, she was singing a song then titled "The Organ Donors' March." It told the story of a girl with a bad heart who gets a new one, only to find herself transforming into the heart's former owner. A drum beat a cardiac rhythm through the song. Poring over the lyrics, Kim and I reimagined the story, creating a new version of the song as the basis of the video.

Kim renamed the song "I Have Your Heart."

We went on Twitter to look for an animator. Several replied, but only one was any good—a lanky, soft-spoken former game maker in Melbourne named Jim Batt. He was full of ideas: We wouldn't make the animation with computers. No, we'd do it in the real world of magic and accident, using paper puppets, shot with stop-motion in a sprawling paper city. The puppets would move and blink, love and die. It would be so much work, but who cared? The three of us Skyped, drinking absinthe and laughing shyly at the possibilities before us.

The Impossible Girl performed all over New York: in illegal lofts, warehouses, in a makers' space in Brooklyn, standing in front of a giant wall of

paper flowers she'd laboriously crafted by herself. Together we watched Courtney Love play a mediocre show in some vast industrial space in the Meatpacking District. When I had been an angry punk kid, Courtney Love had been my dream girl; now she was raspy and tired, a middle-aged Buddhist. I wished Kim could take her place.

After shows, Kim, Jim, and I developed the story for "I Have Your Heart."

A central European city. A hideous family. A frail maiden. And, of course, a swashbuckling queer girl pirate. I named the maiden's parents Mertrude and Jasper. I drew Jasper as a ball, his tiny legs leaping into splits when he walked. We imagined he was the lord of a vast twine fortune, which he'd squandered collecting ornamental pigurines. Mertrude was tall, emaciated, except for a bustle upon which I sometimes drew Jasper riding. Over Skype, Jim pushed me to stylize the bodies even further. I drew until I'd filled pages as big as me.

In May, Kim played in a Village jazz club; she was the most gold-and-silver thing on its tiny stage. Afterward, as we sat on my apartment floor drinking, we told each other about our secret dissatisfactions, which we could never tell anyone else.

We both wanted to make ambitious work, work that would sear the eyes. I wanted to do murals the size of buildings. Kim wanted to play to stadiums. But we were both caught in a vicious circle, never having enough cash to do the major work that would prove that we deserved to get the cash to do major work. My paintings, Kim's tours, it all cost so goddamn much to make—not to mention the cost of surviving in this city.

I lay my head on Kim's back. Her speaking voice was as sweet as her singing one, but when she was angry it came out faster.

To make art, we needed money. To make money, we needed to be more famous. But fame cost money too. We poured ourselves another round. I chewed a bit of dead skin on my lip. It bled.

We lay next to each other on a stained futon and whispered, for once

without shame, about wanting to be Bowie or Picasso or any of those men who had stood before the world and taken it all with entitlement, never asking if he was good enough. They lived in freedom. They could do anything, make anything, be anything. We wanted to be them, and we would fucking die if we were not.

My eyes grew heavy. I passed out.

I woke up with the sunlight too bright in my eyes and staggered to the kitchen, where I poured beakers of water into my parched mouth.

Kim was gone. She had left pink glitter rolled up in my sheets.

Kim spent more time with Jim on Skype. She told me they were planning music videos for her new album. The three of us were still plotting the story for "I Have Your Heart." The main character, Cora, would be a little sickly rich girl who'd fall in love with a cat-headed pirate. He'd die, in a satisfyingly bloody way. Her doctor would cut out his heart, then implant it gorily in the rich girl, saving her life but giving her a pirate-style defiance. We sketched the story in frames, then tightened them into a storyboard.

Gentle voice aside, Jim was an eager dictator, instructing me on how to make the components of our paper world. Under his supervision, I inked huge pages of brick and ivy texture. He cut them up to make the walls of buildings. He sent me plans for paper ships and he had me redraw them, then printed and assembled the ships in Australia. He gave me long lists of expressions Cora would need to make during the film. I drew different heads for her—furious, blinking, alarmed, romantic—from the front and from the side.

Slowly, the project grew real between us. Then it grew outward, into the real world. In one key scene, the cat pirate would throw Cora a handkerchief embroidered with a heart. There was no doing this with puppets. We'd have to animate it properly, frame by frame. I stood atop the flat files; Kim knelt on the floor, throwing me a piece of cloth on which I'd

drawn a sloppy heart. Fred videotaped us throwing the cloth back and forth. Then we digitized the video and broke it into frames, and I used those frames to draw the handkerchief flying through the air as it spread and folded. I drew it thirty times.

As I groused, Kim and Jim stared at each other through the tunnel of Skype. She was on one side of the earth, he on the other. I didn't realize that they were falling in love.

In June 2010, the lease came up on my apartment on Roebling. Kim decided to move on. She'd go to New Orleans, and from there to Australia to meet Jim.

I started giving away my possessions from the last eight years, things I no longer needed. The apartment grew sadder and barer. The landlord couldn't wait to gut the place and then triple the rent.

Kim played a final show in New York. The room could have been lit up by her joy. After the show, we sat together in the Norwood's high armchairs. Kim wore a silver beaded purse from the 1920s that I admired. We licked the salt that lined the rims of our cocktails. Then she went back to the bare apartment on Roebling Street. She'd given away her mattress, so she slept on the floor.

Before Kim flew away, she left that silver beaded purse on my drafting table. I opened it up. Inside sat her farewell note, scribbled on music paper.

The video for "I Have Your Heart" came out two years later. In his loft in Melbourne, Jim had used my art as the raw material to construct a world. He had built a Victorian street, a garden, and then a harbor. My heart leapt as the camera swooped over the paper galleons. But even more impressive than the scenery: the characters were alive. Jasper, Mertrude, Cora, the corrupt doctor, and the cat-headed pirates. Out of a few simple expres-

sions, printed on paper heads, Jim had created real feeling. I gasped when the pirate's blood poured over the cobblestones I'd inked, and I snickered when Jasper scuttled over the docks to prevent Cora's escape.

"I Have Your Heart" took two years to make, and three minutes to watch.

Jim and Kim are still in love.

*i*n November 2010, my cell phone showed a call from a familiar number.

"Darling! Gorgeous! We're opening a new club in London." It was Richard, his voice bubbling with enthusiasm.

"Yes?" I forced myself to sound bored.

"We want you out there! We want you to paint the whole place. The stairs. The rooms. The mirrors. The tile. The wallpaper. The everything. Think of it as your Sistine Chapel."

I paused. I'd never done a mural before. But Diego Rivera, the Mexican muralist, was my idol. He took years to paint the Palacio Nacional in Mexico City, living on his scaffolding, fucking on his scaffolding, wearing guns at his belt to wave at anyone who dared criticize him.

I wanted to be Diego. I wanted to paint walls as elaborate love letters between me and the Box's staff. When the audience entered, they'd be forced to see that they were the pigs in this hellscape. The performers were the gods.

"Yes, of course. I would love to," I told Richard. "I adore you."

That December, the Box flew Melissa Dowell and me out to London. From the airport, we took the tube to Piccadilly Circus. "Cockfosters," the mechanical conductress's voice announced, indicating the direction of the line. We burst out in giggles.

The Box Soho was taking shape in the shell of an old strip club, surrounded by gay bars, jack shacks, and bookstores with signs blinking "Sex! Sex! Sex!" When we arrived, it was a construction site, unheated in November, festooned with asbestos warning signs. A desperately polite British staff fought to get it ready in time for its scheduled opening date, while Simon and the designer made capricious changes. The budget spiraled. Simon disappeared for days at a time.

My job would call for ninety feet of murals in two weeks. When we showed up, the site didn't even have scaffolding. The builders cobbled together a platform, then watched us as we balanced on the rickety thing in our miniskirts and Doc Martens. Neither Melissa nor I knew what to wear on job sites. After the first few hours, we were caked in grit. The green dust came out in our snot.

"Don't fall. We don't have insurance," one of the staff warned me as I balanced a ladder on the staircase.

I didn't care. Wobbling on that platform, I just wanted to paint.

I started on the staircase, sketching so loosely that only I could understand my marks. "I know your secret," Melissa snickered. "To do the Molly Crabapple style, just draw like you have epilepsy."

Out of those lines, my friends started to emerge. I painted Buck, Flambeaux, and Nik Sin. Melody Sweets sang next to Rose Wood, whose tits were as massive as her cock. Waitresses in towering wigs served pig customers. When I was alone, I'd kiss the wall. "This belongs to you," I'd whisper to whatever girl I'd just painted.

I drew and Melissa filled. I shaded and Melissa gilded. We worked feverishly, racing to complete enough of the wall that Simon wouldn't tell us to tear it down when he returned.

Days passed. Simon still didn't show. We hadn't seen each other since our fight over the poster, and I started to worry that the whole job was some sort of trick. Every day, I grew more certain that Simon would appear like Rumpelstiltskin and order everything sandblasted off the walls, as

whimsically as he might order a staircase torn out. The morning Richard texted me to tell me Simon was back, I hid under the hotel bed.

At the job site, a new Simon approached us. He'd lost weight, trimmed his beard, and seemed to have stepped right out of the bath. "Love it, Molly," he said, hugging me. "Absolutely love it."

"That's who you were whining over?" Melissa laughed. "From now on, I'm calling him Sweet Philanthropist Simon."

In the Box's antechamber, I painted pigs riding the eternal symbols of Britain: lions and unicorns. The pigs were dressed as fox hunters but hunted a faceless man. Pigs threw money from trees. Women chased the fox-man. He ran up the staircase, where Rose Wood presided like a goddess. At the other end, he was thrown back out, in pig form, to persecute humans alongside his friends.

The walls were raw linen, which soaked up the paint. I diluted the paint with water, then scrubbed it in with brute force. The paint water froze. My hands cracked, then bled. Melissa added constellations in gilt.

We worked mostly nights, from eight in the evening till four in the morning, after the construction workers left. Halfway through our shifts, we overhead drunk Brits pouring out of the bars. "Why the fuck you looking at me?" one shouted. Angry grunts in reply. Then the sound of breaking glass. When we complained about the November cold, the Box gave us a heater that resembled a flamethrower in a cage.

On the builders' radio, we blared the Pogues. We screamed along, gorging ourselves with champagne and potato chips from Tesco. No matter how much she drank, Melissa never got tired. "Alcohol is a beautiful woman," she told me. "I'm not going to ditch her before the end of the night."

Artists are the fanciest of the fancy. We're presumed to exist in a rarified space requiring silence and deep thought. Because of this, the world often ignores the physical reality of what we do in favor of the ideas that animate it. The work of artists often involves skilled and demanding manual labor. Yet we're often treated more like sophisticated pets than like true workers.

This has its privileges. Unlike the builders working alongside us, Melissa and I were allowed to smoke and drink. We came in whenever we wanted. We needed no foreman, no management, and no discipline.

But art is labor, and labor is art, and both have a claim on the sublime. The construction workers and Melissa and I were all skilled craftspeople. They built the walls. Then, as they watched, I scrubbed pigment into their walls until pictures emerged. We all had dirty nails and aching backs. As an artist, I got credit for my work—even the stars Melissa actually gilded. The construction workers got nothing but pay. They were a team, unnamed, lost to history. But we all built that rich kids' paradise together.

Stone carvers once chiseled their names below the windowsills of buildings they worked on. It was an artist's signature, by people whose talent is seldom acknowledged. With that tradition in mind, I took some time in the Box's tiled VIP room to draw Sharpie portraits of the construction guys, their hard hats and lined faces. Then, with clear nail polish, I lacquered them into the tile.

Those construction workers would never get past the doormen once the club opened. But in my pictures they partied forever. They were the room's first VIPs.

That night, Melissa and I ran into Simon at the Groucho, a private club across the street from the Box. "I'm so sorry about everything, Molly," he told me, his eyes wide. "Your art is so good and it seems so easy because you do it so fast. We got off wrong, and I just want to make things right."

I was incredulous. Simon *never* apologized.

"Well, thank you," I stuttered.

"Let's do something fun." He smiled. "Let's to go to a brothel and ask the whores why they do it," he continued.

"They do it for the money, Simon," I answered, shaking my head.

"Oh." He paused, as if he'd never thought of that. "Want to go to a sex club with me?"

"I have to work for you tomorrow."

"Suit yourself." He scowled, then stormed out.

The next day Simon walked through the site, his eyes bloodshot and his beard wild. Unlike Melissa and me, he wore a hard hat. To demonstrate his kinship with the working man, he picked up a block of sandpaper and flailed at the wall. After a few minutes he gave up, ordering his assistant to finish what he'd started.

After an afternoon meeting with the Box's staff, I left for lunch. A hundred protesters from the antiausterity group UK Uncut were marching down Oxford Street toward the clothing store Topshop, carrying signs accusing its owner, Phillip Green, of tax dodging. "If you don't pay your tax, we can't pay the police!" the crowd chanted.

I watched them go by. As demands go, paying the police was a convoluted one, since police officers usually beat protesters. But I stared after them anyway, an ache in my chest.

Then I walked back to Soho. Patisserie Valerie was waiting. I climbed its rickety steps, sat at a small table, and ordered myself some cake.

While I was in London, I was summoned to drinks by Warren Ellis, a British comics writer and longtime Internet friend. Warren was the writer of *Transmetropolitan*, a famous series about Spider Jerusalem, a Hunter Thompsonesque figure who believes that "journalism is just a gun. It's only got one bullet in it, but if you aim right, that's all you need. Aim it right, and you can blow a kneecap off the world." *Transmetropolitan* is a bit of an international token among weird kids, referenced in the forearm ink of Kurdish academics, in shout-outs from Greek journalists.

Warren liked to spread his fame around by promoting young artists. A decade ago, after noticing the class satire in my college drawing of a Victorian woman on the skateboard, he'd started championing my work. We started an on-and-off correspondence, threatening to murder each other by various depraved and sinister means. But we'd met only once, for a few minutes before his signing at San Diego Comic-Con.

Melissa and I found Warren in the back room of a pub in Soho, holding court over a half-dozen comics creators he'd mentored, including Kieron Gillen and Jamie McKelvie. Warren was large, and bearded, angrily puffing on an e-cigarette as he cursed the indoor smoking ban.

"Hello, angel," he greeted me. "You're fucking late."

When he embraced me, I barely came up to his chest. Then he turned to Melissa. "Is that a dress you have on or a belt?" he asked skeptically.

Though I'd corresponded with Warren for years, he intimidated me in person. His eyes were piercing, and I avoided his stare, afraid to come off as a dim fangirl if I met his gaze. He had a South End accent, his voice as deep and sweet as old whiskey. He asked me a few polite questions; I gave him a few not especially bright answers. In lieu of words, I showed him cell phone pictures of the walls I'd just painted.

As we settled in, my attention was caught by the one girl in the group. She had a black slash of hair and a red slash of lips. She was in her early twenties, but she was so short she looked twelve, with bangs framing her pointy face and a small body that she smothered in stained black sweaters. She introduced herself as Laurie Penny.

I'd heard that name before. In 2009, Laurie had written an article about her early experiences in burlesque—complete with a screamingly offensive headline that snarked about "stripping and grinding." My burlesque friends circulated it incredulously. *Were our jobs really that evil?*

"Why the hell did you write that piece?" I asked. "I danced burlesque for years and don't remember anything quite so dystopian."

She laughed—an adorable, elfin laugh, nothing like how I thought

she'd sound. "That's what editors want from you when you're a young woman. I pitched at least twenty straight politics stories before I got my first two pieces accepted in the broadsheets, and guess what they were about? Stripping and eating disorders. Both from personal experience. It's ironic, really. Even as a writer they want you to start with your body, with your personal pain, before you get into the broader arguments."

I smiled, in spite of myself. "I know the feeling. The main thing I get paid for is drawing sexy girls. You're always selling girlhood, one way or another."

"Yep." She nodded. "Before you can be an artist, an activist—any kind of thinker—you have to be a girl first. And the right sort of girl, too," Laurie said. "It pisses me off. Because the real story is always more complex than the one they want to hear. Even the story about being a girl."

"What were those protests I saw yesterday, going down Oxford Street?" I asked, changing the subject.

Laurie's voice sped with excitement. The marchers were part of a student movement against university tuition hikes that had been forced through the month before by David Cameron, the prime minister. The protestors had actually taken over a chunk of University College London.

"Then they went out onto Oxford Street and started shutting down the big department store one by one. You've got to understand—this *never* happens in Britain," she told me. "Not in our generation's memory, anyway. Everyone just grumbles and gets on with it."

"What changed?" I wanted to know.

"Austerity is biting down hard," Laurie explained. "Young people feel like they don't have a future, like they've been cheated, and they're right. Two weeks ago they stormed the Conservative Party headquarters and occupied it for hours. Smashed in all the windows, lit fires in the courtyard, held an impromptu rave—thousands and thousands of them, completely overwhelming the police. Nobody saw it coming."

As we talked, the comics boys faded away.

We shared a final cigarette with Warren. I hugged him good-bye, regretful that I hadn't said anything more clever. Then Melissa and I walked home, past the Italian coffee shops on Dean Street, through the narrow Saint Anne's Court, I didn't want to leave, but back at the Box, I had miles of wall left to fill. I promised myself to read more of Laurie's work.

Before I returned to work I sat in the upstairs office, went to the *New Statesman*'s website, and looked up an article Laurie had written in mid-November about student protesters who'd smashed the Tory headquarters in Millbank. I read the first paragraphs.

*One hundred years ago, a gang of mostly middle-class protesters had finally had enough of being overlooked by successive administrations and decided to go and smash up some government buildings to make their point. Their leader insisted that when the state holds itself unanswerable to the people, "the broken pane of glass is the most valuable argument in modern politics."*

*That leader was Emmeline Pankhurst, and the protesters were the suffragettes.*

I devoured the article. Then I read another. Then a third.

Laurie's beats were protest and feminism. Her columns tied together the students on the streets and young women's more personal rebellions. She wrote dramatically—as if the stakes were massive—with blood and honey and fire.

As I went back to painting my wall, lines from Laurie's articles ran through my mind. She was so brilliant, so engaged with the world. She read all the books I'd never had time to even skim. She'd been to Oxford. She knew about politics and violence. She had thoughts worth writing down.

I scrubbed paint into the raw linen covering an alcove. The dancer started to flesh out, curvaceous and inviting. I daubed her lips red. I felt nauseated, like I'd eaten too many marshmallows. I was working on a grand scale, but what did the work mean? When I was seventeen and drawing at Shakespeare and Company, art felt closer than my skin. I'd cared about things beyond professional advancement. I used to think my pen could fight me into a new world.

But for the past few years, I'd let that part of me die. What had started as a scramble to scrape together enough resources so I could afford to draw had become an obsession with the resources themselves. I was twenty-seven, three years older than Laurie. I'd spent years—wasted years?—doing work for cash instead of desire. After ignoring the deepest parts of myself for so long, I wondered if I could even find them.

The next morning, I emailed Laurie:

Melissa and I would like to take a crusading journalist with a black bob out for a drink, if she has free time.

Laurie couldn't make it out for drinks. She was living full-time now with the student protesters at University College London. Instead, she invited me to visit her.

"Come to the occupation," Laurie wrote me. "There will be tea."

*t*he occupation of the university turned out to be confined to a far smaller area: the Jeremy Bentham Room, named for the school's philosopher-founder. Several hundred students filled the columned space on UCL's ground floor. Bored security guards stood outside, but otherwise left the students alone.

Piles of sleeping bags filled up one corner of the room; alongside tables full of drinks and snacks. The walls swarmed with homemade political banners. One bore a quote from Bentham himself: "Let all come who by merit deserve the most reward"—with the word *merit* angrily scratched out and replaced with *wealth*.

When I entered, I found the room crackling with conversation. In the room's center, a few dozen students sat listening earnestly to a speech. To indicate agreement, they used a gesture from a consensus-based decision-making procedure: holding their hands up and wiggling their fingers.

But for all their passion, the occupation felt like playacting. *Wasn't this really just an occupation of a room*, I wondered. *The rest of the university seems to be going about business as usual. And if the authorities really want the students to leave, wouldn't they just have security kick them out? They haven't exactly barricaded themselves inside.*

Through the crowd, I saw Laurie's head, topped with a Russian fur hat. She darted up and hugged me hard. "Molly! You made it! Do you want some tea? Or some food? There's loads of it—people's mums keep turn-

ing up with supplies." Then she scurried away, distracted by a handsome student organizer.

I grabbed a biscuit from the overflowing table. These food ziggurats would be ubiquitous at every occupied newspaper, school, and workplace I later visited, augmented constantly by supporters trying to show solidarity.

After a few minutes, Laurie reappeared and grabbed me again. "I should show you the Slade! You're an artist, you'll be interested. They've given up all their projects to work on collective art. Most of it's very silly, but the principle is endearing."

The Slade was a famous art school, adjacent to the main buildings of University College London. She led me out the door and through the paths over to Slade's neoclassical exterior. Student protesters had hung banners there reading "Artists Against Cuts" and "Slade Occupied." As we walked, Laurie rolled cigarettes and puffed on them as she talked.

"The police are getting an injunction to evict the students," she told me. "Last I heard, their plan was to get naked and cover themselves with lube to make it as awkward and slippery as possible for the police to manhandle them out the doors. I like it. Resistance as performance art, I suppose."

She led me up the stone steps, through the door, then up a wide staircase to see the studios belonging to the master's students.

The studios were fairly large, but the art was comprised mostly of amorphous brown paintings and bits of fabric tacked to the wall— the sort of work John and I once mocked at FIT. "If only

I got free studio space at art school!" I laughed. "I would have killed for a place to work like this!"

"In the UK, the whole reason we had such incredible art and music for so many decades is that kids from working-class backgrounds were given space and time to study art for free, or at very low cost. The Beatles came out of the London art schools. So did Bowie."

We stopped to talk with a group of Slade students by a wall of windows overlooking the lawn. One young woman told me that the administration was constantly threatening the students with eviction, but the security guards didn't really want to carry out the orders. Guards were working people too.

The Slade was one of a dozen occupied universities, from Bristol to Edinburgh, where students were aiming to prevent what one young protester, in a BBC interview, called "savage cuts to higher education and government attempts to force society to pay for a crisis it didn't cause." The nation's guarantee of cheap university education—even cheap art school—was part of a humane system that treated humans as something more than workhorses.

Outside, Laurie smoked the last of her tobacco. She pointed to a sign on the lawn that read "This Is Actually Happening."

"It feels like everything is changing," Laurie said. "I think that's how you start to change the world. First, you change the terms on which you relate to the world. And nothing's ever quite the same."

On breaks from painting, I checked Twitter on my laptop in the Box's upstairs office. With each new update, the student protests seemed to be getting more daring and more dangerous. On November 30, police officers kettled students in Trafalgar Square. Trapped there in the snow, some burned their placards for warmth. Hundreds more ran through the streets, trying to evade beatings from police truncheons. "I Can't Believe It's Not Thatcher," they chanted. Protesters from UK Uncut superglued closed

the locks of Vodaphone and Topshop stores, forcing them to shut on the busiest shopping days of the year. At the Tate Britain, students in dunce caps disrupted the Turner Prize.

In one photo, an organizer for UK Uncut stood in front of Topshop, demanding the store's owner pay his taxes so the government could preserve low-cost university tuition. A heckler had accused him of wearing a Topshop shirt, so he had ripped the shirt off, revealing a chiseled torso. I sat there in the Box's office and drew him—the first time in ages that I'd drawn the present instead of taking refuge in a curlicued past. I needed to drop the ruffles, to draw something more violent and vivid. I grabbed a fat marker and scribbled in simple black lines, letting emotion guide my strokes. I drew to spite my caution.

That small drawing was the start of something new, but I didn't know it.

I refreshed Twitter, scanning the accounts of the occupied universities and UK Uncut. Finally, I slammed the laptop shut. The wall was calling. We had vast sections to fill.

What did it mean, my garden of pigs and gold? What was I doing here? As I sat on the platform, blasting the Pogues, the city outside was throwing kids in cages, in the opening salvos of a battle that still hasn't stopped. What was I doing on a job site? What sort of compromise was it to work with the Box, hiding my subversion between the cocaine and breasts? Sure, there was satire in my mural. Sure, the staff would get it. But wasn't it just cheeky wallpaper for the rich drunks who filled the club?

Which side was I on?

Before work, I drank cocktails at the Groucho. Simon staggered in, a girl on each arm. "You're fired," he screamed, at no one in particular.

"They don't work for you, Simon," I hollered back.

"You're fired too," he snapped.

"I don't care," I responded.

Simon staggered out.

My last two walls at the Box flanked a dark passageway next to the VIP room. I'd planned to fill them with balloons made of rococo women, but that final night I couldn't lift my arm.

Melissa had wandered off to take selfies against her wall of stars. When she came back to check on me, she found me curled in a fetal position. "Get up!" she ordered.

I pried myself up.

"It's either you or me, you fucker," I said to the wall, then grabbed my palette.

I thought of Diego Rivera painting the Palacio Nacional. For six years he attacked the walls with his tableaus of workers, soldiers, and lush naked women whose bodies somehow represented communism. Diego, who worked for Rockefeller, and painted revolution, and apparently saw no contradiction. What were my two weeks next to his years?

I forced myself onward, relying on muscle memory. I closed my aching fingers around my brush, unable to tell where it started and I stopped.

Earlier that day, students had marched down Oxford Street. Standing on the sidelines, I'd tried to draw them, jostled so often that some of my sketches were just jerks of the pen.

A protester grinned at me. "Don't get arrested," he teased.

*What cheekbones. What a voice.*

"You neither," I called back.

The crowd kept marching. I returned to my walls.

Was the boy arrested, I wondered. I blended the paint on an aristocrat's cheekbones with my fingertips. I hoped fervently he was not.

Then the last rococo girl was done, and the wall with her.

Letting the brush slip from my fingers, I lay down on the icy floor. Melissa stood over me, laughing. "Go away!" I groaned. I didn't know if I'd ever get up again.

On the cab back to the airport, we passed Trafalgar Square. A protester had spray-painted the word *Revolution* on the base of Nelson's Column.

I pressed my forehead to the glass. *How many times can I smile for Simon*, I wondered. With my nail, I dug at my paint-stained palms till the skin was raw. But the color stuck to me. It would take a week to get off.

*How many times can I put this mask on before I have no face left?*

The cab pulled up to Heathrow. Dragging suitcases weighted down with art supplies, Melissa and I ran for the plane.

In the winter of 2010, the world started to burn.

I was painting pigs in Nero's nightclub.

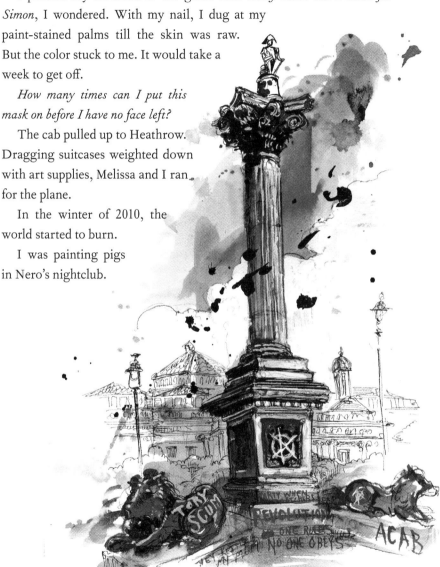

## 25.

When I returned from London, nothing was the same.

In the last days of 2010, the world was exploding. The London protests continued. In front of Parliament, police officers beat students carrying shields painted to look like books. In Tunisia, protests broke out against the dictator Zine El Abdin Ben Ali after a young fruit seller set himself on fire to protest a policewoman's destruction of his cart. In Egypt, protestors fought the military dictatorship. In Greece and Spain, the Indignados movement decried the austerity programs forced on them by the EU. Solidarity emerged from unexpected quarters: When union members in Wisconsin took over the state's capital building, Egyptian activists showed their support by ordering the protesters pizza. These were small gestures, magnified by the Internet, but they hinted at something: from Tahrir to Madison, protestors were watching each other, finding common cause.

Soon, tent cities appeared in city squares from Athens to Madrid to Cairo. Many of those who took up residence in those tents had never before considered themselves political. The encampments had soup kitchens, libraries, first aid stations—and media centers. Governments cracked down, and the camps became war zones: each day, protesters uploaded photos of police repression, the air full of rubber bullets, tear gas, and defensive Molotov cocktails.

From our loft, I watched Twitter as young Egyptians chanted, "The

people want the regime to fall!" I marveled at their bravery. *Americans complain about bankers wrecking the economy*, I thought, *but they'd fight back like that.*

The protest encampments spreading across the world were preceded by, and sometimes inspired by, massive leaks of secret government documents.

In 2010, the transparency group WikiLeaks began releasing information that the United States wanted hidden. It started with a video called *Collateral Murder*. Footage taken in Baghdad in 2007 from an Apache helicopter showed American pilots joking before they gunned down two journalists. Then they opened fire on a car that stopped to help. They were war pigs with a heartland drawl—soldiers from a country that believes its military consists exclusively of heroes.

After *Collateral Murder*, WikiLeaks kept releasing information—hundreds of thousands of pages' worth. Transcripts of Guantánamo tribunals. War logs revealing torture and murder in Afghanistan and Iraq. Diplomatic cables detailing the corruption of America's allies. The document dump made WikiLeaks's editor in chief, a white-haired hacker named Julian Assange, into an international celebrity—and a global target. These combined attentions magnified his already significant faults. When two Swedish women accused Assange of sexual assault, he fled to London.

In May 2010, less than a month after newspapers ran the first diplomatic cables, the US Army arrested a young private, Chelsea (then called Bradley) Manning, for the leaks.

They locked her in an outdoor cage in the Kuwaiti desert.

Back in New York, I kept drawing my foofy burlesque girls for T-shirts, books, and magazines. But on the Internet I kept following the worldwide political upheaval.

I loved my artist friends, but the life we led no longer seemed relevant— 237

forever comparing turpentine textures, angling for gossip about which CEO had bought which painting for how much money. My friends seemed to live in a different universe from the world that was exploding online. And so did I.

I hated myself. I wanted to do violence to my clichés.

*Week in Hell*, my first real art project, was born of this discontent. The idea was simple: I'd lock myself in a hotel room, cover it with paper, and draw until I broke. It wasn't about hell—except perhaps the hell inside my head. It was about being left alone, with nothing to do but draw, nothing to look at but the lines that poured from my fingers.

Melissa and I decided to pay for *Week in Hell* using Kickstarter, the crowdfunding website that Kim had used to fund her *Impossible Girl* record. We planned to cut up the art and sell specific sections of paper for specific amounts. People who contributed even a dollar could watch me draw. Some people thought crowdfunding was begging, but I considered it a way for disobedient artists like me to compete with those who had galleries, grant money, and trust funds.

I finally posted the Kickstarter page on Sunday night. By the next morning I'd raised five grand, enough to rent the hotel I needed. In two weeks, the Internet gave me twenty-five thousand dollars—committing me to draw more than two hundred and fifty square feet of art. Some of the contributors were friends and longtime supporters, but most were strangers. After a decade of throwing Dr. Sketchy's classes, drawing comics, and painting burlesque girls, people had slowly discovered my work. Now they were helping me create more.

I chose the dates of *Week in Hell* to line up as near as possible with my twenty-eighth birthday. We needed a hotel suite, to give me enough wall space to accommodate the two hundred and fifty square feet of art I'd promised. First we booked a suite at the Chelsea. But after developers bought the hotel, they kicked out its long-standing residents and revoked all bookings, including mine. Then we tried the Ace Hotel, but when I

told them about my plans, they refused to book a room for me. All such "artistic collaborations" had to be reviewed by their creative director for "brand consistency," I was told.

Finally, we settled on the newly revived Gramercy Park Hotel. This time, we didn't tell them what we were up to; that way, they'd have no chance to object.

As the date approached, I grew fearful. It was the first time I'd ever stretched myself like this: not drawing for a client, just seeing what I could do on my own. But it thrilled me too. As I filled those sheets of paper, my old self would be discarded. A new self would take her place.

On the first day of *Week in Hell*, we hid the rolls of paper inside a suitcase that would have been large enough to hide me too. Melissa and I dressed up the way I imagined people who could afford to stay at the Gramercy might dress. When we got to the reception desk, I was shaking, certain they'd discern our plan. But they blithely handed us our room keys. Melissa and I were guttersnipes in the house of power. We soaked it in, grinning at each other with wide, sneaky grins. Then she closed the door behind us.

The room echoed around us, its pink walls punctuated by a blue velvet headboard and a vast chaise lounge. The minibar had goblets cut from ruby glass. It was a cloister of expensive silence. No one had stopped us.

We got up on the bed and jumped.

As I stretched out on the bed, Melissa covered the walls with paper. Then she left me to my own devices.

I turned on my laptop, logged into Ustream, and sent the link to my backers. I turned the camera toward myself, smiled, and waved.

Then I began to draw.

I started above the bed, drawing a giant face vomiting girl-things. I hoped the image would influence my dreams. Then I took on the walls: Camels and mermaids holding up umbrellas to collect rain. An undersea Algonquin round table. A Green Man over the TV. I drew for ten hours

and then collapsed, shaking, in my old sweater. Then I got up again and twirled around, singing.

I kept the livestream on for five hours a day. Viewers passed in and out, giving me suggestions for what to draw: lemurs and lampreys, anglerfish luring mice. When they yelled at me for blaring the same songs over and over, I stuck my tongue out at them. They goaded me to draw even more. I had guests, but over the week that stream was my most constant companion.

I may have stayed glued to the wall, but the room was a circus around me. Friends brought whiskey. Photographers, press, and videographers circled inside and out. Steve Prue came to shoot me for a *Week in Hell* art book. Girls visited. My friend Katelan Foisy, an artist and a witch, lay topless on my bed while I sketched her on the wall. I drew angry faces on her nipples. Amber Ray stopped by. I drew her portrait, with dozens of coke-snorting piglets forming an intricate lace over her eyelids. When I finished, she kissed her portrait's lips. That red was the only color on my walls.

An accordionist from LA played for me, and Lauren, a young, red-haired photographer, strummed the ukulele. Dante Posh, a beautiful dominatrix, all cheekbones and legs, stood in the bedroom in short shorts. I drew her as a statue, with her customers as pigs, laying flowers at her feet.

Then Stoya came over.

In 2011, Stoya was arguably the most desirable woman in the world—or at least in the pornographic world. She was also a close friend. We'd met at some forgotten party and decided we were both evil witches, with our cigarettes, fur coats, and sharp tongues, and then we started to make art together.

I hate the word *muse*, but Stoya was mine. I drew her over and over. Later, I even drew *on* her—a series of New Orleans tableaux over her neck and back—as part of a collaboration with the photographer Clayton Cubitt.

A former ballerina, Stoya had kept her dancer's flexibility. I loved drawing her hard stomach and her shoulders, so thin that every detail of muscle stood out. Her narrow eyes were skeptical against the mathematical beauty of her face. Aside from a trademark mink, Stoya dressed in pure slobcore: worn black leggings, black T-shirts falling off her shoulders, hair twisted into a bun. She was too lovely to attract me physically, but her mind fascinated me. Stoya spoke in a girlish whisper that made her contempt for idiots sting harder. Because she was in porn, she was used to the world underestimating her intellect.

Stoya loved avant-garde dresses from Comme des Garçons and avant-garde books by George Bataille. She was working to organize porn performers into a political force. She was reckless, confident, and, above all, free.

I could never draw Stoya as beautiful as she was. Instead, I tried to capture her cleverness.

I devoted one panel of the door just to Stoya. I drew her sylph's cheekbones and mocking brows, then turned her face into a hot air balloon. I started to weave in threads of our conversation, drawing her as much from imagination as from life. Stoya told me she'd just gotten back from Moscow, where a Russian instructor had trained her in acrobatics using the lyra, an aerial hoop. When she made a mistake, the instructor would whack her leg back into place. That's how she knew he cared.

I drew Stoya dangling from a balloon, then filled its basket with tiny Stoyas gluing crystals along the edge of a peacock tail that Stoya had recently constructed for herself.

As I drew, Stoya told me about the latest porn convention she'd been required to attend by the porn company she worked for. For six hours she sat at a table, signing autographs and posing for photos with fans. Then the security shepherded her and her fellow contract performers to a nightclub, where they had been booked to host a party. All day and night, she was trailed by amateur photographers. I worked them into my drawing, lizards floating around the multiplicity of Stoyas.

I woke up and drew and drew until I fell asleep, pausing only to make coffee. My dreams burned. Often I jolted awake in the middle of the night, grabbed the marker, and drew for an hour to soothe myself. I couldn't let the maid in or order room service, so as not to tip off the hotel. Instead, Melissa dropped by every day with food.

Fred visited me only once, but that week he was an interloper. This romance was between the room and me. Each night I would sink into the comforter, rubbing myself, then stare at the walls, planning to conquer them like the Ottomans conquered Constantinople.

As the days passed, I started moving away from drawing girls. The old inspirations were bleeding out of me. New ones, more contemporary and violent, took their place.

I scribbled a five-foot squid with books in its tentacles, inscribing the WikiLeaks slogan, "We Open Governments," on its crown. I drew a pug dog in an ersatz military cap, his face resembling a Botox-mottled dictator. To represent war, I drew hundreds of girl-things lining up, climbing a ladder. Once on top, they gleefully jumped into a fire. Only midway did they realize what they'd done. They burned alive, and their ashes floated onto the heads of their sisters, as they waited, oblivious, to join them in their fate.

I didn't plan this, any of it. But it felt preordained.

After five days, I'd filled two hundred and forty square feet with art. At the end of the last wall, I drew myself as a tiny girl-thing, signing my own name.

The livestream was on when I finished. Ten people were watching. I pointed the camera at the wall, then toward me. I had a dotty grin. "I did it," I gasped. Then I slid down the wall and lay on the floor, propping my face on one hand. "We did it."

The ten usernames typed emoticons of applause.

We sat alone, each in our boxes, grinning at each other.

I finished the last wall on September 9, 2011, four days before my twenty-eighth birthday.

That night, Melissa planned a party for me. Everyone I loved filtered in through the door of Gramercy Hotel's Lexington Premier Suite.

Jo Weldon and Amber Ray. Yao Xiao, a young illustrator who helped at Dr. Sketchy's, brought me enamel nail-guards like those once worn by Chinese aristocrats. Melissa posed for Polaroids in her garter belt. Jen Dziura came in her white cashmere coat. And John came too—John, my best friend.

I lay in bed, without taking off my Louboutins. I couldn't get up.

This was the New York I'd dreamed of. It was Frida's parties and Colette's Paris and everything I'd read in books—all of it here, with girls pressing around me, posing for pictures against my art. They were so beautiful, and so rare, and I kissed their smooth cheeks. How could anything be as right as this, right now?

John stripped. I stripped. We jumped on the bed. I hit him with my pillow and he slugged me hard with his. We went down, then sprang up again.

"You are a work-obsessed monster!" he shouted.

"You never worked at all!" I yelled back.

We hit each other, over and over, until we collapsed on the bed, covered in sweat. Naked except for his violet underwear, John lay belly up, panting.

"I won!" I screamed.

"Only because I let you," he answered.

I woke up the next morning unable to move. My mouth tasted like ash. "Water," I gasped. The photographer Steve Prue and a videographer were there to document the pack-up. Melissa rolled the paper back into the suitcase, ripping long strings of paint off the wall, then frantically patching it where needed.

Without the art, the room was a shell. So was I. In that room, I'd emptied myself of reserves I didn't know I had. Now I was dying to leave.

The hotel disgorged us blinking into the sun, those crawling walls rolled safe in the suitcase. I stood on the street in my dress, its shoulders poking out like an exoskeleton. I didn't know it, but in a week, everything would change.

On September 17, 2011, I walked down to the National Museum of the American Indian, on the southern tip of Manhattan. A few dozen protesters sat on the steps.

One man held a sign reading, "I Can't Afford a Lobbyist. I Am the 99%." He was part of a small group of protesters calling themselves Occupy Wall Street, who were protesting against financial corruption, against the influence of money on politics, and for the vast majority of Americans who made too little income to be enfranchised in the American system. Looking at that lone protestor, I couldn't know that Occupy would soon come to stand against much more: against violent cops, the control of public space, unfair deportation, systemic corruption, endemic capitalism, and war.

After the protests that had torn through the rest of the world, America felt primed for something big. But what that might be, few people knew. In late June, activists with a group called New Yorkers Against Budget Cuts had been trying to sleep on the streets near the Federal Reserve. Then, on July 13, the Canadian anticonsumerist group Adbusters called for something more grand.

"Are you ready for a Tahrir moment?" the Adbusters website asked.

*Well, obviously,* I thought.

The website called for twenty thousand people to "flood" into New York's financial district, to set up a home base there, and to "occupy Wall

Street" for a peaceful protest based on their idea of the Egyptian revolution. "Following this model," the posting asked, "what is our equally uncomplicated demand?" But it left the question open.

Beneath the hashtag #OccupyWallStreet, Adbusters ran a photo collage of a ballerina balanced on Wall Street's famous bull. Smiling beatifically, she stood en pointe, her arms floating, one leg in arabesque. Behind her, tear gas swelled, barely obscuring hordes of rioters in what I presumed was the revolution.

Adbusters had marketing as slick as any corporation they critiqued, but that poster caught my heart.

Still, I went down to the protest with low expectations. I imagined it would resemble all the others I'd been to since the days of the Iraq War protests. There'd be a small crowd on a street corner, hollering conflicting slogans and waving signs for five dozen different causes. I'd stand around, feel vaguely embarrassed, then leave without telling anyone I'd gone. I kept going to protests in the same way many go to church: because I really ought to, no matter how futile it was, and it couldn't do any harm.

At first, Occupy didn't shatter my expectations. With a crowd closer to a few hundred than the twenty thousand Adbusters had hoped for, this was no American Tahrir. *At least I showed up*, I thought. After standing dutifully for half an hour, I left.

As the day passed, though, the Occupy Wall Street crowd swelled to two thousand. Then, as night fell, a hundred or so protesters started camping in Zuccotti Park.

Just a block from our apartment, Zuccotti was an unlovely square of concrete, half a city block in size, owned by Brookfield Properties, a real estate company. In the spring, construction workers working on the Freedom Tower across the street sometimes ate their lunch in Zuccotti. Otherwise, it was empty, as sterile as all corporately owned public space.

Still, there in Zuccotti Park, beneath *Joie de Vivre*, a seventy-foot sculpture made of crimson beams, the protesters stayed.

Later that night, I stopped by the occupation. That was a rainy September, and I came bearing an armful of plastic tarp to protect the protesters.

A few people stood with their "We Are the 99%" signs. I saw a few crust-punks in sleeping bags, some dreadlocked white dudes pounding it out in a desultory drum circle, a few tarps tied to Zuccotti's trees as makeshift shelter. Someone had left a stack of books on the long ledge bounding the north side of the park.

At the park's Broadway entrance stood a card table with a small, hand-lettered sign reading "Info." It was empty, and no one seemed to be in charge. I left the tarps next to the tree, hoping they'd be put to good use.

I spent a week in London, working on some art commissions. On September 24, the day after I returned, I met a few journalist friends for lunch in the East Village. Since winter, we'd all been obsessed by the previous year's student protests in England. The conversation turned to Occupy.

"What do you think?" I asked my friend, who'd recently written a short piece on Occupy. "Is it just the same old white guys with dreads doing the same old protest?" I secretly hoped she'd say no.

She said she admired what she'd seen, but was still skeptical about the movement's future. "We've all seen too many mediocre marches that burned out and solved nothing."

I took a bite of my bacon. "Plus, can we kill all drum circles?" I asked, pretending not to care.

I left lunch early to get back to an illustration job. That afternoon, the sun shone hot. As I walked toward the subway at Union Square, the sunlight blinded me. I heard the march before I saw it.

"All Day! All Week! Occupy Wall Street!"

Broadway was flooded with hundreds of protesters. They were walking right down the center of the street, blocking cars with their bodies. Drivers honked, many in approval. They were far from the white hippies my prejudices had led me to expect. These were old ladies and young black women and hard-looking construction guys. One girl held a sign that read, "One day the poor will have nothing to eat but the rich." She was black, with a round lovely face framed by braids.

"Join us," she screamed.

I gave a brief thumbs-up as I watched her go by.

As I stared at the crowd, shame filled me. My dismissal of Occupy over lunch was nothing but a defense against disappointment. These were the protests I'd been hoping to see in America. But why wasn't I joining them? Sure, I had work to do, had my drawings and deadlines. But if I didn't join them, why should anyone?

I looked over my shoulder as I walked away.

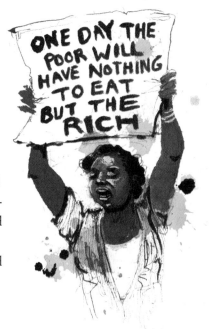

Later, from the news, I learned that the September 24 march had ended when the NYPD brandished its orange netting—a stiff plastic material designed to contain human beings. The cops whipped it out faster than the protesters could run. As they stood there, trapped, an NYPD officer named Anthony Bologna pepper-sprayed two girls in the face.

The girls sank to their knees. They screamed in agony, their slim hands clawing at the air. Their screams were uploaded to YouTube, then replayed on TV. Still photos of the incident ran in the papers. The NYPD has killed or beaten thousands of black men, but these girls were a different story. White, slender, lovely, these girls' screams won Occupy international sympathy, even as they exposed one of its greatest problems.

That day, several brown male protesters were also assaulted by the police. While those attacks were also caught on camera, they got nowhere near the media coverage. Focusing on police abuse of white protesters often meant diverting attention from those whom the police have always abused.

IF A CORPORATION were really a person, it would be A SOCIOPATH

OUR LIVES BEGIN TO END THE DAY WE BECOME SILENT ABOUT THINGS THAT MATTER

The next day, I went over to Zuccotti Park.

The occupation had grown since I first visited. What were once a few sleeping bags had swelled into a mini society, a ragtag David dogging the heels of Goliath. After the economic crash of 2008, the government had bailed out criminal banks, deeming them "too big to fail." Banks who helped crash the economy squandered $18 billion of this money on bonuses.

"People come here because they want to work hard and get paid a lot for working hard," one anonymous investment banker told the *New York Times*, in defense of his bonus. In the same article, an insurance broker claimed that criticizing these bonuses was a slippery slope to "socialism."

Ruined homeowners received no such handouts.

In the fall of 2011, anyone could see there were two Americas: the America of the ultrarich, and the America of everyone else.

Economics aside, Anthony Bologna's pepper spray was the fuel that made Occupy's fire spread. More people came down to the park to check out the protests they'd seen on the news. An activist sat at an info table greeting new visitors. There was a tech tent, with its own Wi-Fi hotspot to handle livestreams, and laptops from which press people dealt with the endless media inquiries. There was a soup kitchen, sometimes run by a gourmet chef who'd been laid off from the Sheraton, and a medical tent with real doctors. Protesters created two newspapers: *The Occupied Wall Street Journal*, and the Spanish-language *IndigNación*. Later there would be a toy-filled area for kids to play. Union members hung one tree with their helmets. There was even a table offering free hand-rolled cigarettes. Strangers worked together, planning to reform the economy or take down the museum system or just make sure Zuccotti Park stayed clean.

I walked over to the north side of the park, where that pile of books had sat on the first day. Now the stack had swollen to a battery of crates— labeled "Politics," "Theory," and "Fiction," all organized by real librarians. A whiteboard listed a schedule of signings by famous authors. Ever since they'd appeared in the Puerta del Sol protest camps of 2011 in

Madrid, Spain, libraries had become a fixture at occupations worldwide. What was more peaceful than a book? Or more dangerous?

I added some books from my shelves at home.

As I walked west, the tents grew thicker. This was the side of the park where a hundred people lived. These crustpunk kids were the backbones of Occupy; without their presence, the square would have been evicted within days. A boy in a Guy Fawkes mask—the symbol of Anonymous, the hacktivist network—beat a drum. On the sidewalk of the park's northwest corner was a luxuriant display of cardboard signs. "Shit Is Fucked Up and Bullshit." "Take Money Out of Politics." "All Cops Are Bastards."

Occupy was a participatory uprising. Anyone was welcome, and everyone was needed. You didn't have to speak theory. You could cook food, wash dishes, or donate books. Or you could just stand your feet on Zuccotti's concrete, occupying ground in the most literal sense. In a city where every use of public space is regimented from the top down, Occupy allowed people to build something up from the bottom.

For the first time, outside of my *Spread* sex worker activism, I felt like I had a right to contribute to a political space. Leftists can be as welcoming as vipers, but in Zuccotti they came together. Teamsters stood shoulder to shoulder with Brooklyn party promoters. The park's generosity rubbed off on me, even if my conversation partners sometimes nodded off from heroin. But mostly I was silent, wandering and smiling.

Every day, marches took off from the park to locations around Manhattan. Occupiers marched in solidarity with striking art handlers and victims of police violence. Leaflets called these marches "trainings." Their purpose was to build bridges to unions and anti-incarceration groups, and thus to make the movement grow.

There were small marches, on sidewalks rather than in streets. Police officers darted into the crowd at random, arresting people who'd been profiled as leaders. The arrests I saw were violent; one person was thrown to the concrete, a boot on his back.

After Occupy began, the police barricaded the financial district's most potent symbol: the Wall Street bull. Ironically, the giant bronze bull was not a commissioned piece of art but a guerrilla one, left there by the artist years ago as a gift to New York. Its testicles had been polished by the hands of a million tourists, but if protesters touched those balls, capitalism might have fallen.

The barricades stayed up for three years.

Zuccotti enchanted me. Fred and I had some money, and our loft gave the illusion that we had more. But I remembered the powerless girl I'd been. I'd beaten a treacherous system, but the system was still broken, and my hold was precarious at best. No matter how far we'd come in New York, or how fancy our high heels were, my friends and I were always a slip from ruin. I wanted to help in any way I could.

At first I was too intimidated to talk to the Occupy organizers, afraid they'd see me as a flaky former naked girl. Fortunately, Occupy had a webpage set up to take donations for bailing out protestors who had been arrested. I started giving them a percentage of money from my print sales. Then I auctioned off some original art on Twitter. I also drew a poster of a vampire squid—the journalist Matt Taibbi's metaphor for rapacious banks—that was bold enough to work as a protest sign, and put it online. It was downloaded all over the country.

Soon I was coming to the park every day, bringing art supplies with me, quietly absorbing the unfolding scene. Because I wasn't close to the organizers, Occupy seemed to me a miracle of decentralized protest—something enabled both by the Internet and the Occupiers' constant presence in an outdoor public space. I'd be standing somewhere in the park, and someone would shove a flyer into my hand, advertising a protest later that day. I'd go home, draw, then come back for the march. I was a follower, not a leader. I lent whatever support an extra body was good for.

"Guys, are Occupy Wall Street or other related activities gonna continue until the weekend? If they are, and I can stay with you, I'm on a bloody plane tomorrow. SAY YES SAY YES," read Laurie Penny's email.

Outside my window, protesters screamed: "All day, all week, Occupy Wall Street!"

I wrote back. "My apartment is probably the most convenient place in NYC to cover the protests from. Been visiting every day. It's still lots of crust punks and consensus decision making, but for god's sakes the kids are doing something and I'm tentatively hopeful and have been supporting as best I could . . .

"The people aren't as awesome or together or organized as in London, I warn you."

Since last December, Laurie's profile had exploded. She had argued on the BBC and debated old men at the Oxford Union. The media used her neon hair as a signifier of rebel youth. But Britain eats its favorites, chewing up women with special delight.

Conservative bloggers tried to blackmail Laurie with old photos of her drunk and topless at university. Leftist protesters excoriated her for being too ambitious, too credentialed, too posh. The media was cruel enough to label her the voice of her generation. Her generation didn't think any one person should be its voice.

When Laurie showed up on my doorstep to cover the two-week-old occupation for *The New Statesman*, she was chasing a protest high that was fading fast in London. But she was also looking for a space to be more than her media caricature.

Laurie stayed with the journalist Sarah Jaffe but she often slept on my floor. She wrote her columns at my kitchen table, hunched over a laptop covered in stickers reading "Make Out Not War." I drew her portrait as she worked. Every so often, she'd take a break and show me music videos made from footage of students smashing the Tory headquarters at

Millbank. Broken glass flew like tinsel. An acquaintance down at the People's Library, Stephen Boyar, a queer kid with glitter-lined eyes, was compiling a Zuccotti Park poetry journal. I sent him my drawing of Laurie at her laptop; he put it on the anthology's cover.

Laurie and I stayed up all night, smoking and drinking milk-drowned tea, and discussing the Greek and Spanish antiausterity protesters. We talked about Egypt, where the revolutionaries had succeeded in toppling Mubarak, but it looked like the Muslim Brotherhood would win the first democratic elections in the country's history. We talked about the London student protests, which were fading into nostalgic memories. In the fall of 2011, everything felt connected: crowds rising up against police repression; the Internet out-organizing established institutions; tent cities across the world; mutual aid; single, brave individuals like Chelsea Manning standing against governments.

Politics needs stories. These were lovely, if simplistic, myths, and they served us well that autumn. But myths aren't enough, for a person or a movement.

Though protests like those in Greece, Egypt, Spain, or New York spread quickly, they were rarely preceded by the dull years of organizing that movements have traditionally required to grow and sustain themselves. Because of that, they stood on fragile ground. Governments are old machines, built more strongly than we realized. They kept outflanking the ecstatic explosions of networked protest.

Since I lived across the street from Zuccotti, my living room floor soon turned into a home for wayward journalists and activists involved with Occupy. They drank my coffee, plugged their laptops into my outlets. The journalists were always on deadline, racing time across their keyboards. Sarah Jaffe came, of course. Meredith Clark, a journalist then fact-checking at *Rolling Stone*. Melissa Gira Grant, a journalist I knew from sex worker activism. Later we were joined by Eleanor Saitta, a hacker, and Quinn Norton, a journalist covering hackers for *Wired*. We were all

finding our voices in Zuccotti, and my fake oriental carpet was a temporary home.

We often talked about police violence. Cops attacked protests constantly. White-shirted superiors would point into the crowd; then blue-shirted officers would dive in, yanking someone off to jail. During the course of Occupy, cops broke the thumbs of Shawn Carrié, a classical piano player. They ran over a legal observer's leg with a scooter. Each day we saw the police punching, kicking, beating protesters who almost never fought back.

Cops were particularly vicious to black occupiers. Hero Vincent, a daily presence at Zuccotti, was violently arrested over and over again. After the dancer Sade Adona told cops to leave a fellow protester alone, two hulking officers smashed her to the ground. One pinned her head to the concrete with his boot, while the other beat her shins bloody with his baton.

At Occupy, journalists had little protection from police attacks. Theoretically, the press could get passes, but the system was controlled by the NYPD, who made it near impossible. Without that pass, you were fair game. John Knefel, a journalist friend of Sarah Jaffe's, was arrested while

John Knefel

covering the protests for his podcast, *Radio Dispatch*. "Got press credentials?" a cop shouted at Knefel. Seconds later, the cop threw him facedown on the pavement. Police officers pounced on Knefel as he scrambled for his glasses. He spent thirty-seven hours in jail.

We were not traditional or objective journalists. At marches, we participated as much as we covered. After beatings and arrests, after long nights, waiting outside 1 Police Plaza for our friends to get out of jail, we had little faith in any authority. But Occupy gave us an urgency to see clearly and write sharply. The group of writers that came together at Zuccotti is still friends today.

By this time, scads of people were turning the park into their personal art project. A photographer using a nineteenth-century camera, complete with bellows, made wet plate portraits. A woman dressed as a steampunk Emma Goldman lectured on anarchism. Dozens of photographers, videographers, documentarians, and journalists wandered through, shoving cameras or mics into the faces of anyone who'd let them.

I took iPhone shots of the crowd, went back to my studio, and got out my paints, eager to capture the protestors in portraits. These were fast watercolors, done hot in the moment. One showed a woman lifting up her shirt to reveal the Lawyers Guild's telephone number scrawled in sharpie on her stomach. Another was of a construction worker holding a sign reading, "Give a Damn." A young veteran, originally from Bangladesh, held a placard reading "First I Occupied Iraq. Now I Occupy Wall Street."

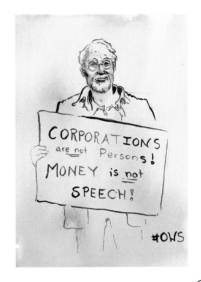

I wanted to draw it all. I wanted to show myself there was still a reason to draw. We live in the most image-saturated age in history, and a thousand cell phone pics mark the

occasion whenever a cop cracks a protester's skull, but I wanted to prove that artists had a reason to leave the studio—to show that illustration had something to say.

That September, the days felt long and urgent. More and more drawings poured from my hands. John and I riffed the compositions together. He wrote the copy. I did the art. We made a poster for the Occupy Medics, portraying them and their patients as kindly animals who treated everyone who came—even the nasty fat cat. Another poster, "We Are All in This Together," showed a massive cat, costumed like a French aristocrat. At her feet, a mouse dressed in a suit fought over a small cookie with a mouse dressed as a construction worker. "Are you going to let that union guy steal your cookie?" the cat purred. She sat on a towering pile of cookies.

An artist can engage with politics as a documentarian or propagandist, but at that moment, I was just a searching human, trying to figure out where I stood.

On September 30, Radiohead's manager emailed Occupy, saying the band would play at the park. Thousands of fans flooded to Zuccotti. But the band never showed. It turned out the email was forged, an attempt to get the park to critical mass. Malcolm Harris, an editor at *The New Inquiry*, an online intellectual journal, later admitted to the prank.

It worked.

After the spike of press around Anthony Bologna's pepper-spray ejaculation, coverage of Occupy was dropping off. The media only liked us when we were getting beaten, but now the only news we were making was the Concert That Wasn't.

On October 1, Occupy called another protest. It was well publicized, and promised to be huge. Laurie, Sarah Jaffe, and I met up in the square so we could march together. We posed grinning with the *Occupied Wall Street Journal*. I tweeted the photo, adding with embarrassing earnestness: "Join us. Everyone join us."

The cops eyed the Occupiers warily. "We're an affinity group," Laurie

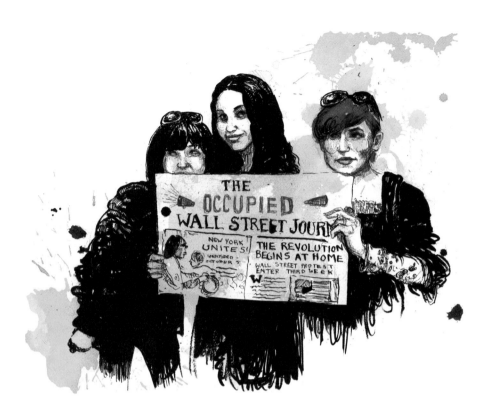

announced. "We stay together. We don't make decisions without each other." Her fey little face was solemn, but I wanted to laugh. What would happen to us?

The breeze was sweet as the march snaked up Broadway, in the direction of City Hall. As we turned toward the Brooklyn Bridge, the cops said something, and the protesters' leaders something else, but I couldn't hear either. All I could feel was the push of hundreds of bodies; it felt safe. And it was the Brooklyn Bridge! How many futile marches had that bridge seen? How many times had the police shrugged and let them pass?

"You can't arrest a bridge," the crowd chanted.

Laurie frowned. "Um, yes you can," she said.

In London that previous December, cops steered more than a thousand protesters onto Westminster Bridge. Once trapped, the protesters

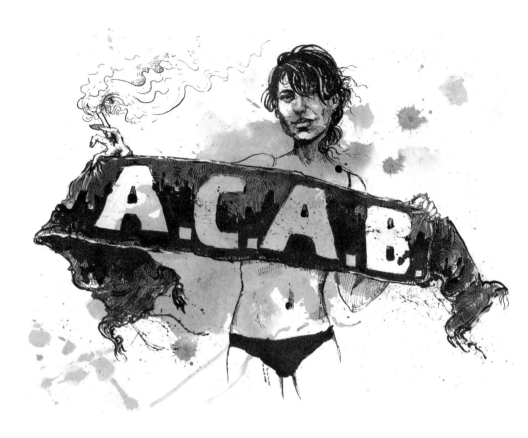

remained kettled in the cold for hours. Those on the edges thought they'd fall into the Thames.

Laurie had an instinct for avoiding arrest. She turned away from the march. I followed her. The crowd surged on.

In the crowd, I saw Natasha Lennard, a writer who was freelancing for the *New York Times*. Slim as a greyhound, in dirty black jeans and cropped hair, Tash was nearly an aristocrat; she'd been a fashion model before attending Cambridge, and from some angles, her face still had a magazine perfection. But then she laughed, and the sound had a joy so fierce that it cracked her facade. Her eyes crinkled. She looked like an imp.

I met Tash's eyes. She laughed and was gone.

The police arrested seven hundred people on the Brooklyn Bridge that day. Tash was one of them. She sat for hours, in the weak rain, waiting to be handcuffed. "For the briefest moment, the bridge and the city felt like ours," she later wrote. "Call me fanciful, call me delusional—I said it was love, after all."

If Michael Bloomberg thought hundreds of arrests would quash the protests, he was wrong. Each time the police beat down Occupy, it renewed its energy. The Brooklyn Bridge marked a turning point. Suddenly, Zuccotti became the place to be.

Journalists flooded the park, thrusting microphones into the face of anyone who looked interesting, demanding critiques of the global banking system. Celebrities swooped in. Patti Smith bought the People's Library a tent. Jonathan Lethem read. The street artist Swoon left a painting in the park, next to the cleaning station where there were stacks of brooms for anyone to use. The Marxist philosopher Slavoj Žižek harangued the park not to fall in love with itself, and Susan Sarandon lectured a boy in tie-dye leggings, telling him that Occupiers needed to focus on getting out the vote.

Activists from Spain, Greece, Tunisia, and Egypt flew to New York to support the Zuccotti Park occupation.

The photographer Kate Black, a friend of mine, came down to the park with a tray of shrimp skewers pilfered from an art opening she'd bartended. Since they weren't vegan, the soup kitchen refused them. She walked around the park, passing the shrimp out to more omnivorous Occupiers.

John came down too, bearing boxes of gourmet chocolates. By now he'd married—and well enough to go on benders at Claridge's—but he hadn't forgotten where he came from.

Even my mother marched.

One unseasonably warm night, I sat in the park listening to a young man play the viola and another young man recite poetry, reading a book from the People's Library, eating free ice cream scooped by Jerry of Ben and Jerry's fame. It had all the loveliness of a new world.

As the fall wore on, I brought mi padre down to Zuccotti. He'd given me my political bent, but the networked protests felt like something spontaneous, subversive, and new. I wondered what he would think.

We sat next to a working group that was discussing the theory of nonviolence. In Occupy, everyone had a chance to speak. This usually meant the conversation went nowhere. Mi padre started shifting with annoyance as soon as the occupiers began their finger wiggles.

"They have some good ideas, but they're also pretending," he said tartly as we walked out. He'd seen a lot of protests. The groups he'd raised me to admire—the Black Panthers and their Puerto Rican equivalent, the Young Lords—were far sleeker and more disciplined. Mi padre lived in Albany now, where the Occupy contingent there was less impressive—they mainly occupied a gazebo—but he admired their bravery.

As we walked away, the drum circle pounded behind us. Their noise had earned Occupy the contempt of many locals—though the police, who drove around the park each night blaring their sirens, hardly made things any quieter.

Mi padre asked if the drums were a psyop.

During the 2008 election, Sarah Jaffe and I had both volunteered for Obama's campaign. Obama won, but the ideals we ascribed to him had lost all the same. Under Obama, the banks that wrecked the economy were bailed out. The war continued, now supplemented with drone strikes in Yemen and Pakistan. Guantánamo stayed open. Government spying flourished. The new administration locked Chelsea Manning in military prison. No matter what fine sentiments a politician expressed, the machine remained the same.

Occupy rejected the idea of leaders. This was in some ways a response to the way Barack Obama had failed us. Any leader could become co-opted, we thought, into a smiling symbol of what we despised. So Occupy

chucked the whole notion of rallying around an individual; all we could count on was that we had each other's backs.

This leaderless state did not go over well with the media, which soon fell into a knee-jerk portrayal of Occupy as a collection of dirty, drug-addled brats. Why didn't we try to elect some officials? Why didn't we choose leaders? Why didn't we make some goddamn demands?

Even the liberal media figures many protesters had loved during the 2008 election turned against us. We were too raw for Stephen Colbert and Jon Stewart. When the *Daily Show* finally acknowledged Occupy, it spent the entire segment asking where the protesters pissed. No matter how progressive the media was presumed to be, when its reporters came to Zuccotti, they focused on the same white guys in dreads and tie-dye. We were beyond the pantomime of party politics, so we were lost to them.

Some protesters tried to use business attire as a creative tactic. Jeff Stark, an underground party promoter I knew from the burlesque scene, bought suits for Occupiers, knowing that TV producers would leap at a shot of cops dragging off a respectable-looking protester who was trying to close her account at a bank that received bailout money. But respectability politics doesn't work. Suits or no suits, the cops kept beating the protesters. When the game is rigged, you can't win by following the rules.

Winter came early, coating New York in a gray, piss-smelling slush. Occupy brought in gas generators to fight the cold, and to power the media tents. The police stole them, claiming they were a safety hazard. Occupy replaced them with bike-powered generators—the occupiers pedaling madly, as if to run away from the winter, from the growing divisions, from the future. Livestreamers made their names filming a park that increasingly despised them—night after night, fight after fight.

But how long could they stay? I kept visiting each day, my hands shoved into my pockets, the cold pricking me like needles.

When I wasn't in the park, I watched Zuccotti's livestream at home. The girl manning it coughed. Her nose ran. She shivered, wrapped in donated blankets given out by Occupy's "comfort station." She coughed again, then smiled. She—no, *we*—were still there.

There is no one story of Occupy. There is her story, my story, and those of all the others who joined the movement, with their traumas, hopes, and aching disappointments.

When I talk about Occupy, I'm still unsure whether to say *we* or *they*.

Nearly a month into Occupy's existence, Bloomberg paid a visit to Zuccotti Park. He flounced through fast, casting stinkeye, leaving a chill in his wake.

The next day he announced that the city would clean the park.

We were filthy disease-spreaders, brewing up a Zuccotti flu. The whole park needed a good scouring before we could return. When we were allowed back, we could no longer stay the night. During the day, we'd be forbidden from setting up tents, even so much as laying an object on the floor.

The occupiers refused to leave. Instead, they announced they'd clean the park themselves. OWS took sixty thousand dollars from donations they'd raised and got a cleaning truck.

That night I was in London, watching Twitter for the inevitable police attack.

In New York, the sky leaked freezing rain. Fifteen hundred people descended on Zuccotti. The unions showed up—nurses, teachers, and Teamsters, shaking and coughing from the cold. By dawn, the crowd had swelled so much that organizers ran out of brooms.

As the pale sun rose, the crowd stood shoulder to shoulder, bracing for the police to charge.

But when Mayor Bloomberg saw more than fifteen hundred people ready to resist his riot cops, he flinched. Brookfield Properties canceled its cleaning operation.

Occupy would live another day.

All books about Occupy retell the story of that night. Despite the failures that came later, it was our golden time. In those brief hours before dawn, the movement took care of itself.

Briefly, we thought we might win.

# 27...

By late October, there were hundreds of Occupy encampments. Tent cities calling themselves Occupy bloomed in LA and Oakland, Boston and New Orleans—in Rome, London, and Tel Aviv. Many of these encampments became life support for local homeless communities, whose members found they were being listened to for the first time.

But with Occupy's growth came a coordinated crackdown. On October 25, local police shot tear gas into the Oakland encampment. A canister hit a veteran named Scott Olsen in the head, fracturing his skull. While medics tried to save Scott, the police fired more tear gas canisters at them. Scott fell into a coma.

With a thousand other protesters, I marched on the NYPD headquarters in Manhattan, protesting the police crackdown. Later I sat on my floor with John, drinking espresso, trying to come up with a new poster idea. Thinking of the tear gas canister that had wounded Olsen, I whispered a line: "Can you see the new world through the tear gas?"

We started sketching the idea as a poster, with John providing the composition and me the detail. I drew a Latina

CAN YOU SEE THE NEW WORLD THROUGH THE TEAR GAS

woman surrounded by clouds of gas, holding aloft an American flag. I made a high-resolution scan of the image, then uploaded it to an Occupy database of protest art. Soon it showed up at protests in New York and San Francisco.

To see my art held on the streets meant more to me than to see it hanging in any gallery.

Decisions at Occupy were supposedly made in Zuccotti Park at large public gatherings known as General Assemblies, or GAs. They were run along elaborate rules, derived from Quaker and anarchist principles. Anyone could speak at a GA, but to prevent white guys from dominating, women and people of color were slated to speak first. Decisions were made by consensus. This meant that anyone attending the GA could block a proposal. You indicated your approval or disapproval with hand gestures. Because the police prohibited amplification, GAs adopted a method called "the People's Mic" in which waves of occupiers repeated each sentence until it traveled to the very back of the park.

GAs were supposed to be experiments in direct democracy—forums where everyone could speak and no one would be coerced to take actions he or she didn't support.

But because everyone could speak, the GAs lasted for hours. Because anyone could block a proposal, soon only the most stubborn triumphed. Soon, all the real decisions were being made by working groups, which often met in the lobby of an office building on Rector Street. This made many at the GA furious. Where was the transparency if people were working in secret? Worse, the movement had raised hundreds of thousands of dollars in donations. Since the Occupiers were inexperienced at accounting, tens of thousands of dollars went missing or were wasted on frivolous pet projects.

The GAs soon dissolved amid accusations of financial malfeasance, punctuated by fistfights.

I attended only one GA in New York, in mid-October. Each sentence took three times as long to say, since the People's Mic had to shout it from the front to the back of the park. Between the repetition and the lag, I couldn't follow what was being debated.

*If this is the new world*, I thought, *I don't think I can suffer through it.*

I left quickly.

Constant police violence began to take its toll. Occupiers grew more paranoid. Rumors flew that undercover cops had infiltrated the working groups. (After Occupy ended, several such undercovers were indeed exposed.) The NYPD watched the occupiers each day from their nearby tower, poised to attack, while the trauma they caused tore apart the occupation from within.

By late October, Zuccotti's neighborhoods began to look like hostile camps. The east side was mediagenic: the press tent, the People's Library, the radical grandmas knitting. On the west were the tents housing the poor people who needed Occupy most of all. When I walked through the west side, angry men hawked Occupy merch at me, shouting if I declined.

Some occupier friends told me that the NYPD was telling homeless people they could avoid police harassment by crashing at Zuccotti. While Occupy tried to be radically inclusive, the operation at Zuccotti wasn't equipped to deal with mental illness or drug addiction. Fights began to break out between different groups of organizers—from the respectable, reform-minded camp who wanted Occupy to run candidates in local elections to those who wanted Occupy to care for the most marginalized members of society. The movement had become bigger than any one group could control, and everyone thought everyone else was trying to steal the reins.

Bloomberg kept announcing that Occupy's days were numbered. Each day, the police would stomp into the park, stealing a tent here, a generator there. They lurked, malignant and constant, grumbling among themselves, shouting when Occupiers tried to take their pictures.

As threats from the mayor grew louder, survival in Zuccotti began to feel like Occupy's main purpose.

I went to countless marches, squeezed between steel barricades. Once, as an officer ran past me to make an arrest, the loop of my purse snagged his pistol butt. For a second I was paralyzed, certain he would think I was going for his gun, and then turn to beat or kill me. When the strap loosed itself, I ran closer and saw the police pounding a medic's head into the pavement. Young people in torn black hoodies chanted "Shame!"

Yet other times, I felt we were on the verge of some unnamable victory. I'd look up to see the frail turret of Trinity Church, and think, *We have to do this, because we've done so much already,* and *I have to stay here, because nothing else means as much as this.*

On November 14, 2011, the NYPD cleared Zuccotti Park. I was working in London again, so I learned about the raid online the next morning.

The police waited till one A.M. Then, with no warning—Bloomberg didn't want to give Occupy a chance to summon crowds of resistors—the cops moved with military quickness to seal off lower Manhattan. Then they surrounded the park. They gave the occupiers the choice to leave. Anyone who stayed would be arrested, their belongings destroyed.

Alerted by Twitter, journalists started gathering outside the police cordon. Police officers wouldn't let them in, punching anyone who got too close.

Inside the park, the police began to destroy the occupation. They slashed apart tents that had been painted with poetry. They threw the People's Library's three thousand books into garbage trucks. They pulverized laptops, signs, and tents.

In the course of four hours, they effaced Occupy's existence, like parents soaping defiant words from the mouth of a child.

There is a universal vindictiveness to the way governments destroy protest cities. They speak of them as disease vectors—as dirt. Amid the tents grows something so dangerous that no seeds must be allowed to remain.

As the police pillaged, seventy protesters—among Occupy's most devoted—remained inside the park. They knew the raid was coming, and they'd known what they'd do when it came. The protesters surrounded the soup kitchen at the center of Zuccotti. They sat down, and they linked arms.

The cops went in with batons.

After the raid, Occupy was never the same. Land gave Occupy something to defend. While they had the park, Occupiers could spend their energies on feeding their people, keeping warm, and keeping clean, and this allowed them to look past internal disputes. The simple work of subsistence allowed them to carry on.

Now that clarity was lost.

Occupy continued, of course. For thousands of people, it had been the most vivid experience of their lives. The working groups still met in the broad glass atrium of 60 Wall Street. The marches continued. Zuccotti was barricaded, so we met at Duarte Square or Foley Square. In April, a hundred activists were able to spend a week in Union Square. But the police eventually routed them, as they routed us each time. The librarians kept trying to rebuild the People's Library, but the police always broke it up, before the books had been around long enough for anyone to read.

To some observers, Occupy may have looked like a scrum of middle-class white kids, so privileged they reacted with incredulity when cops beat in their ribs. There's a kernel of truth to that: many white occupiers were shocked to find themselves on the wrong end of a police baton. But the demographics of Occupy were far more complex. One of Occupy's strongest links consisted of homeless young people. Yes, they fought capitalism, but they were also fighting for survival. After the Zuccotti raid, many crashed on the floor of the sympathetic West-Park Presbyterian Church. But when some of the church's property went missing, the church blamed the Occupiers and kicked them out.

By January 2012, this core group was reduced to sleeping on the sidewalks near the park they had made famous. Except for their signs, they were indistinguishable from any other group of homeless people scratching out a life in this city.

During that long winter, my friends and I drew closer. In the warmth of my apartment, we sat in circles on the floor, drinking whiskey and talking about the protests that still raged in other countries. We refused to believe Occupy was over. We had come so close. To what? We didn't know.

Always, I kept drawing. I drew posters for the destroyed People's Library, for the rebellions in Bahrain, for the students marching against tuition hikes in Quebec. I drew jailed activists. The journalist Quinn Norton, who was covering the hacker group Anonymous, came to visit me. We drank whiskey, and I drew tentacles across the khaki vest she wore to demonstrations to identify herself as press.

When George Whitman, who had welcomed me at Shakespeare and Company when I was seventeen, died that December, I drew his lined face, surrounded by the legend "Be kind to strangers, for they may be angels in disguise." I wept as I drew, realizing I'd never told him how much he'd meant to me.

Laurie came from London on a regular basis, often crashing on my floor.

We didn't just speak about changing the world. Laurie complained about the childlike men in her life, and we tried on lipstick and practiced teasing our hair big in the mirror. We talked about our goals, our hunger for travel and creation, which drove us to work harder than we imagined we could. We were small young women, so our ambitions threatened others. Unhealthily, we pored over conservative British message boards, where trolls talked about garroting Laurie to death, or tying me to a post and smothering me with shit. White men never seemed to provoke this sort of rage.

I wanted to meld my two communities: professionally-gazed-at girls like Stoya, and professionally-listened-to journalists like Laurie and Tash. The world tells women they must choose between intellect and glamour, but I saw no such distinction. If we could sit in a room and drink

till the world swam, maybe we'd create something new. I threw parties just for women at which we drank champagne from olive jars and mocked the men who had disappointed us. As dawn rose, Stoya, Tash, and I sat smoking on the fire escape. Tash tried to convince Stoya to write for *The New Inquiry*, but Stoya, who'd never been to college, worried that she wasn't educated enough.

"Fuck college," I told her, suddenly furious. "Of course you're smart enough. You know things none of these people do."

"Fuck college," Tash agreed enthusiastically.

The fire escape faced a wall, but from each end we could see the shining buildings beyond, beacons of the New York we were promised.

On Saint Patrick's Day 2012, I heard screams coming from Zuccotti Park. Not chanting, but rage. I ran downstairs, then fought my way to the front of the crowd, where I saw wounded-looking girls with bandaged heads being loaded into buses commandeered from the MTA.

A policewoman shoved a barricade hard into my chest. I gasped, more with shock than pain.

"Shame on you!" an older lady screamed at the policewoman. The lady's face twisted with anger. She pointed at the policewoman, "I survived breast cancer. I'm not afraid of you."

The policewoman smirked back.

"From Oakland! To Greece! Fuck the police!" the crowd shouted.

A girl convulsed on the pavement apparently having a seizure. Her hands were cuffed behind her back. She looked so small, a bright fairy on the concrete, her skirt hitched over her waist. The crowd screamed for an ambulance. The cops wouldn't call for one.

MOLLY CRABAPPLE AND JOHN LEAVITT

Later I learned the name of the girl on the pavement. She was Cecily McMillan, an OWS organizer. That day, she'd been looking for a friend she'd arranged to meet in the park when a plainclothes cop grabbed her from behind. Instinctively, she elbowed him. When grabbed, most women

would do the same. Photos taken later showed a hand-shaped bruise on her breast.

In May 2014, a jury convicted Cecily of assaulting an officer. She spent fifty-eight days on Rikers Island.

Just as the Smithsonian Museum once scoured Occupy encampments for discarded posters for their collection, the media scoured Occupy for its future celebrities.

As Occupy's high faded, it became clear who the winners were. They were not the people who had believed the most or fought the hardest. One veteran Occupier tweeted that she had spent thirty hours a week in her city's encampment. She'd washed dishes, organized, fought through general assemblies, and been hauled off to jail. Now she was homeless. Meanwhile, people who'd spent one night at the park had book deals. People like me.

That Occupier was right to hate a system that can commodify even its opponents. But the media fixates on individuals. Even a movement that fought the idea of having spokespeople would have them imposed upon it in retrospect. The shiny, clever, and opportunistic seized the credit for Occupy, as they always seize everything. The humble and hardworking were kicked to the bottom, as they always are, even here.

My friends and I clung to our faith in the spring. When the weather was warm, Occupy would rise again like Adonis, or some other god who'd been killed by a wild pig.

For May Day, the anarchists who helped create Occupy called a general strike. Natasha Lennard was involved in planning one of the actions, and she asked me to draw a May Day poster. John and I thought up the idea: a Latina woman, striking a match, surrounded by black cats that symbolized wildcat strikes.

OccuCopy, an activist printmaking collective, ran off thousands of copies. Activists wheat-pasted them around the world. For the next year, I saw my poster fused to construction fences in San Francisco and Bushwick. Sometimes viewers drew dicks on my woman's face.

And yet, when May Day came, there was no general strike. A hundred anarchists ran through the streets of Chinatown, trying to evade police officers who had started arresting them before their action even began. Unions staged a planned march down Broadway. Sarah and I marched alongside thousands of protestors. She scrawled "All $ from labor" in red lipstick across a piece of cardboard, and held it as a placard. Fellow marchers banged pots and pans, in imitation of the antituition protests in Quebec.

The sun warmed our faces as we threw victory signs to the crowd.

But the parks remained empty.

n February 2012, I started painting to remember.

The previous December, as the Occupy protests dwindled in the cold, I looked at the art I'd made over the past four months. I leafed through my stacks of sketchbooks, staring at protest posters for the Bahrain uprising, now crushed, and drawings of construction workers holding protest signs in Zuccotti, now empty.

As I flipped through those sketches, letting myself feel the loss, I longed to have made something more. I wanted to create paintings that were iconic, huge, gilded, and bright—as detailed as the scenes I'd scrawled across the walls of the Box in London, but devoted instead to the past year's upheavals. I wanted to make them a cohesive body of work, one in which each piece would speak to the others.

I made lists:

2011 REVOLUTIONS: *Greece, Tunisia, Spain, Occupy Wall Street, London Student Riots, Hackers.*
2011 VILLAINS: *Goldman Sachs, Healthcare System, Debt*

Out of these lists grew *Shell Game*, my first major art show, and my love letter to 2011. Like many love letters, it was steeped in sad-

ness, for the object of my affection was moving further and further away.

At first, *Shell Game* frightened me. It was something I doubted I'd be able to accomplish. The murals I'd painted in London were rough, done for impact from afar. And the massive canvas I'd painted for that heiress's Halloween party was performance art, more about the act than the image. I'd never done a large, detailed painting for its own sake—never mind nine of them, as I envisioned for *Shell Game*.

The largeness of the concept scared me too. I didn't know how to tackle subjects like the Tunisian Revolution or global debt: there was so much to learn, and there are so many ways to go wrong when you make visual symbols from the events of other people's lives. I wondered if a style honed in burlesque clubs could convey complexity, or pain.

I made more plans, as I always do when I'm afraid.

First I'd spend a solid month researching the subject of each painting. I'd read every book, then seek out people who'd participated in the actual protests, interviewing them as a journalist would. But I wouldn't just ask about facts. I wanted trivia, emotions, and visceral memories: favorite signs, scenester gossip, the times when the cops threw tear gas directly into the medical tents. In their complexity, I wanted the paintings to resemble the bits of dreams that cling to your eyelids when you wake.

I sketched out a loose framework for the series. Each *Shell Game* painting would have the same composition, inspired by the artwork I'd once done for the Box: An iconic woman would stand center stage, curtains to either side, crowd below. In the paintings based on protests, this woman would represent the ideal behind the protestors' fight. In the paintings based on crises, she would be villainy embodied. The stage curtains would represent the country where the events of the painting took place.

At each woman's feet was a gaggle of symbolic animals—attacking, protesting, scheming, acting out real events while surrounded by sumptuous versions of protest detritus. Dogs represented the police. Cats were

rich people and politicians. Each nationality of protestors got its own animal: Tunisians were sparrows, Americans mice, Brits foxes, Spaniards rabbits, Greeks yellow street dogs. Hackers, who lived online, became

bees. My research also manifested itself in visual symbols: baroque ornaments that referred to computers, barricades, and the tools of arrest.

After choosing my symbols, I did a rough sketch, then a detailed sketch, then a two-foot-by-three-foot pen-and-ink rendition, with each line of the final painting planned in swirling detail.

Then I started to paint.

Borrowing from Matt Taibbi's *Rolling Stone* article of the same name, *The Great American Bubble Machine* was my first *Shell Game* painting. In this article, Taibbi described Goldman Sachs's airy financial fraud and its devastating effects on the American economy. Drawing on Taibbi's imagery and narrative, I inked fat cats gamboling onstage, blowing and popping bubbles. Three cats manned an elaborate bubble maker, out of which grew Capital's bubble queen. This pale goddess held a pin in one hand, a bubble wand in the other. As a hat, she wore a vampire squid.

As with all my large paintings, *The Great American Bubble Machine* was a collective effort. Melissa ordered a four-foot-by-six-foot panel from a lumber yard; Yao Xiao gessoed it; together, we sanded it smooth. I printed my working drawing on Mylar, then projected it onto the wood panel, where my mom traced my lines.

Then I attacked the board.

I painted eight, then ten, then fourteen hours a day. I painted in glazes, meticulously, with the compulsion of picking lice. I used zinc white to catch the shine on each cat's eyeball. In diluted red, I outlined each sucker of the vampire squid. In the month it took to finish the painting, I hardly ate, drugging myself up and down with coffee and whiskey instead. Since I seldom left the apartment, I stopped bothering to dress. Instead, I wore Fred's paint-stiff work shirts. Late each night, Fred carefully looked over

my day's work and gave me notes on how to improve it. I fell asleep staring at the panel, each mistake glowing bright inside my dreams.

Then, one day, it was done. Fred told me to put down the brush or else I'd overwork it, and he was right. He took the panel off the easel and laid it on the floor. I was too short to handle a roller on such a large piece, so Fred rolled on the final glaze of gloss medium for me. As the gloss dried, the paint layers married, till they were as translucent as sugar candy. The details stood apart, yet they coexisted, coming together into a world so convincing that I wanted to walk into it through the fourth wall of the panel.

As a final touch, Melissa gilded the stars on the stage's American flag curtains.

I'd researched *The Great American Bubble Machine* as exhaustively as any journalist, but as an object it most closely resembled a religious icon. Swirling, opulent, and surreal, it was the best piece of art I'd ever done.

It didn't seem right to make an art show about the way the financial elites screwed the world up, and then price the pieces so that only financial elites could afford them. Gold-encrusted artwork was magnificent, but so was populism. I wanted to fuse the two. Refusing to give anyone else creative control over the show, I decided not to pitch it to galleries in advance. Instead, in March 2012, I funded the show through Kickstarter, financing my supplies by selling rough sketches, prints, and even the fake money I'd designed.

With these practicalities settled, I set about painting the next eight pieces.

My next painting, *The Hivemind*, was a love letter to dissident hackers.

The persecution of WikiLeaks in 2010 had politicized Anonymous, the group of pranksters, hackers, and Internet assholes whose previous experience of activism had consisted of bedeviling the Church of Scientology. Since then, they'd lent their support to a dizzying array of movements,

including the Tunisian Revolution and Occupy Wall Street. The primary weapons in their arsenal were the dox (leaking personal information, or documents, about a target) and the DDoS ("distributed denial of service," bringing down a website by flooding it with a massive number of automated hits). They wore trademark Guy Fawkes masks—concealing their identities behind a symbol of revolution lifted from a graphic novel by Dave Gibbons and Alan Moore.

Anonymous often described itself as a swarm, so I painted the hackers as bees. Light shimmered through their elaborately patterned wings. Together, the bees bashed ornate computers, spied on each other, ensnared themselves in wires, and flew around a wire goddess, who represented the network. On the painting's curtains, I wrote an Anonymous saying in binary code: "None of us are as cruel as all of us." Some of the bees wore Guy Fawkes masks. Others wore top hats and monocles, like those worn by the character representing LulzSec, a brilliantly ruinous hacker collective, who became folk heroes after leaking emails that revealed how the private intelligence contractor Stratfor had spied on activists on behalf of both corporations and governments.

What the hackers didn't know was that the Stratfor hack was a trap, planned by a snitch under the FBI's direction. On March 5, as I added highlights for the bees representing LulzSec hackers, more than a dozen cops broke down the door of an anarchist named Jeremy Hammond and arrested him for the hack on Stratfor.

My maniacal work on *Shell Game* spurred me to more intense creation. I washed a swath of board with yellow dye; then, in sepia ink, I drew a woman from the lips down, using my finest nib to draw a nightclub partying across her neck. On March 7, International Working Woman's Day, I drew a smirking woman striking a match, wearing a shirt that said "Deeds not Words." I sketched the murdered teenager Trayvon Martin. As I dried the watercolor with a blow dryer, the brown dye I used to paint his skin flew outward, toward the edge of the page, like an explosion.

I drew Dante Posh, my dominatrix muse from *Week in Hell*. With markers, I took an actual Guy Fawkes mask and turned it femme, giving it lipstick, eyeliner, and curls. Jacob Applebaum, a hacker who volunteered for WikiLeaks, wore it at a party he threw at my

apartment in late April. That night I also met Laura Poitras, the filmmaker who helped bring Edward Snowden's story to the public.

My sketchbook pile grew. *Occupy! Gazette*, a newspaper put out by the literary journal *N+1*, ran my drawings as back covers. Sometimes, during the protests, I saw them held aloft like signs.

One morning, during one of Laurie's visits, we took our coffee out to the fire escape, where we sat shivering in the April chill. The London student protests had been crushed, and I wondered if Occupy would be as well—and if anything would be different when it was over.

"Things did change," Laurie said. "The conversation around what people deserve out of the system has changed forever. I just wish they'd been given more time." She drank the last of her cold coffee. "I wish we'd all been given more time."

Down the block, Occupiers kept laying out their signs in Zuccotti Park. It didn't matter that the police threw them away at the end of each day. They kept coming back.

One sign, beautifully drawn, showed a riot cop swinging his baton at a dandelion. As he beat it, the seeds flew. "An idea cannot be destroyed," it read.

Another, scrawled across a deconstructed pizza box, put it more bluntly: "We're still here, you bastards."

The next night, Laurie brought me to a salon hosted by *The New Inquiry*, where she was editor at large. The journal, founded by Rachel Rosenfelt in 2009, had come into its own during Occupy. Its writers were mostly young, their ideas lacerating, their prose more sensuous than the vast majority of criticism.

Rachel considered a hidden bookstore called Brazenhead Books to be *The New Inquiry*'s spiritual home. Brazenhead was run out of a residential building in the Upper East Side. When you first entered the store,

the owner Michael Seidenberg's pipe smoke embraced you only moments before he did. Books filled the walls, floor to ceiling, and more books lay piled atop each chair. In carefully mocking voices, Malcolm Harris, Rachel, Laurie, and the rest of the *New Inquiry* crew read aloud from mainstream magazine articles.

One night, as I sat listening at Brazenhead, I thought back to when I was twenty-four, when a drunken art director told me, "Molly Crabapple stands for sexy sex." In the circles in which I moved then, sex was never allowed to be clever, so I couldn't be clever either. During Occupy, I made friends with writers who found ideas they respected in my art. That night at Brazenhead was one of many I spent in their company, reeling from a party at the *Paris Review* to an *N+1* magazine launch to the rooftop of the Jane Hotel. The dawn often broke before the time I limped home, but I always came back to *Shell Game*.

Spring faded into summer, summer into fall, but Occupy never returned to what it was.

September 17, 2012, marked Occupy Wall Street's first birthday. Mayor Bloomberg announced he would quarantine Lower Manhattan for the protests. To evade the blockade, protesters and sympathetic journalists gathered at my apartment hours before dawn. In our kitchen, Laurie Penny, Alexis Goldstein, Sarah Jaffe, and the livestreamer Tim Pool gulped down espresso. None of us had much faith that the anniversary would change things. We were there out of loyalty to what it once was.

When the sun rose, Laurie and I walked downstairs together. Wall Street was a mess of barricades. Cops in riot gear packed downtown Manhattan, descending on the area on foot, scooter, and horseback. They vastly outnumbered the protesters. On the side streets, police buses waited to be filled. As usual, the NYPD had shut down Wall Street more effectively than any occupation.

We walked south, through Liberty Plaza with its halal chicken carts and looming cube of corporate art. I grinned when I saw the head of pink

hair that belonged to Nicole Aptekar, an artist I'd met during the Zuccotti occupation. I ran up to her and hugged her hard. If nothing else, today would be a family reunion.

As I crossed the plaza to walk toward Zuccotti, I recognized someone else—the girl I'd seen marching down Broadway on that Saturday afternoon at the start of Occupy. Back then, she was holding a sign reading "One Day, the Poor Will Have Nothing to Eat But the Rich."

Now she had a new sign: "Hey Wall Street, I Got a Job. And I'm Still Here."

As the crowd started edging forward, Laurie tapped me on the shoulder. "This feels like it's going to turn bad fast, and I don't want to be here when it does," she told me, then retreated north, toward the McDonald's.

I didn't follow her. The day was so bright, and my friends from Occupy were marching.

With Broadway cut off by barricades, a crowd of people turned east, down Pine Street, with the police shoving and barking. Some protesters walked in the street, but most, myself included, clung cautiously to the sidewalk. We shouted the old protest chants that feel so meaningful when they're coming from your lungs.

Now and then, a high-ranking officer in a white shirt would point into the crowd, and the lower-ranking blue-shirted officers would snatch someone. On the curb, I saw a cop grab the arm of a woman in front of me and pull her into the street. It was the same gesture you might use to escort an old lady.

Silently, the next officer grabbed my arm and started to lead me. When we reached the center of the street, though, I realized he wasn't letting go.

I was a head shorter than the officer. I stared up at his ruddy face. He had small eyes the color of concrete, and his nose was turned up sharply. I looked at his chest and memorized his badge number.

"Officer, am I free to go?" I asked.

"Put your hands behind your back," he answered.

There was no warning. No Miranda rights like in the movies. I didn't even know what I was accused of doing.

"You know I was on the sidewalk. I'm two blocks from my home. Am I free to leave?" I asked him.

He wouldn't meet my eyes. Because I was part of a protest, I was no longer a local resident, but rather a body to fill a quota.

"Put your hands behind your back," he repeated.

I forced myself to comply. When the media reports that a suspect in custody was killed after resisting arrest, they never tell you how hard it is to assist passively with your own kidnapping. They never talk about the discipline it takes to submit.

I copied what I'd always seen protesters do during an arrest. As he led me off in handcuffs, I screamed my name. Protesters screamed it back until it passed like a wave through the crowd. Maybe a lawyer would hear it, I thought. Maybe my friends would know where I was.

The officer led me behind a barricade. I was wearing my grandmother's purse, which had a chain for a strap. When he handcuffed me, he trapped the chain over my arm, keeping him from confiscating the purse. I stood with him, in a crowd of other officers, each guarding his captive. There were two young, scared-looking Latino guys, and a legal observer in his lime green cap.

As we were led into the police van, a cop snapped our pictures with a Polaroid camera, hipster party style. Not wanting to let the police believe they'd cowed me, I gave them my best grin. A man in a suit passed by, looked us over, and told the police, "Nice work." Then the door closed.

In the van, I wriggled my purse to my side and managed to fish my phone out. I started emailing Laurie, Sarah Jaffe, and Fred, so they'd know where I was. Then I tweeted: "Arrested. Everyone in this police van is super smart and funny except for the driver."

A cop opened the door. "Put your phone away," he snapped. As soon as he closed the door, I started tweeting again. I wished I'd actually done something illegal—jumped a barricade or sat in the street—instead of sitting there filling some cop's quota. I certainly wasn't going to act more obediently than I had to.

In the van we shared our stories. The elderly nurse explained that he'd

thought his gray hair would save him from arrest. The legal observer thought his uniform would save him from arrest. The well-dressed white teacher handcuffed next to me grew more and more furious, yelling, "This is America!" at the cops, as if that meant anything at all.

John Knefel was also arrested on Occupy's anniversary. The day had started poorly for him, with Capt. Ed Winski, the officer in charge of policing OWS, telling John that his podcast credentials didn't qualify him for press access. A few hours later, photographers captured him in handcuffs, screaming, his glasses sliding down his nose. When cops hauled him off, he looked like an infuriated professor. At the station, one cop fingered his press pass. "This is bullshit, right?" the cop sneered.

In the police yard, officers confiscated our possessions, giving us vouchers in return. We waited to have our pockets searched, our shoulders aching from an hour in zip-cuffs. Our arresting officers hauled us against the wall to take another set of Polaroids. Again I grinned.

Inside 1 Police Plaza, cops separated us by gender. Female protesters waited in a large holding cage. Periodically, a cop would call some names. They dragged us out, then lined us up to present our IDs to a scowling female officer. The woman in front of me wore wrist braces, to protect wrists the cops had broken in a previous protest. To the policewoman here, though, those braces were weapons. "Take them off or I'll send you to the Tombs!" she yelled—the Tombs being Manhattan's municipal jail, where everything was twice as shit-encrusted, and took twice as long.

"I have a right to medical devices," the woman snapped. The policewoman sighed, then waved her past.

From the cells, a long line of female prisoners applauded as the policewoman led us to our cage. It was a narrow, freezing rectangle, with a padded bench just long enough for three people to sit on. In the corner, there was a nonfunctioning sink and a barely functioning toilet. When one woman needed to use it, we formed a line to block her from the view of cops.

We weren't the first round of protesters this cell had seen. On the beige walls, former detainees had scratched "Shit is fucked up and bullshit," "#OWS," and "You'll be the first when the reckoning comes."

Jail Cell @ 1 Police Plaza

SHIT IS FUCKED UP AND BULLSHIT

#OWS

No cop is a good cop

Fuck the police

You'll be first when the reckoning comes

I shared the small bench with a legal observer and a young Turkish photographer who sat silently rocking, terrified that her visa would be canceled. The woman with the wrist braces lay on the floor. She was a welder in her late forties with a bony body and long curls sloppily pulled back. A veteran protester, she'd done time in Rikers. "This white shirt saw me from the back for the protest, and said 'grab her,'" she told us. "They know exactly who I am,"

I grinned, reassured to have her with me.

Officially, the police were supposed to hold us for only twenty-four hours, but countless people stewed for far longer than that. How many hours we stayed inside was largely at the whim of our arresting officer, who was in no hurry. The women sang songs to pass the time: "Solidarity Forever"; "Tomorrow"; "Ninety-Nine Bottles of Beer on the Wall."

The policewoman screamed that she'd send us all to the Tombs if we didn't shut up. We sang anyway.

The policewoman walked from cell to cell, trying to hustle information from protesters. "Where do you work?" she barked. "What are the names of your roommates?" Sometimes she demanded that protesters submit to iris scans—something we were under no obligation to do. When women refused to give their biometric data to a police database, she threatened to send them to you-know-where.

This was an empty threat, the legal observer in my cell reassured us. Tell them nothing, she warned us. Anything we said would be used to incriminate us or our friends. "How do you know a cop is lying? Because her mouth is moving," she finished.

One by one, police released my cellmates, until I sat there alone, scratching a self-portrait into my Styrofoam cup, every second expanding like a rack. Getting arrested for protest is like being put through aversion therapy. It's a punishment in itself. In the time I was held, we got no phone calls. There was a single meal: four slices of soggy bread, a packet of mayo, and a mini carton of milk.

I kicked the bars, just to watch them shake.

Occupy Wall Street taught some middle-class white people what poor people and people of color already know: the law is a hostile and arbitrary thing. Speak too loudly, stand in the wrong place, and you can end up on the wrong side of it.

While we were in the cell, after we banged too long and chanted too hard, an officer stared at us. "Look at you people," she said. "What do you hope to accomplish? You brought this on yourselves."

After eleven hours, my arresting officer told me I was free to go.

I collected my purse, then waited as cops filled out my forms. In line behind me was an elderly priest, a veteran of civil disobedience. Ahead of

me was a reporter from Boston whom the cops had kicked in the ribs. An officer gave me a desk appearance ticket accusing me of blocking traffic. I'd have to show up in court in three months.

I walked slowly through the back gates, out into 1 Police Plaza. I was all alone. I'd been arrested at eight o'clock in the morning. Now night was falling, and I shivered through my thin jacket. My phone was dead.

I walked through the sets of gates without looking back.

As soon as I reached Pearl Street, I ran.

I came home to a dark apartment. *No one missed me*, I thought.

Then I looked at the computer. #FreeMollyCrabapple was trending on Twitter in New York. A photo of my arrest ran on the CNN homepage. An Al Jazeera anchor described how I'd tweeted in handcuffs. As the cop had handcuffed me, the Agence France-Presse photographed me. The camera caught me while I looked up, the light hitting my face at its most noble angle, like I was some sort of Joan of Arc.

Photos are such lies.

I was elated to be out, this amount of attention felt ludicrous compared to that received by others arrested that day.

Then I saw Laurie's email: "Where are you?? We're all waiting for you at 1 Police Plaza."

I tweeted: "I love you all. God, jail is boring." Then I ran back to the station.

I found Laurie, Sarah, and Fred at the deli near 1 Police Plaza, waiting for me to join them and for word of John Knefel's release. I hugged Fred tight. "I'm so hungry," I gasped, hiding my face in his shoulder, shoving a slice of pizza in my mouth. An older woman limped up to the counter, having just left the holding cell where she'd been detained for fourteen hours. Her eyes were bloodshot, and her hair was matted to her skull with sweat.

In the hours and days after my arrest, people kept asking how I was.

They were curious, even congratulatory, in a way they'd never be to a black man who gets arrested for walking down the street. It's impossible for a quick stint in jail for protesting to compare with the horrors of mass incarceration that black men and women endure. What we experienced was a millisecond's faint taste of that.

Still, once I was out, I couldn't stop shaking. I hated myself for it, when I had had it so easy. But I shook, because even that tiny brush with incarceration had chilled me.

I buried my head on Fred's shoulder and whispered, "Drag me home."

For two months, Occupy had so much. Then, suddenly, we did not.

I am an artist, not a political organizer. During Occupy, I drew pictures, marched, and helped however I could. Impassioned but peripheral, I was more loyal to my sketchbook than any movement.

Cops never broke my ribs. I never picked up trash, cooked a meal, or organized a demonstration. After every march, I went back to my studio to draw. I never froze in a tent all night, hoping to use my body as a placeholder for the new world.

If I seem to remember Zuccotti through the rosy light of an Instagram filter, maybe that's why. As the months wore on, those who sacrificed the most for Occupy became some of its most bitter critics. Their disappointment is more real than my love.

I conceived one *Shell Game* painting, *Our Lady of Liberty Park*, as an homage to Occupy. Its central figure was a beautiful black woman wearing a ruff of orange police netting. Her hair was braided around *Joie de Vivre*, the red sculpture that dominated Zuccotti. Her arms bore zip-cuff bracelets, and her dress was a tarp covered with protest signs featuring actual protest slogans, including "Shit is fucked up and bullshit." Shrouded by Our Lady's tarps, my American mice reenacted Zuccotti Park—the marches, the soup kitchen, the medics, even that vile drum circle. Doberman cops in riot helmets menaced the protestors, beating, macing, and arresting them.

Banker cats watched from above, waiting for their servants to clear the park.

On October 29, 2012, Hurricane Sandy hit New York.

The previous winter, a much-hyped hurricane had bypassed the city, leaving our shelves cluttered with candles and canned goods. As a result,

Fred and I didn't take the threat of Sandy seriously. We thought, at worst, that the power might be out for a day.

In preparation for the new storm, Bloomberg had divided up the city into flood zones. Those in Zone A, closest to the water, would have to evacuate. We lived in Zone B, so we decided to stay. I was just starting *Debt and Her Debtors*, the sixth piece in *Shell Game*, and there were so many mice left to paint.

The rain began to fall. It beat against our windows. Between the storm and the darkness, I could see little. But I could hear things: Branches snapping. Phone booths tipping. Glass shattering. Outside, the sea rose, and millions of gallons of water poured into the subterranean power stations.

At six o'clock that evening, the lights flickered off.

If hadn't been raining, the night might have been dark enough to see the stars. In that stillness, the only electricity was the light from the windows of the Goldman Sachs building. Of course, they had their own generators.

For light, but also for luck, I lit green candles for Santa Marta la Dominadora. Fred and I fell asleep in their flame's frail glow. We were in New York, the center of the empire. The city would patch itself up by morning.

When we woke up, our power was still off—as it was for millions of homes, from Far Rockaway to the Jersey Shore. We were on the seventh floor, high enough to avoid any flooding. But the power outage knocked out our water supply, and we had to flush our toilet with buckets of water we'd saved in our tub.

In the uneasy daylight, we took a walk through the ruined neighborhood. The pay phones were dead. The storefronts by the river had been bashed in—looted, I hoped, since toxic river water would have destroyed any inventory left inside. A few shopkeepers in wading boots picked through the remains.

We walked east. Crushed cars lay strewn around the entrances of the underground parking garages down Pine Street; they'd been hoisted off the ground by the tide, then smashed down when it receded. Later, I heard

that one of those garages contained the corpse of an attendant whose boss demanded he work through the storm.

Our neighborhood's sole open restaurant served instant coffee at an extreme markup. Crowds lined up for it, then sipped it in the dark.

Back in the apartment, we charged our phones from an iPod dock. I called my friend Clayton Cubitt, a photographer who lived in Williamsburg. With neither power nor water, we needed a place to stay.

Though he was already sheltering a collection of storm refugees, he graciously offered us a bed.

Clayton came from New Orleans, so he had painful memories of Hurricane Katrina. It had been seven years since that storm broke the levees protecting his city, stranding thousands of residents. Nearly ten thousand were left at the Superdome, without water, food, or sanitation—even as President Bush glibly congratulated FEMA director Michael Brown on the "heckuva job" he'd done. Sandy was a shadow of Katrina, but storms highlighted the frailty of cities, as well as the need to take care of each other.

Public transit was down, so Fred and I walked the four miles to Clayton's apartment. The lights on the Williamsburg Bridge were dead near the Manhattan side, but toward the center they sprang on. Standing there, we looked back at a city divided into a checkerboard of dark and light zones. Williamsburg, too high for the floodwaters, remained untouched and bright.

In Clayton's red-lit loft, we went online. I clicked over to the news. In New York and

New Jersey, Sandy had killed eighty-seven people; the final death toll would rise to two hundred. Twenty feet of water had filled the South Ferry subway station. The Coney Island boardwalk was smashed like tinder. Swaths of Seaside Heights, New Jersey, lay buried under sand. Wind had torn trees from their roots in Queens. In Staten Island and Far Rockaway, flooding contaminated thousands of homes, and it would take only a week for mold to set in.

In neighborhoods that lost power, the elderly and disabled remained trapped in their apartments, dependent for food and water on neighbors who were able to climb the stairs.

The next day, Clayton left the apartment for a walk. When he returned, he had a bandage on his arm. Under it was a new tattoo: "This too shall pass."

The next day, lights snapped back on, on Wall Street.

Far Rockaway and Staten Island stayed dark.

In the wake of the storm, Occupy Wall Street morphed into a disaster relief organization—one that was quicker and more helpful than either the Red Cross or FEMA. Volunteers with Occupy Sandy delivered food, clean water, insulin, and candles. They ferried people to shelters. They organized distribution centers out of churches, and ran logistics on Google Docs.

Yes, there was waste—wasted supplies, wasted efforts—but compared with the expensive marketing campaigns and elaborate bureaucracy of the large aid organizations, Occupy Sandy's ad hoc efforts were like manna.

They also inspired others. My friend Franz, a wiry Sicilian whose favorite word was *fuck*, was a professional producer of dubiously legal events; he also owned a burger truck. A few days after the storm, he started driving his truck out to Rockaway to distribute food. I'd done some fund-raising already, selling some of my prints to help a local Sandy

relief effort, but I wanted to help more directly, so I asked Franz if could ride along with him.

On November 3, Fred, Kate Black, and I piled into the rickety burger truck with Franz and his then–business partner. At the Restaurant Depot on Hamilton Avenue, we bought vast stacks of burgers, cheese, and bacon; delicious, greasy food can heal many wounds.

As we drove out, we passed block-length lines of cars in front of gas stations. The city had started rationing gasoline, and fights broke out if anyone tried to cut the line. But Franz's partner had some "entrepreneurial" friends, and after the storm they'd worked out a deal with a local mechanic, siphoning the gas from the cars left behind in his garage. They were profiteers, but they wanted to help Far Rockaway. When we met them outside a warehouse in Nowhere, Brooklyn, they greeted us with grins and plastic jugs of gas, for which they refused to charge.

As we crossed the bridge to Rockaway, Sandy's wounds grew more obvious. It was as if vast hands had lifted up the whole peninsula, shaken it, then left the pieces where they fell. Sand dunes covered many streets, and small recreational boats lay smashed on top of them. We passed houses whose walls had come apart like the sides of wet shoeboxes. Grim families dug out their basements, piling the street corners with the soggy detritus of their lives. Since the storm had hit a few days before Halloween, scarecrows and jack-o-lanterns presided over the trash heaps like kings.

Locals posted handmade signs asking "FEMA where are you?" but neither the Red Cross nor FEMA was anywhere to be seen. Yet every few blocks we came across unaffiliated humans offering warm clothes, water, and soup.

Franz parked his burger truck in a friend's backyard. We grilled burgers, heated up coffee, and dangled power strips from the truck so people could charge their phones. Soon, a crowd gathered around us. We blared Black Sabbath from the truck's speakers. As dusk fell, the truck glowed like a firefly: one small point of light and warmth in the powerless neighborhood.

I handed a grilled cheese to an older man, whose face was mostly obscured by his worn Mets cap. "Usually metal isn't my thing, but I'm so fucking glad to hear it now," he told us. "I haven't heard a fucking goddamn song for a week."

Another girl asked why we were there.

"To hand out food," Fred answered.

She burst into tears.

After Sandy, more such efforts grew out of the Occupy network. Independent media proliferated, as did workers' co-ops. The Rolling Jubilee abolished millions of dollars of healthcare debt. Under the banner of Occupy Our Homes, protesters helped fight off foreclosures, using their bodies as shields. "The 99%" is now part of American political vocabulary. Politicians like Bill de Blasio and Elizabeth Warren rose to power by projecting Occupy-style populism—though their words seldom translated into actions on the ground.

Above all, Occupy created an alchemical change in its participants. We learned to help each other across perceived divisions, then link arms against a police charge. When I think of what Occupy meant, my mind returns not to any march, but instead to that night in Franz's burger truck: the bacon sandwiches, the death metal screaming over the ruins of Rockaway, and the phones charging by stolen gas.

*I*n 2012, I slowly made myself into a writer.

I'd been writing on and off for a decade, but those were small things: art reviews for the underground rag *Coagula*, instructions on throwing your own gallery show, and odes to the publisher Loompanics. I never considered myself a writer. True writers, I thought, were far smarter than me; they saw more deeply and had reservoirs of insight and feeling that a doodler such as myself couldn't touch. Art was superficial, easy even; we artists were craftsmen, making single images on flat surfaces. I could look at most paintings and tell you how they were done, almost as though I were debunking a magic trick.

I tried to analyze writing by the same method, but the frank way the words sat on the page was deceptive. An essay's structure seemed like such an obvious thing, but for me it never was. I couldn't parse out the rhetorical strategies that Laurie, Sarah Jaffe, or Tash Lennard put into their pieces. I only saw them going into the world, interviewing and experiencing. Then, the next day, a polished piece of writing would appear online, full of cutting prose and apt insights.

Intimidated, I kept to my artist's box.

But the more time I spent with journalists, the more their techniques rubbed off on me—like glitter, or a rash. As I completed each *Shell Game* painting, I read, researched, and interviewed. I Skyped with Tunisian bloggers who had helped thwart censorship during the revolution. I

plied the nomadic hacker Eleanor Saitta with whiskey, then begged her to review the connectors and modems I drew in *The Hivemind*, making sure they made practical as well as aesthetic sense. An emergency room doctor told me the most evil pharmaceutical companies to paint in *The Business of Illness*, and I raided the memories of countless Occupiers to create *Our Lady of Liberty Park*. I loved how these interviews tore apart my preconceptions; they gave me insight into worlds I'd never otherwise have glimpsed.

With each painting, without knowing it, I was learning a skill I'd told myself I wasn't good enough to attempt.

By April 2012, I had finished two *Shell Game* paintings, and I was sketching my third, *Syntagma Athena*, devoted to the Greek protests. But this new work felt somehow false to me, a tableau of easy symbols attempting to capture a protest movement that was more complex and elusive than any single image. Frustrated, I shoved my sketchbook away.

The next week I was in London to do a signing of the just-released *Week in Hell* art book. One night, the journalist Paul Mason and I sat in the back of the Groucho Club, working our way through a bottle of scotch. At the time, Paul was the BBC's economics editor. In his fifties, with a lined, rugged face, and dark circles under his eyes, Paul has a deep Lancashire accent that recalls the coal miners in his family—a working-class voice that sounded pure punk next to the posh drawls usually heard on the BBC. His Marxism was not a comfortable fit there either, though it was more tolerated than it would have been in the States. A former musician, Paul

Paul Mason

now covered war, economic collapse, and global protest; his book on the 2010–11 protests, *Why It's Kicking Off Everywhere*, was one of *Shell Game*'s bibles.

Paul had just come from the studio, still in his TV suit. As he loosened his collar and took off his tie, we drank shot after shot, until the world swayed around us and the boozy frankness set in.

"In 2011, the world felt like it was on the brink of changing," I told him. "But now, I don't know where that went. It's like being in love, I suppose, after the first high fades." Resting my head on the edge of the booth, I told him I was having a hard time finding the right visual language for the *Syntagma Athena*.

Paul had spent the last year working on a documentary about the Greek protests, breathing tear gas and getting repeatedly truncheoned by riot cops. He started to tell me about the white antacid protesters poured into each other's eyes to counteract tear gas. Then he stopped.

"You've got to go to Exarcheia," Paul told me, referring to a neighborhood in Athens. "It's like the old Lower East Side and the old Soho and the old Arbat rolled into one, but it's a fucking anarchist autonomous zone. That's what you should draw."

As he spoke, I thought back to the moment I got off the boat in Morocco when I was seventeen. I remembered the intoxication of finding a new world to capture in my sketchbook. I wanted to chase after that, rather than just sitting in my studio, waiting for the world to come to me. On that London night, what he was saying felt impossibly right: I needed to be somewhere where it was still kicking off.

"I'll go draw Exarcheia, Paul," I promised him.

Paul looked down at my shoes. "Don't wear any ridiculous fuckin' stilettos," he said. "You probably don't want to talk out loud in that American accent until they know you." He laughed, not unkindly. "And practice putting on a gas mask."

Back in New York, I had a pile of art jobs that needed doing. *Shell Game*'s panels waited in my studio like nine accusations. Still, I thought, promises are meant to be kept.

In May 2011, the Greek parliament announced it was accepting a €110 billion bailout, to try to fix the nation's financial crisis. In exchange, it would raise taxes and impose devastating public spending cuts. Within days, mass protests sprung up in every city in the country, building until three hundred thousand protestors gathered in Athens's Syntagma Square. The unions joined in, calling general strikes.

The crackdown was brutal. Riot cops shot so much tear gas into the crowds that they ran out of it; the police then started throwing rocks. Protesters fought back with Molotov cocktails.

Despite the protests, the austerity program passed that July. It only exacerbated the crisis. By April 2012, one out of three Greeks was unemployed, and the country's emotional depression matched its economic one.

That spring, benefit cuts pushed countless elders toward suicide. The government slashed the pension of Dimitris Christoulas, a seventy-seven-year-old retired pharmacist, leaving him destitute. On April 4, Christoulas walked into Syntagma Square, took out a pistol, and calmly shot himself in the head. His suicide note urged young Greeks to grab Kalashnikovs, overthrow the austerity government, and hang the "traitors" in the middle of Syntagma Square.

DIMITRIS
Christoulas

One segment of Greeks did benefit from austerity: a neo-Nazi group known as the Golden Dawn. At once a political party, a mafia, and a violent paramilitary group, the Golden Dawn exploited the country's economic misery by blaming it on the oldest scapegoat: immigrants. In Syntagma Square, the Golden Dawn ran Greek-only soup kitchens, while in the working-class neighborhood of Omnia, members of the group murdered dark-skinned refugees. By 2012, they were the third most popular polit-

ical party in the country. As their base swelled, their violence went from secret to spectacle, with one of their MPs punching a female Socialist politician on live TV.

The Golden Dawn's logo resembled an unraveled swastika. As the winter of austerity turned to spring, the symbol appeared on more walls, in more cities. The party's thugs swaggered openly, beating and killing in plain view.

By April 2012, Athens was starting to look like our generation's Weimar Berlin.

Back in New York, I worked on *The Business of Illness*, my third *Shell Game* painting. When Laurie stopped by to visit, I was balanced on a chair, daubing cadmium in the villainess's hair. As I smoothed an outline, I told Laurie about my plan to go to Athens and draw the aftermath of the Greek protests

"I've been wanting to cover the Greek protests, too, and do something more in-depth. We should go together!" Laurie announced.

We'd always wanted to work together, but British newspapers weren't keen on printing my art beside Laurie's increasingly famous columns. Fuck them and their refusal to let us mix our disciplines, we vowed. In Athens, we'd do as we pleased—on our own, if we had to. We started planning a piece of illustrated long-form journalism, with the art and the text to be equal and interdependent—like *Fear and Loathing in Las Vegas*, if Hunter S. Thompson and Ralph Steadman had been angry young feminists.

In May, Laurie took the train to Montreal to write about Quebec's student protests. As practice, after she interviewed protesters, she sent me their

"The police say it's not the way to hurt me"

MAYENCE
VALADE
20

"Police assaulted protesters who in turn assaulted police. Many demonstrators who were far outside the riot zone were hit by plastic bullets. On the seventh of March, someone else lost an eye. He's an artist and can't draw any more"

"SHIT HAPPENS AND THEN YOU DIE"

photos. One of them was Maxence Valade, a young man partially blinded by a cop's rubber bullet. I drew his eye socket, and the meat of his destroyed eye. *The New Inquiry* ran the drawings along with her essay.

Armed with this collaboration Laurie emailed a publisher to pitch him on our plan. Two weeks later, we had an ebook contract and two tickets to Athens.

Warren Ellis gave us the book's title: *Discordia*.

When we landed in Athens, on a hot night in July 2012, Syntagma Square was as silent as a coma. We dragged our suitcases past smashed shop windows, though crooked streets electric with anti-Euro graffiti, and up the battered cage elevator of the Hotel Carolina.

Before we left for Athens, a young investigative journalist named Yiannis Baboulias had emailed Laurie and offered to show us around. *Mono*, the magazine Yiannis had cofounded, had just shuttered, and like many young Greeks, he found himself unemployed.

When we met Yiannis that night, he was hunched over on the battered stoop of our hotel. Yiannis was tall and bony, with black hair falling into his pale, sweaty face. Despite the darkness, he balanced a pair of sunglasses on his nose, but one of the lenses had been knocked out, and he stared at us with a single bloodshot eye.

When he saw us, he swaggered up, shook Laurie's hand, and explained that he'd just come from a party. He was moderately fucked up on ecstasy, he added—some bastard had spiked the punch.

Over the next few days, Yiannis showed us Athens. He led us through Exarcheia, an anarchist stronghold whose walls were bright with murals of gas-masked protesters. On one wall, a defaced fashion ad read "It is really sad that only now I feel alive." Graffiti was everywhere, livid and swirling: anarchist A's, pig-headed cops, snippets of dark, wise poetry that Yiannis translated for me later: "Thank money we have a god." "Vote Ali Baba: He Only Has Forty Thieves." "Sorry I'm late, Mom—I'm at war."

He brought us to the shrine where, in 2008, the police had murdered

"Fight. Resist. Don't nag"- graffiti. Athens

a fifteen-year-old named Alexandros Grigoropoulos. Graffiti covered every inch of wall and ground in that Exarcheia corner, where Alexandros's face was graven in bronze, over the line: "Oh Alexis, you were so young." After the murder, Exarcheia rioted. Students from Athens Polytechnic hurled cobblestones at the police, whose violence they saw as the ground-level enforcement of the corrupt and bloody state.

Despite those riots, cops still idled in pairs on every Exarcheia street corner. They were comic-book caricatures of men, puffed as if with steroids, weighted down with shields, guns, and bandoliers of tear gas, hassling anyone young or brown. Behind them, the graffiti read "All Cops Are Bastards." According to election exit polls, 50 percent of Greek cops had voted for the Golden Dawn.

Yiannis set up meetings with us at the illegal anarchist cafés, where Laurie interviewed activists whose parents had been tortured under Greece's military junta. I sketched them in my notebook, since photos were not allowed for safety reasons.

I had some of my own contacts in Athens. Paul Mason had connected me with others, including a migrant-rights activist, Katia, and a journalist from the ascendant leftist party Syriza. A young communist activist, Ioanna Panagiotopoulou, set up many more meetings for Laurie and me, yet we would have been lost without Yiannis. Years later, I asked him why he'd done so much for us. "Why wouldn't I?" he replied, incredulous. "I quite literally had nothing better to do."

After a dozen interviews in two days, Laurie and I drank icy frappés with Yiannis at Floral Café in Exarcheia.

"What do you think the Syntagma Square protests accomplished?" I

asked him. Even to myself, I sounded like a typical naïf American, seeking someone from another place to give me a meaning I could then bring back to Occupy.

"They gave us a sense of narrative. They broke the isolation, the idea that as political subjects we were powerless to change stuff. The idea that the two main parties will always win—that ended there. It acted as a platform, a dialogue, an Agora." As he spoke, I drew him in caricature, a nose with skinny legs. Laurie looked at my sketchbook and burst into giggles.

"What the fuck is this?" He stared. "Is this what you think of me? Now you see why I'm a fucking nihilist."

A yellow dog came up to us. Big, dopey, dirty, he looked like a twin to Loukanikos, the legendary riot dog who stood at the front lines of the 2011 protests, barreling through tear gas to bite the police. But this was 2012's burning summer. The dog plopped down and went to sleep.

Yiannis and Laurie were journalists, but as an artist I saw things they missed. While we walked from interview to interview, I lagged after them, scribbling furiously. In front of the old Parliament building, I lingered at the statue of General Theodoros Kolokotronis, a hero of the nineteenth-century War of Greek Independence. At the base of the statue, someone had spray-painted the words "Fuck Heroes—

Fight Now." I drew it as quickly as I could, before I was hurried along by that tiny, punk Laurie and long, slouching, Yiannis.

We dragged ourselves through the baking concrete of the working-class neighborhood Neos Kosmos to the offices of *Eleftherotypia*, a leftist newspaper. Once the second-best-selling newspaper in Greece, *Eleftherotypia* had filed for bankruptcy in 2011. Refusing to give up, the workers took over the

ΕΛΕΥΘΕΡΟΤΥΠIΑ

"thank money, we have a god"-graffiti, Athens

paper. When we walked into the building, the paper's eight hundred employees had not been paid for nearly a year, and they were living off donations from workers' groups. Still, they kept producing the newspaper.

Under a halo of cigarette smoke, *Eleftherotypia*'s journalists banged out their copy. The Athens summer could liquefy your eyeballs, but the paper had no money for air conditioning. Yiannis introduced us. An older man offered us plastic cups of raki, then led us to the boss's former office.

Laurie interviewed, Yiannis translated, I drew. Laurie asked about protest, financial corruption, the Golden Dawn. While she spoke, I sketched the paper's financial editor—her blond curls and her eyes drooping with cynical glamour. Focused as I was on the lines, I could barely follow her rapid-fire tirades about who was fucking up this fucking country, but she sounded devastatingly smart. Once I finished her face, I drew Laurie's furrowed little brow, the tilt of her head as she leaned forward to listen.

Artists are the dorks in the corner; drawing gives us an excuse to stare. As I made those pictures, I admired *Eleftherotypia*'s journalists with a ferocious ache. These were middle-aged professionals, broke, squatting in

a sweltering office tower. They were investigative journalists, trying to expose bastards while their country collapsed around them.

After we finished the interviews, Laurie ran off to a protest in Nicaea, where the Golden Dawn had been harassing local Pakistani shopkeepers, advising them to skip town or risk seeing their stores burned. The Pakistani community staged a demonstration in response, proudly holding banners reading "Fascism, Never Again." I followed her online as she tweeted about the fascists, the police's refusal to protect the protesters, the Golden Dawn's attack, and finally a picture of blood, red and sticky, on the streets.

Meanwhile, I was sitting at Radio Bubble, a café and anarchist radio station that broadcast English-language news from Greece. In the dark bar, I did my first interviews as a journalist, holding up a recorder as I'd seen Laurie do, to capture the mocking voices over the music. One protestor I interviewed told me that he'd met his wife in Syntagma. Mousi looked like every respectable white-collar professional, except for a scar across one cheek, which he'd gotten in the course of saving a South Asian street vendor from a Golden Dawn attack. He asked me not to use his real name or draw his face. The fascists were still looking for him.

On our last night in Athens, Yiannis led Laurie and me through the twisted alleys of Monastiraki, past walls covered with the Golden Dawn's swastika manqué, to a bar called Cantina Social, whose owner had hired him to DJ. The bar's makeshift garden was lit by candlelight and guarded by a dog large as Cerberus. Yiannis, half drunk already, stood in the DJ booth. Laurie and I kicked off our shoes. We danced until the cement cut our feet. The exhaustion and alcohol made the music swell until it encompassed everything. We laughed and threw back whiskey and danced some more.

We drank so much that hot night, in this city that was so unlike New York or London yet torn apart by the same economic forces. I didn't then understand Greece's resilience; I couldn't know that in two years the Golden Dawn's leader would be in prison, and the leftist coalition Syriza would be in charge, only to be defeated in turn. I just knew that, in that moment, the powers that be had won—both in the United States and here in Greece, where the stakes were higher.

I looked up, through the trees, into the hazy sky. No time feels as precious as the moment you think things will break.

I flew home.

The details I'd struggled for as I was sketching *Syntagma Athena* now flew from my pen. My central figure would be a battered classical sculpture of Athena, covered in the Exarcheia graffiti I'd copied down. At her feet, a thousand Loukanikos dogs battled it out with gas-masked riot cops. A gas mask dangled from Athena's finger; over her eyes she wore a coating of Maalox, the white antacid used to counteract tear gas.

My art for *Discordia* hit me just as hard. Sometimes you chase the muse, and sometimes she shows up at your doorway wearing black stockings and ties you to the bed. Using watercolor paper, I tried to capture the sticky heat of *Eleftherotypia*'s pressroom. In diluted ink, I sketched the clouds of smoke, under which the glamorous financial editor stared off into the distance. I gouged the paper with my pen to capture the violent stillness of the now-empty Syntagma. With clouds of gray wash, I concealed the faces of Greek hipsters kissing in front of the Parthenon. I used a micron to draw rows of riot cops, faces hidden behind gas masks, their bodies as steroid-swollen as ticks.

As I illustrated *Discordia*, I found that drawings, like photojournalism, could distill the essential. Unlike photography, though, visual art has no pretense of objectivity. It is joyfully, defiantly subjective. Its truth is individual. Picasso's *Guernica* doesn't explain what a body looks like after a carpet bombing, but it does show the agony of war. When I drew, I could see nothing more clearly than the space between my art and its subject. My brush drawing of Yiannis was not the real Yiannis, cackling at Laurie until his half-ruined glasses fell off. That laugh was gone; my page bore only an approximation of his mouth's outline.

My final *Discordia* drawing was an homage to *The Problem We All Live With*, Norman Rockwell's painting of Ruby Bridges, the young black girl who in 1964 desegregated an all-white school in New Orleans. In Rock-

well's painting, Ruby walks proudly in her starched white dress, guarded by two US marshals. She looks past the tomatoes thrown in her direction, past the racist slur painted on the wall behind her.

In *Discordia*, my Ruby Bridges was a young Pakistani boy at that antifascist march in Nicaea. He walks between two men gripping their anti-Nazi placards by the handles, like clubs, and he holds his own small placard in his small, determined fist. Behind him, the Golden Dawn had spray-painted their insignia. Instead of tomatoes, the street is stained with blood.

As we were working on *Discordia*, Laurie and I felt like we were chasing ghosts. The Syntagma protests lay dead by the time we arrived in Athens. On Gchat, she asked me if I felt we'd gone too late.

"I'm sad the year is over," I told her. "I never wanted that fucking year to end, but it had to. Time has to pass. And you have to look into what comes next, after ecstasy, with courage and clear eyes and a taste for infinite hard work."

A pause. Then Laurie's response: "I WANT 2011 BACK."

"Me too," I answered.

When Laurie handed in the manuscript for *Discordia*, she closed it with me saying those words, and a line from the Bible: "The summer is over and we are not yet saved."

Since June, we'd been sniping at each other, supposedly over work, but really because of jealousy. We both wanted to be the "Best Girl." We had both fought so hard for our places in the world, and we were threatened by the same talent we loved in each other. We were both feminists, but still we'd absorbed patriarchy's lie that there's room for only one woman to win.

When I read Laurie's manuscript, her words were so right that I forgave her every fight and petty jealousy and moment of competition. Laurie's

words seduced me, and through them the idea of writing seduced me too. I wanted to whisper my thoughts silently into someone else's mind. I looked up at my painting, *Syntagma Athena*. It couldn't speak, only gesture. In that moment, I hated the muteness of art.

On September 18, 2012, the day after I was arrested, I started writing for real.

I wrote an essay about my arrest out of anger. Not anger for myself, though I still involuntarily shook when I thought about sitting alone in that cell. It was for all the arrests in New York—for weed, or jaywalking, or just because someone was black and standing outside. I typed fast, in a hot jag of rage. The first draft made no sense, but once I started cutting away at the sludge, I found insight and argument—even wordplay—there.

Laurie edited my pages as I wrote. We worked until dawn. She helped me so much, slicing extraneous words until my intention hit the way I wanted. Art was broad, writing specific, but she teased out the commonality between them, and as the sun rose I had something I wanted other humans to read.

Five days later, CNN ran my essay, accompanied by my drawings of my jail cell.

After that, an editor at *Vice* asked me to write something about beauty. I spent a month thinking it through, then responded with a long essay, "The World of a Professional Naked Girl." As I wrote, I remembered the words that ran through my mind while I smeared myself with jam for a lecherous dentist's camera. My years of posing were years of silence, but many of those snarky pebbles remained lodged in my brain, and now I put them into a gem tumbler until they emerged shiny enough to show. Remembering Laurie's example, I sliced, burned, eviscerated. I murdered my darlings, then posted their heads on pikes at the gates of town as a warning to future interlopers. Pressing delete soothed me. Writing for Twitter further taught me to cut down excess verbiage. I tried to make sentences taut as garrotes.

When the story of my naked model past went live on Vice.com, hundreds of people contacted me. Because I'd written about my life, they wrote to me about theirs, with an intimacy that humbled me. Young women especially emailed me, asking for advice, describing depressions, rapes, and abusive boyfriends. I wrote back to every one.

The essay was popular enough that *Vice* gave me a column. In November, they sent me to Madrid to cover a general strike that Spanish unions had called to protest against austerity. In a week, I interviewed countless Spaniards, many of whom had grown disillusioned with the country's antiausterity movement for the same reasons that New Yorkers grew disillusioned with Occupy. With the help of local activists, I visited squats, occupied hospitals, and an Andalusian farm that had been seized by anarchists.

I ran after demonstrations on nights that smelled like fireworks and spray paint, and I watched thousands of masked students smash up banks with their hands. I heard the pop of rubber bullets for the first time in Madrid's Plaza Real, as police officers chased mocking teenagers. Surrounded by militant, often violent protesters, I felt safe from the cops in a way I hadn't in New York since Occupy. Protesters had each other's backs, and they had mine as well. During the day of the general strike, the journalist Dan Hancox hoisted me up on a lamppost. From up high, I could see the dancing of hundreds of thousands of marchers. The streets belonged to them.

I wrote two reports for *Vice*, accompanying them with drawings of smashed ATMs and occupied theaters based on my iPhone photos. I made errors, and waxed vaingloriously romantic, but even my failures were getting better. Inspired by what I'd seen, I completed my eighth *Shell Game* painting, *Indignada*. The central woman's body became a baroque Madrid building, hung with banners from the Spanish Civil War.

Writing became a joyful compulsion—and a way to clarify my own thoughts. In an essay for the *Paris Review*, I used the stories of Diego Rivera and Frida Kahlo to explain how men were expected to do big art, about the wide world, while women were confined to work about sex,

pain, and themselves. In *Jacobin*, a socialist journal, I tried to explain what Occupy had given my work, as well as the kinship I felt with construction workers.

I wrote about my abortion, and about how much I had hated being a child.

In blank tones I put painful bits of my past on the computer screen. As I wrote, these memories became external to me. They were art now, less a burden than a product. They couldn't hurt me anymore.

Still, I was always a visual artist first. I marked the passage of time by the number of *Shell Game* paintings I had finished. Each piece took six weeks. Soon a stack of completed panels was piled up by our door, creating a wall that guests knocked into each time they entered. Each weighed fifty pounds. Some nights, I begged Fred to haul out all the finished art so I could see them at once. I lay on the floor and stared up at the paintings, ran my fingertips over their glossy surfaces, traced the curls of my icons' hair.

Each day I painted until my eyes blurred. I worked naked, with slashes of red paint on my forehead, green on my breasts, burnt sienna on my belly and feet. I didn't bother to wash off. The paint would just get on me again.

When I started *Shell Game*, I was painting the news, but as the months passed, news became history. Protesters on the street turned into dissidents in cells. The arrest of the LulzSec hacker Jeremy Hammond was followed in September 2012 by that of Barrett Brown, a journalist who worked closely with Anonymous. Prosecutors threatened him with a hundred years in prison for posting a link related to Stratfor.

The news wasn't much better abroad. Katia, the migrant-rights activist we'd met in Athens, posted videos on Facebook that showed Golden Dawn members rampaging through a hospital, dragging out patients who they suspected were immigrants. In Egypt, soccer hooligans held the frontline of the 2011 revolution, but in February 2012, seventy-two fans died in the Port Said stadium in a riot many deemed a police massacre.

While I was painting *Degage*, my homage to the Tunisian revolution, gunmen shot leftist politician Chokri Belaïd in the street. I listened to the news as I shaded the eyes of *Degage*'s central woman, an icon for a revolution whose future seemed more fragile than ever.

As the news grew grimmer, the paintings began to take on an irony. Large projects often made me sad, but as I painted *Shell Game*, the scale of the work and the scale of events conspired to send me into a black depression.

What was the point of art, in a world so full of hell?

Most nights, I drank myself to sleep.

Fred and I worked all day, but we bracketed those days with each other. Each morning I woke up on the canopy bed. Fred's naked body was big and warm against mine. I kissed down his hair-covered chest. He'd grab me, pin me down, and push himself into me. Afterward, he fell back to sleep. I staggered over to the kitchen, made espresso, then faced my painting.

Each night, I poured two shots of whiskey, one for me and one for Fred. Sometimes we shared a cigar. Then we fell into bed, and afterward he would go back to work. I slept, the light above his drafting table glowing against my eyelids.

On March 22, 2013, I finished painting *Shell Game*.

The final piece was a five-foot-wide wheel of fortune. With tiny brushes, I rendered a dozen nasty fates that could befall the spinner. When I finished the last slice of wheel, I lay on the rug. Fred bought me a glass of champagne. Then we hauled out all the paintings and I walked between them, from one end of the apartment to the other, letting my hands trail over the characters. I stared into the women's eyes, then pressed my cheek to their cold polished faces. I'd made them, but now they were their own beings, as independent as children. I was so happy that I sat on the floor and cried.

For the first two weeks of April 2013, *Shell Game* took over Smart Clothes Gallery, a small storefront in the Lower East Side.

Fred and his friend Richard Clark framed the paintings, and Melissa arranged for professional art handlers to hang them. She rented a claw-foot bathtub, then filled it with money I'd designed—hundreds of green bills graven with cats and tentacles. On April 7, the day before the show, we watched art handlers mount the last piece on the wall. It was the first time I'd seen *Shell Game* as it was meant to be seen: each painting speaking to the others, unified by their shared language, bright, gilded, swarming with detail, reminiscent of old political cartoons yet giant, surrealist, and new.

The exhaustion that had been weighing on me drained away, replaced by gold-leafed celebration. We needed joy, even as the police smashed all we'd built. I looked at the paintings and saw monuments to two years of friendship. I remembered Melissa gilding the stars, Quinn Norton advising me on how to portray hackers, Fred cutting the frames, Sarah Jaffe posing next to Our Lady of Liberty Park while patiently explaining the mechanics of debt bubbles so I could draw them right. I remembered Laurie editing my work, and Paul Mason telling me to go to Exarcheia. And I remembered John Leavitt, and all the nights we'd spent a decade ago dreaming up impossible schemes—schemes like this one.

I stood in the center of the room, ignoring both Melissa and the gallery owners, filled with gratitude. I was so lucky to be alive, in this city, with these friends, in this world.

We launched *Shell Game* with three nights of openings. The first was for my friends. The second was for Kickstarter backers. The third was for everyone.

I've been to many art shows, and most are dull—bad wine in a white cube, attendees chatting according to a strict social hierarchy while only occasionally pretending to look at the art.

I didn't want that. I wanted my worlds to blend together, as they had during those nights on the fire escape with Tash and Stoya.

Hundreds of people came: Walmart labor organizers, John Waters, gold-haired models, the woman who had pretended to be J. T. LeRoy, *Spread* writers, a hacker who'd worked with LulzSec, an Occupy Sandy activist with a bright blue beard. Old ladies grabbed my arm and told me I'd done good.

To keep me company during my long nights working on *Shell Game*, Kim Boekbinder had written a song for me. I asked her to perform it on opening night. Wearing black silk, her hair teased into a magenta cloud, Kim sang:

> *Everybody knows the game is fixed*
> *the poor stay poor and the rich get richer*
> *so why you crying now, it's not like anything has changed.*
> *You're an adult, playing the shell game.*

In the basement, Stoya smoked a final cigarette, then placed a pink Marie Antoinette wig on her head. The stylist Isaac Davidson had created

a miniature Zuccotti Park within its curls: the cops, the protesters, even the big red *Joie de Vive* sculpture. Stoya wrapped herself in her mink, then strode out into the crowd, shrugged off the coat, and stepped into the tub with a coy smile, naked save for heels, pasties, and a rhinestone thong. She frolicked in the cash, throwing it in the air, tossing it at guests, kicking her feet up as crowds stared through the window.

All my friends were there. Laurie had flown in from London for the opening, as had Paul Mason. Eleanor Saitta and Quinn Norton flew in from Berlin. Sarah Jaffe was there, as was the whole Occupy journalist crew. Katelan Foisy grinned, wearing a transparent lace dress, next to Melissa, in her gold miniskirt, glamorous even after weeks of making this damn thing possible. John showed up in his bespoke suit, flowers in hand. He grabbed me by the waist and whirled me around until I could barely stand.

I fell out of his arms and collapsed into the bathtub, sagging with exhaustion, grinning stupidly as Kim stroked my hair.

In his *9.5 Theses on Art and Class*, the critic Ben Davis calls Picasso's massive painting *Guernica* "an indubitably heroic example of political art." The painting portrays the deaths of civilians under aerial bombardment during the Spanish Civil War. But what Davis finds heroic is not the painting's content, but its effects. In 1937, the price to see the painting exhibited was a pair of boots to be sent to the Spanish front. The gallery collected fifteen thousand pairs.

Radicals often suspect beauty of corruption. Uptight fuckers though they sometimes are, they're right in one thing: art alone cannot change the world. Pens can't take on swords, let alone Predator drones. But as disappointment and violence spread, the antidote is a generosity that the best art can still inspire.

Art is hope against cynicism, creation against entropy. To make art is an act of both love and defiance. Though I'm a cynic, I believe these things are all we have.

the month before I finished *Shell Game*, Paul Mason interviewed me in London.

"What are you going to do next?" he asked.

"I don't know," I told him. I was overwhelmed with both the show and the news, and my voice shook with exhaustion. "I think I'll go somewhere really fucked up and draw it."

Two months after I finished *Shell Game*, I went to Guantánamo Bay.

In April 2013, I read a *New York Times* editorial by Samir Moqbel, who had been held for more than eleven years at Guantánamo without charge. In the editorial, Moqbel, who was in the midst of a brutal hunger strike, described the experience of being force-fed. Twice a day, guards shackled him to a restraint chair, beating him if he resisted. A nurse jammed a tube down his nostril and into his stomach, then a pumped a can of Ensure through the tube.

For Moqbel, worse than physical suffering was the torture of indefinite detention. Though a judge had cleared him to leave the prison years ago, he remained inside. A hunger strike was the last way he could assert his humanity.

Moqbel's words haunted me. But I never suspected I'd soon visit his prison.

After our arrests at Occupy's anniversary, I'd become friendly with John Knefel, the journalist and *Radio Dispatch* podcaster. In October 2012, he started making trips to Guantánamo Bay. At first I was incredulous, but it turned out that the world's most notorious prison had biweekly flights carrying media and legal observers to see the hearings for the alleged 9/11 mastermind Khalid Sheikh Mohammed. Knefel gave me generous advice—and shared his contact at the military press office. After extensive badgering, I got a seat on a press flight from Fort Andrews.

Once the military gave me my clearance, I pitched my editor at *Vice* a Guantánamo story. The base was one of the most censored environments for photography, I said, but as an artist I might be able to draw my way around the military's blackout.

Thinking of Samir Moqbel's *Times* editorial, I told my editor I wanted to focus on a single prisoner. Guantánamo was a symptom of the War on Terror's systematic violence: the military had erased prisoners' humanity, turning them into bogeymen in orange jumpsuits. But no matter how many Americans knew about torture or force-feeding, they wouldn't care until they saw what it did to an actual man.

NABIL
HADJARAB

As the date for my flight drew closer, I poured over the websites of legal groups who represented detainees. The search for a main character resembled a perverse form of headhunting, but I wanted to find a prisoner with whom I had something in common. On the website of Reprieve, a British legal charity, I found the biography of a man named Nabil Hadjarab.

Algerian by birth, Nabil grew up in France, speaking French as a first language. He was arrested in 2002 in Afghanistan, at age twenty-two. Held on the flimsiest of pretexts, he'd been cleared for release five years ago.

So far, so typical. Then, my eyes stopped on one sentence.

In Nabil's biography, a guard described him as a "great artist."

I spent the next month on the phone with Cori Crider, Nabil Hadjarab's lawyer at Reprieve. She told me more about his life: he was good with languages, enjoyed playing soccer, and dreamed of becoming a translator. As I had been in southeast Turkey, he'd been detained while in a war zone, but there the similarities ended. Whereas the Turkish police let me out after a few hours, Nabil had been tortured, forced to sign a false confession, and thrown on a plane to Cuba.

In June 2013, our plane touched down in Guantánamo. Soldiers ushered us off, past barbed wire and scowling, camo-clad guards. We lined up in the dust to be photographed, then presented with badges reading "Military Escort at All Times."

Our pressroom was in a former airplane hangar. Soldiers watched our computer screens, reading our tweets aloud in mocking voices if they disapproved. The pressroom's phones bore stickers reading "Use Means Consent to Monitoring."

We slept six to an army tent, beds separated by plywood dividers, and showered in another tent. In the blinding heat, iguanas frolicked. An endangered species, they were the true kings of the island. Killing one would earn a soldier a ten-thousand-dollar fine.

It all seemed so cordial. Press officers went about their work monitoring us, joking while they helped journalists set up their Internet connections. On the other side of the wire, most of Guantánamo's prisoners were on hunger strike, being force-fed through the excruciating process Moqbel had described. We wouldn't be allowed to see these prisoners, but the press officers' charm couldn't make me forget they were there.

Once we set up our desks in the pressroom, military escorts led us to a press conference being given by the family members of those murdered on

September 11. The family members had been chosen via lottery, with the winners being flown to Cuba to see the trial.

The press conference was an obvious propaganda attempt, but it did not go as the military might have hoped. One of the first to speak was the frail, elderly Rita Lazar. Her brother Abraham had died in 2 World Trade Center beside a quadriplegic colleague he would not abandon. Despite her loss, or perhaps because of it, Rita was a peace activist. She stood onstage and called KSM's trial a travesty, then called for the closing of Guantánamo.

More family members spoke, in the Brooklyn accents of the people I'd grown up with. A firefighter described being buried in the towers' rubble, surrounded by the moans of the dying. He told us how he'd tried to force his face into the ash, to breathe it in so that he'd die quickly.

Listening to him brought me back to that warm morning of 9/11. His words hit me with the harshness of a dream. I saw the wall of missing-persons flyers at Penn Station, as clearly as if I were standing in front of them. I saw the two thousand gone: dead from fire, building collapse, or breathing smoke. I imagined pairs of office workers holding hands by their windows, then jumping together into that clear September sky.

I thought of the pain of the victims' families—then imagined it spiraling outward, reverberating across America, shaped and mutilated by politicians to justify more wars. That pain was used to justify drone bombings, torture, and Guantánamo Bay itself. In Cuba, it came full circle. Family members of 9/11 victims relived their pain for the media, while uncharged men rotted in cells a mile away, their families' pain unreported.

The next day, we went to court to see the 9/11 military commissions. I sketched next to Janet Hamlin, the resident courtroom artist. When I peered at KSM through opera glasses, a solider confiscated them, calling them "prohibited ocular amplification." Like so many rules at Guantánamo, this seemed to have been improvised on the spot. He confiscated Janet's stadium glasses for good measure.

Before I left the courtroom, a military censor flipped through my book

to make sure I'd followed the rules of "operational security": no doors, no cameras, no faces of guards. To make the censorship obvious, I replaced the guards' faces with blank death masks. The censor laughed, then added a sticker to each page, stating that this art was approved by the United States Military.

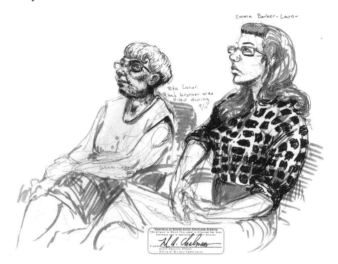

Nabil Hadjarab, like most Guantánamo prisoners, lived in a camp modeled on an American Supermax prison. The military took a baffling pride in these camps, bragging about the ice cream detainees ate, or the books they were allowed to read. Yet we weren't allowed anywhere near the prisons during the 9/11 commissions. As a substitute, the military permitted me to visit Camp X-Ray.

Closed in 2002, Camp X-Ray was a complex of outdoor cages surrounded by barbed wire. For hygiene, prisoners had had two buckets: one for water, one for shit. When prisoners weren't being tortured by interrogators, they endured insects and the Cuban sun. The cages held early detainees like Nabil for months.

The sun burned so hot that the military would let me visit X-Ray only before dawn. My escort's name was Sharon. She had a lovely, windburned face, and her bun was the color of crème brûlée. Before we left the hangar, a moth landed on her collar, its wings blending with her camo. She stroked

it gently with one finger. It was an incongruous gesture, an appreciation for beauty in a place that had none.

Sharon was in her thirties, but she'd joined the army at eighteen to escape rural poverty. Once a mechanic in Iraq, she now shepherded journalists like me around Gitmo, repeating lines meant to convince members of the press that detainees were just spoiled children—lines I could not bring myself to think she believed.

"Don't ask me to talk about the hunger strike," Sharon warned as she drove me out to Camp X-Ray. The words hung sharp. When she spoke, she often seemed to have truths caught in the back of her throat. Despite myself, I liked her each time I heard that ache, though I cautioned myself to shove that fondness back down inside me. In Guantánamo, the military wanted to win our sympathy by any means necessary.

We wandered into the huts where interrogators once raped and tortured detainees. They were collapsing now, packed with moldy Victorian chairs, like decommissioned dollhouses. Dead lizards lay rotting in the weeds. Butterflies fluttered. Sparrows nested in the razor wire. The overgrown grass made Camp X-Ray feel like a relic, as if nature could take back the horror.

At X-Ray, Sharon watched for hours as I drew. As brutal as the sun burned me, Sharon, in her army uniform, had it worse. She took her dress shirt off, sweating through her khaki T-shirt.

"I don't know why the media focuses on Camp X-Ray," she said, looking at the cages. "That was so long ago."

Guantánamo has a gift shop. There, Jamaican contractors sell banana rat plush toys, and T-shirts reading "It Don't Gitmo Better Than This." You can buy pink tank tops decorated with glitter skulls and the legend

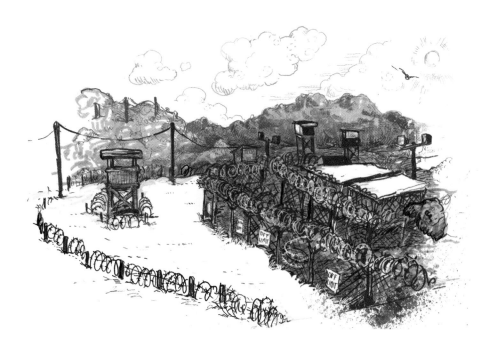

"Guantánamo Bay Little Princess," and postcards boasting the Gitmo motto: "Honor-Bound to Defend Freedom." These American trinkets were made in Honduras or Indonesia, and they're sold with the obliviousness it would take to hawk commemorative beer steins at Buchenwald.

On my last day, I ran into the young *Truthout* journalist Adam Hudson at the store; it was like we'd found each other at a child brothel. To avoid each other's eyes, we stared at the piles of Guantánamo Bay–branded toy iguanas.

Then a German reporter burst out, grinning, his arms laden with T-shirts, laughing at the crazy kitsch he'd found.

Why shouldn't he? America wasn't his country.

That night, we journalists gathered together our remaining liquor on a picnic table outside our tents. One reporter had covered Guantánamo since the first detainees arrived, and she had been responsible for revealing some of its worst secrets. In her fifties, she had a sarcastic grimace that

belied her terrifying dedication to the island. I got the sense that she didn't like me, or anyone else who came to Guantánamo once and then bragged about it for years at parties, but that night she deigned to speak to me. This whole press tour is to keep us from remembering those men locked in camps five and six, she said, tossing back her whiskey in one gulp.

We drank till we could no longer see the stars.

At six o'clock the next morning, we took the ferry back to the airport. As the sunlight glittered off the bay, I thought of Nabil Hadjarab, shackled to a force-feeding chair. This was not right. America had done something unforgivable. And, because of our refusal to admit that crime, we would never be redeemed.

A reporter who works the disaster beat once told me that journalists are meant to be sieves for the trauma of others. Yet despite myself, Guantánamo stayed in me.

As soon as I got back from Cuba, I had a text from Eleanor Saitta asking me to lunch with her fellow hacker Morgan Marquis-Boire. The two traveled the world using tech to protect dissidents from adversaries, including the US government. They were always good for stories.

I showed up half an hour late at a restaurant on Chambers Street. The two sat by the window, draped in black, their fingers weighed down with menacing silver rings. Morgan had long dreads, and Eleanor wore her hair in a ponytail above an avant-garde black coat.

At first, I couldn't speak. I sat there trembling, feeling the same nauseating dread I'd felt on that ferry leaving Guantánamo. They ordered me liquor, then urged me to drink.

Then, suddenly, the words came out in gulps: Nabil, the razor wire, the force-feeding chair, the Kafkaesque prison through which eight hundred men had passed, and the shame I'd felt. Eleanor embraced me. I shrank into her arms.

After lunch, I got down to work on my Guantánamo piece for *Vice*. I flipped through the dozens of drawings I'd done there—of Camp X-Ray, soldiers with their faces replaced with masks, Khalid Sheikh Mohammed adjusting his beard—then worked up the best into detailed scenes. The writing came hard. Every edit felt like a betrayal; each sentence seemed like a halting step toward a truth hidden behind government redactions. But when I finished, I was proud.

By the time the article ran, Nabil was free. The army had thrown a bag over his head, shackled him to the floor of a private jet, and dropped him off in an Algeria he hadn't seen since childhood. A few months after his release, Nabil emailed me to thank me for my article. I stared at his email address. Once I'd seen him only through the dark mirror of censored documents. Now his words flashed bright on my computer screen. He could speak for himself.

Nabil wrote that he was looking forward to starting his life again. His note was witty and optimistic. But he apologized for one thing: he no longer drew pictures.